"An exquisite fusion of faith leavened by four decades of [...] [...] for everyone who wonders why churches look the way they do. For those charged with designing, funding, and renovating older houses of worship or building new ones, it will prove an exceptional resource."

—Judith Dupré, *New York Times* bestselling author of *Churches*

"As a skilled architectural consultant, Fr. Richard Vosko brings together a much-needed conversation between the spiritual longing for beauty and the formation of just relationships to heal our world. With a creative use of history, theology, and contemporary architectural theory, Vosko insists that we can build houses of prayer that are immanent and transcendent, honoring the assembly, the tradition we love, and the creative innovation needed in these times."

—Paul Janowiak, SJ
Associate Professor of Liturgical and Sacramental Theology
Jesuit School of Theology

"Richard Vosko's book is more than a search for common ground. It is a thoughtful, scholarly, and pastoral approach to what is arguably the most basic question for worship today."

—Dr. Julia Upton, RSM
Distinguished Professor of Theology
St. John's University, New York

"This book is timely. Vosko's powerful call for unity and his desire to build common ground are inspiring for anyone in these turbulent, polarizing times; but they are particularly poignant for those of us who seek to support and harness the potential power of spiritual communities to bridge our divides through architecture."

—Joan M. Soranno, FAIA
Design Principal
HGA

"Richard Vosko has for many years been a clear voice for encouraging congregations of different faith communities to come together through the sensitive design of worship facilities. This new book takes on the very important work of finding ways that architecture and design can lessen tribal dissonance and find ways to discover the holy spirit in each one of us."

—Michael J. Crosbie, FAIA, Editor-in-Chief, *Faith & Form: The Interfaith Journal on Religion, Art, and Architecture*

"This book is a must-read for individuals and groups involved in the ministry of church building and renovation. Moreover, Vosko's reflections help the reader fathom the deeper developments in the meaning of liturgical symbol in our contemporary age."

—Mark E. Wedig, OP
Professor of Liturgical Studies
President, Aquinas Institute of Theology

"Vosko's extensive experience designing, constructing, and furnishing places for worship is guided by his abiding and ardent belief that those places should help to shape justice-seeking, compassionate, and God-centered Christian communities. His vision is evident on every page of this accessible, theologically grounded, and inspirational book."

—Robin Jensen
Patrick O'Brien Professor of Theology
University of Notre Dame

"Vosko has opened a critical conversation between the meanings of liturgical ritual, liturgical space as ecclesial text, and the demands of social action. For him, worship doesn't just point to a social agenda, it includes every aspect of social action."

—Father J. Philip Horrigan, DMin, liturgical design
consultant, Chicago

Art and Architecture for Congregational Worship

The Search for a Common Ground

Richard S. Vosko

LITURGICAL PRESS
Collegeville, Minnesota

www.litpress.org

1 2 3 4 5 6 7 8 9

Library of Congress Cataloging-in-Publication Data

Names: Vosko, Richard S., author.
Title: Art and architecture for congregational worship : the search for a
 common ground / Richard S. Vosko.
Description: Collegeville, Minnesota : Liturgical Press, [2019] | Includes
 bibliographical references and index.
Identifiers: LCCN 2019001472 (print) | LCCN 2019007430 (ebook) | ISBN
 9780814684955 (eBook) | ISBN 9780814684719 (pbk.)
Subjects: LCSH: Public worship. | Christianity and art. | Church buildings. |
 Church decoration and ornament. | Architecture and religion.
Classification: LCC BV15 (ebook) | LCC BV15 .V67 2019 (print) | DDC
 246/.9582—dc23
LC record available at https://lccn.loc.gov/2019001472

To

Howard J. Hubbard

Bishop Emeritus of the Roman Catholic Diocese
of Albany, New York

A street priest, who became a bishop,
who exemplifies the inseparable link
between worshiping God and working for justice and peace

Contents

List of Illustrations

Acknowledgments

Since 1970 many pioneers in the field have influenced my work as a designer and consultant for worship environments. I continue to learn from these colleagues and friends. Though I cannot list the many architects, artists, clergy, and liturgists who have helped me, I have not forgotten who they are.

For this book I want to mention a few persons who have been specifically helpful to me while I wrote this book. I am grateful to Janet Walton, who encouraged me to put my theories into print and who read many chapters along the way. I thank Professors of Architecture Walter Kroner and Thomas Walton and liturgist/publisher Gabe Huck, who took time to read earlier drafts and share valuable insights and suggestions.

I am indebted also to Rita Ferrone for her conscientious editing. All through our collaboration Rita displayed a solid grasp of key issues regarding church polity, liturgy, and social justice. Her keen eye and creative hand not only made this manuscript readable, but she honestly challenged, corrected, and changed the way I presented some of my ideas. I am so grateful to Rita.

Finally, I thank my friends at Liturgical Press, the acquisitions committee and the editorial and marketing staffs. They made this kind of project most enjoyable and rewarding. My gratitude goes especially to Hans Christoffersen, who patiently ushered this book into print.

Please note that all royalties received from the purchases of this book are donated to Habitat for Humanity Capital District New York.
Thank you.

part one

Foundations

1. Introduction

I am writing this book to encourage a change in the way most Christians think about the interior design of churches and the art that is in them.[1] Although my perspective is Roman Catholic, I am confident that this material will be helpful to other Christian denominations. Ecumenical and theological scholar James Puglisi reminds us of academics and practitioners who are loyal in the quest for liturgical renewal in their own churches. He wrote of "the riches which other ecclesial traditions carry within their traditions and which caused the Second Vatican Council to affirm that elements of sanctification do indeed exist outside the confines of the Catholic Church, because the Spirit of God will blow where it will"[2]

Here are my three main objectives: 1) to help the reader perceive the environment for worship in fresh practical ways so it can demonstrate the inclusive and hospitable nature of the Gospel message; 2) to foster appreciation for the fact that houses of worship can serve as tangible expressions of unity and peace in societies broken apart by polarization; and 3) to establish the

1. In this book I am using the word "church" to include all houses of worship—cathedrals, chapels, and shrine churches—actively used by a congregation.

2. James F. Puglisi, ed., *Liturgical Renewal as a Way to Christian Unity* (Collegeville, MN: Liturgical Press, 2005), ix.

understanding that acts of worship and social justice are inextricable: we cannot do one without doing the other.

The last of these objectives, although not directly connected to religious art and architecture, is greatly influenced by them. Indeed, the thread that ties this whole work together is the conviction that worship and justice are inseparable. The call to worship God and the summons to work for justice are one and the same invitation to the entire Body of Christ. It is my thesis that the establishment of egalitarian equivalence within the architectural setting for worship will manifest not only a more united church, but also a people of God more capable of answering that call.

The term "common ground" in the subtitle has a double meaning. First, a common ground is a place where people of differing viewpoints can move toward mutual *agreement*. This book brings together the various opinions about the characteristics of a functional and beautiful place of worship. Second, a common ground is a real borderless place inside church buildings—one that is shared by both laity and clergy during worship. This book outlines the relationships among God, creation, congregations, architecture, art, and worship and shows how they all fit together. The interiors of our houses of worship can create a strong sense of unity between the clergy and laity while together they praise and thank God in concert with Christ the High Priest. Also, because the liturgy is a celebration of the paschal mystery I agree with those who believe that it cannot be contained within four walls. Christ's death and resurrection are ongoing in the world. Therefore, liturgy requires social action. Without social action, worship is like the proverbial bell without a gong.

Although buildings are important features in our countrysides and cityscapes, I am not so concerned about the external curb appeal or architectural style of a church building (Neo-Classical, Neo-Gothic, Mission, Georgian, or Post-Modern). I am more interested in what takes place *inside* and how the architectural setting and works of art affect the ritual performances of the congregation as well as their mission in the larger community.

At one of his audiences Pope Francis spoke about the preparation of the gifts at the Eucharist. He said, "May the spirituality of self-giving that this moment of Mass teaches us illuminate our days, our relationships with others, the things we do, the suffering we encounter, helping us to build up the earthly city in the light of the Gospel."[3]

Two fundamental assumptions concerning liturgical ministry and spirituality underlie this work. The first is the desirability of a shared approach to liturgical ministry, based on charisms and the gifts of the Spirit. The universal call to holiness is an open invitation to all people to acknowledge God's gifts and then to respond in various ministerial ways. The second is this: Engagement in the sacramental life of the church, especially at the Eucharist, is a divine gift that requires a response, that is, fruitful, active, conscious participation in the Christian life. On a deeper level this is an invitation to all baptized persons to comprehend that the paschal mystery they are ritually memorializing is not something extraneous to their beings. It is a living spirituality that informs our way of being in the world. Although most denominations presume their members are in communion with one another, there are striking architectural factors inside places of worship that weaken the claim that the church is "a sacrament of unity" (SC 26).[4]

The physical and psychological borderlines that exist in traditional and even in modern church buildings undeniably give the impression that religious institutions are organized according to a class system. The architectural distinction between the nave (the

3. Pope Francis, *General Audience on the Liturgy of the Eucharist* (February 28, 2018), http://w2.vatican.va/content/francesco/en/audiences/2018/documents/papa-francesco_20180228_udienza-generale.html.

4. *Sacrosanctum Concilium* (SC [The Constitution on the Sacred Liturgy]), in Austin Flannery, ed., *Vatican Council II: Constitutions, Decrees, Declarations; The Basic Sixteen Documents* (Collegeville, MN: Liturgical Press, 2014).

assembly area) and sanctuary, presbyterium, or chancel[5] indicates a framework in ecclesial polity that distinguishes the clergy from the laity. I am aware that the Catholic General Instruction of the Roman Missal calls for the presbyterium (sanctuary) to be set off from the rest of the assembly area (GIRM 295).[6] Presumably this direction is intended to counter the emergence of more "collaborative ecclesiologies."[7] Nevertheless, my proposition for egalitarian worship settings is a response to challenges the church faces at this time in history. Valuable and loyal bonds between clergy and laity have been fractured for one reason or another over a long period of history leading up to the present. The relationships continue to be ruptured because of more recent and extremely disturbing concerns that have to do with the way we treat one another as human beings. Without abrogating the hierarchical nature of any denomination, what can be done? Might the elimination of all architectural and artistic barriers during worship help to restore right relationships within the Body of Christ? My answer to that question is a resounding Yes.

There are innumerable studies that point out how the built environment shapes human behavior. My intent is to illustrate how church architecture and art specifically can provide a common ground in an age when religions and societies are wounded by cultural and personal clashes that are mean-spirited and hurtful. Social psychological findings and other sources regarding beauty and nature offer compelling evidence for the claim that the envi-

5. In this book I am using the words "sanctuary," "chancel," and "presbyterium" interchangeably to refer to that area in the churches of most Christian denominations where the clergy preside over the ritual actions occurring there.

6. *General Instruction of the Roman Missal* (Collegeville, MN: Liturgical Press, 2011).

7. See Nathan Mitchell, "Liturgy and Ecclesiology," in *Handbook for Liturgical Studies*, vol. 2, *Fundamental Liturgy*, ed. Anscar J. Chupungco (Collegeville, MN: Liturgical Press, 1998), 113–17.

ronment for worship shapes the identity of the members of the congregation and influences how they treat one another, how they worship, and how they tend to strangers in the larger community. The work of designing an environment for worship is much more than a matter of observing rubrical guidelines or following fashionable trends. To explore this material I will examine diversity in architectural and artistic styles as expressions of culture, taste, memory, and imagination.

Part One of this book consists of "foundation" topics that are essential to consider before even thinking about church design. This section will focus on polarizations, reformations, the common good, God, the cosmos, and dualistic language. In Part Two I will examine the development of philosophical and theological theories and how they influence an understanding of the ritual performances of sacraments, especially as they relate to the memorialization of the paschal mystery. In Part Three I will review a seemingly endless flow of new intelligence regarding the impact of architecture and art on human behavior in places of worship. I will also examine why there are such strong opinions about traditional and modern styles. In Part Four I will personify the church building as a sacramental minister and point out how various spaces, furnishings, and artifacts are required by the building in order for it to be a servant to the congregation. In Part Five I will examine generational expectations and emergent churches, two subjects that are related to the dramatic shifts in religious behavior in the United States. In the concluding section I will offer a vision of what church complexes might look like in the future.

The title of my book borrows from the one used by renowned architect Edward A. Sövik (1918–2014) in his concise and influential work.[8] I inserted the word "congregational" not because Sövik overlooked the importance of the assembly. He believed the primary

8. Edward A. Sövik, *Architecture for Worship* (Minneapolis: Augsburg, 1973).

function of any house of worship is precisely to serve the members and their mission in the world. He also promoted the challenging idea of a "non-church church" suggesting that our houses of worship must be more than just a place for liturgical activity.[9] During a visit with Ed shortly before he died I asked him what the most important thing is that artists and architects should know today. His incisive and lucid answer was one that he had repeated frequently throughout his professional career—"theology!" One might deduce from his answer that an essential question to ask is: What theology is expressed in this place of worship?

Allow me a few disclaimers. 1) If you want an exhaustive theoretical treatise on sacred art and architecture, this is not it. Selected resources for further reading are listed at the end of this book. 2) If you are looking for an exacting "how to do it" manual or to browse through nice photos of liturgical places, this is not it. Countless other books and journals might be more useful. 3) If you are hoping for an apologetic treatise that defends traditional or Post-Modern architectural styles, this is not it. I am searching for a paradigm that balances what is new with what is old. 4) It is not my intent to offer a compendium of significant studies dealing with so-called sacred places or ritual performance. Nevertheless, I hope you will appreciate my effort to weave brief excerpts from the writings of theologians, architects, artists, and others that are directly related to the fields of worship, art, and architecture. Finally, 5) Although much of this book may appear to be iconoclastic in terms of hierarchy, rituals, art, and architecture, I fully acknowledge with abundant gratitude the uncountable ways in which Christianity at large and the Catholic Church and other faith traditions in particular have contributed to the rise and welfare of civilizations over the centuries. I am also mindful of the many risks taken by the laity and clergy to promote justice and

9. See Mark Torgerson, "Sövik's House for the People of God," *Faith & Form* 51, no. 2 (2018): 22–27.

peace for all human beings. There are, of course, many issues that Catholics, in particular, have to deal with in terms of credibility, trust, leadership, and governance. The future of the liturgical life of the church will depend on what all members of the Body of Christ will do to address these concerns. My thesis is specifically related to art and architecture as valuable agents in celebrating the presence of God at work within living stones. My hope is that this book, based on fifty years of experience as a designer, consultant, educator, and liturgical presider, will broaden perspectives. May it also assist congregations, leaders, artists, and architects in moving to a common ground where humility, truth, and beauty can serve a world desperate for moral moorings.

2. Polarizations Everywhere

"Healing yourself is connected with healing others."
—Yoko Ono

Why write a book on church art and architecture as a way to seek a common ground—something we desperately need in both the religious and the secular worlds? Polarization and its effects are not only a problem of the church. There is without doubt a deep strain of tribal politics, manifested in nativistic or nationalistic behavior that is dividing societies around the globe. Former president of the United States Barack Obama said recently that in the great arc of American history there has always been a push and pull "between those who want to divide and those who are seeking to bring people together."[1] Sadly, organized religions are also dealing with tensions that split their members into separate and opposing camps. Throughout history the Christian religion has been fractured by conflict over doctrinal, ministerial, moral, and territorial issues. We have learned that divisions arising from such disputes do not heal but wound the church. Although tensions in life are inevitable and can act as healthy tools when seeking the common good, they can be destructive and self-serving when opposing parties are unwilling to compromise.

1. The World News, https://theworldnews.net/us-news/obama-campaigns
-in-california-says-2018-brings-a-chance-to-restore-sanity-in-politics.

There is another, more constructive way to understand and deal with the reality of tension. Ever wonder why our church buildings do not fall over? Buildings stand because of the tensions between certain parts of the structure pushing against other pieces. The magnetic force that can pull things apart can also exert tension to keep things together. We need a positive viewpoint of our own centers of gravity, our moorings or bearings, to prevent religious and secular worlds from tumbling down.

Even a cursory glance at news reports shows disturbing evidence that conflicts and divisions have reached a dangerous level. In the United States hate crimes and brutal acts of prejudice are on the rise. Murderous acts are occurring in schools, churches, offices, and entertainment venues. Bullying is rampant on the Internet and age-based and gender-based harassment in the workplace is on the rise.[2] Uncivil behavior is fueled by strong divisions in society over gun control, immigration, health care, women's rights, climate change, housing, and voting rights. Drug use and the number of suicides is on the rise in all age groups. The vast gap between wealthy and poor people is another dividing factor. According to Jonathan Rauch, who writes about the connections between income inequity and happiness, "Like it or not, inequality in today's America drives politics toward rage and polarization, and toward destabilizing and dangerous populisms of both left and right."[3] Two things are clear. First, we human beings are responsible for these problems. The polarizations in American society are the symptoms of just how narcissistic and self-centered we have become as a nation. Second, most people are frustrated and want to see an end to partisan pillorying fueled by media

2. See Chai R. Feldblum and Victoria A. Lipnic, *Report of the Co-Chairs of the Select Task Force on the Study of Harassment in the Workplace*, U.S. Equal Employment Opportunity Commission, Washington, DC (June 2016).

3. Jonathan Rauch, "Why Prosperity Has Increased but Happiness Has Not," *The New York Times* (August 21, 2018), https://www.nytimes.com/2018/08/21/opinion/happiness-inequality-prosperity-.html.

personalities as well as by leaders of government and religion.[4] In one of his columns David Brooks analyzed the problem in this way. "From an identity politics that emphasized our common humanity, we've gone to an identity politics that emphasizes having a common enemy."[5] Brooks is referring to the sad reality caused by politicians and lobbyists who support populist ideologies that further divide people into tribal camps. Candidates for office make promises to disenfranchised voters with no reasonable strategy for achieving them; their pitch consists solely in blaming the other side. When promises are not kept, people get angry, and when people get angry they mistrust and fight one another.

What do these frightening phenomena of contemporary life in the United States have to do with church art and architecture? They should cause us to ask serious questions about the symbolic statements that are made by our church buildings. Like it or not, the prevailing physical separation of clergy and laity in church buildings during liturgy is an expression of the divisions and polarizations that exist in the church. Massimo Faggioli, theologian and frequent author on ecclesiastical affairs, wrote that "the church appears to represent something very different from a community of unity and reconciled diversities."[6]

4. See two commentaries: Matt Malone, SJ, "Who Is the Cause of Society's Polarization? All of Us," *America: A Jesuit Review* (April 30, 2018), https://www.americamagazine.org/politics-society/2018/04/20/who-cause -societys-polarization-all-us; and Jay W. Cobb, "Enough Tribalism," *The Buckley Club* (November 4, 2016), https://thebuckleyclub.com/enough -tribalism-4827f9718380.

5. David Brooks, "The Retreat to Tribalism," *The New York Times* (January 1, 2018), https://www.nytimes.com/2018/01/01/opinion/the-retreat-to -tribalism.html?rref=collection%2Fsectioncollection%2Fopinion&action =click&contentCollection=opinion.

6. Massimo Faggioli, "Polarization in the Church and the Crisis of the Catholic Mind," *LaCroix International* (November 27, 2017), https:// international.la-croix.com/news/polarization-in-the-church-and-the-crisis -of-the-catholic-mind/6444.

Faggioli is focusing on church-related divisions, but many cultural and moral issues are just as problematic for society as a whole in the United States and have spilled over into the church. A couple of examples pertain to our broken immigration system. The policy of separating children from their parents who are seeking asylum and the proposal to construct a wall between Mexico and the United States have divided Catholics into opposing camps. Recent polls say that a 55-percent majority of white non-Hispanic Catholics favor the wall, while fully 83 percent of the Catholic Latinx population is opposed to an expanded rampart. In the context of American Catholic history, perhaps this should not surprise us. As history professor Julia Young wrote, "Catholic nativism toward other Catholic immigrants is a recurring sentiment that dates to at least the second half of the nineteenth century, when the influx of Catholics changed the religious landscape of the United States."[7] Yet, it remains a troubling divide. This is why it is impressive to see some bishops and others taking their place among migrant workers and immigrants seeking asylum along the Mexican–U.S. borders and advocating for their human rights. Would we Catholics in the United States step up our resistance to social injustice if every one of our bishops showed up as a group at the border wall that separates Nogales, Arizona (U.S.) from Nogales, Sonora (Mexico) to protest? A more united church would indeed make a difference.

Most Catholics and Protestants agree that immigrants brought to the U.S. illegally as children should be granted permanent legal status. Yet, although the United States Congress is 88.2 percent Christian, with Catholics comprising one-third of the House of Representatives and about 22 percent of the Senate,[8] elected officials continue to be passionately divided over the Deferred Action

7. Julia G. Young, "We Were Different: Why Nativism Persists Among U.S. Catholics," *Commonweal* (March 9, 2018): 10.

8. These are the figures as of the 2018 mid-term elections in the United States.

for Childhood Arrivals program (DACA) and immigration laws in general. To its credit, the United States Conference of Catholic Bishops (USCCB) joined other Christian denominations and groups such as Advocates for Justice Inspired by Catholic Sisters (also known as Network) in supporting federal laws that would protect undocumented children from deportation. But are the Catholic people united with their bishops in this effort? Or are they, too, caught up in the political gridlock of opposing camps?

In another example, the USCCB published strong objections to President Donald Trump's travel ban denying entry into the United States by refugees and citizens from several countries heavily populated by Muslims. The Conference wrote: "Such blatant religious discrimination is repugnant to the Catholic faith, core American values, and the United States Constitution. It poses a substantial threat to religious liberty that this [Supreme] Court has never tolerated before and should not tolerate now."[9] Despite strong denunciations such as this, the Supreme Court[10] ruled that, aside from what his personal feelings may be, President Trump's decision to impose the ban was within the limits of his executive authority. Tensions remain.

It is understandable that these divisions within this country did not emerge overnight. The 2016 presidential election campaign gave witness to a growing dissatisfaction with government in the United States. According to the Pew Research Center (PEW) 60 percent of white Catholics voted for Donald Trump while 37 per-

9. Brief *Amici Curiae* of the United States Conference of Catholic Bishops, Catholic Charities USA, and Catholic Legal Immigration Network, Inc. in the Supreme Court of the United States Inc. in Support of Respondents (No. 17-965): 6, https://www.supremecourt.gov/DocketPDF/17/17-965/41839/20180330170127467_No.%2017-965%20Amicus%20Brief%20ISO%20Respondents%20Final.pdf.

10. At this writing there are six Roman Catholics on the United States Supreme Court if you include Neil Gorsuch, who was raised Catholic but now attends an Episcopal Church. The other three are Jewish.

cent of Latinx Catholics voted for Hillary Clinton. White Evangelicals voted overwhelming (80 percent) in favor of Trump and his platform. Not all Christians are on the same political page when it comes to human rights, income inequality, climate change, gun control, and war.

An issue that will most likely intensify polarizations among Catholics in the United States concerns capital punishment. In August 2018 Pope Francis revised No. 2267 in the *Catechism of the Catholic Church* to read, "the death penalty is inadmissible because it is an attack on the inviolability and dignity of the person."[11] Although the U.S. Catholic bishops immediately announced their support for the pope's action (a doctrinal change that has been in the works for years), how Catholics will respond to this development in church teaching cannot be gauged.[12] As recently as June 2018 the PEW research center reported that 57 percent of *white* Roman Catholics in the United States favored the death penalty.

Indeed, there is no way for Catholics to know if even the U.S. bishops are all on the same page in any ecclesial or civic matter. In principle the bishops act collegially (as a college), but the Conference as a whole has little power. Committees of the USCCB have at times produced very helpful and sometimes controversial pastoral statements, such as the landmark pastoral letters about the

11. Edward Pentin, "Pope Francis Changes Catechism to Say Death Penalty 'Inadmissible,'" *National Catholic Register* (August 2, 2018), http://www.ncregister.com/blog/edward-pentin/pope-francis-changes-catechism-to-declare-death-penalty-inadmissible/.

12. A trio of bishops urged action to halt an upcoming execution in Nebraska while the Catholic governor said that he remains in support of capital punishment. See Joe Duggan, "As Vatican seeks to abolish death penalty, local bishops urge Nebraska to halt Moore's execution," *Omaha World Herald* (August 3, 2018), https://www.omaha.com/news/courts/as-vatican-seeks-to-abolish-death-penalty-local-bishops-urge/article_dea3ef07-7ce9-5250-9e1e-592fdb453c9f.html.

economy, war, and the arms race.[13] However, archbishops and bishops are autonomous authorities in their own archdioceses or dioceses. They answer to the Vatican and not to the leadership of the USCCB. Increasingly, the Conference itself appears to be polarized. One example of the divide in the USCCB can be found in the way the bishops responded to Archbishop Carlo Maria Viganò's "Testimony."[14] That letter accused Pope Francis and many high-ranking prelates of sheltering and promoting known sexual abusers and "homosexual networks" in the church, and it called on Pope Francis to resign. Some American bishops vociferously supported Viganó while others dismissed his charges as totally unsubstantiated. The varying responses revealed an underlying rift between Francis and certain bishops that seems to have little to do with the abuse crisis and more to do with enmity and partisanship in church politics. Historians of the papacy such as Michael Walsh, an editor for the *Oxford Dictionary of Popes*, remarked that tensions between Francis, who is seen as a reformer, and conservatives such as Viganò have been brewing for some time.[15]

The popular perception is that the United States bishops are in solidarity on certain pro-life matters. Yet, it is also clear that the "Seamless Garment" mantra of Cardinal Joseph Bernardin (1928–1996) is not their overarching guidepost for the so-called "life" issues. Cardinal Bernardin was deeply committed to reconciling differences and bridging polarities in the church, not only concerning "life issues" but also in other contentious areas. He founded

13. See, for example, *A Catholic Framework for Economic Life*, November 1996, and *The Challenge of Peace: God's Promise and Our Response*, May 1983 (Washington, DC: USCCB).

14. Carlo Maria Viganò, *Testimony*, trans. Diane Montagna (Rome, August 22, 2018).

15. Saphora Smith and Claudio Lavanga, "Clerical Sex-Abuse Scandal Exposes 'War within the Vatican,'" in NBC News online, August 28, 2018, https://www.nbcnews.com/news/world/clerical-sex-abuse-scandal-exposes-war-within-vatican-n904376.

the Catholic Common Ground Initiative[16] in 1996 with the National Pastoral Life Center in pursuit of that effort. Yet, this initiative met with only limited success. Today, to the extent that bishops represent a cross section of the U.S. Catholic population, the red, blue, and purple state categories also define the Conference. It is more than likely that bishops will not agree as a group on issues that affect our common life, and they will teach from a partisan point of view when they get back to their own dioceses. This is unfortunate. When any conference of bishops in any country remains silent or shows discord on certain moral matters, the seamless garment is torn asunder and Catholics in those countries will remain fragmented as well.

The premise of this book is that the church's own symbol system calls us to something better. The fissions between the laity and their clergy that are demonstrated in church buildings that physically separate the two groups do not need to prevail. Other, better models are available. In truth, while countless congregations, clergy and laity, do worship in a spirit of unity and act as agents of justice in a spirit of solidarity, most church buildings do not give testimony that such collaborations exist. The interior design of church buildings and rituals that occur inside a church point out clearly that clergy and laity are two separate estates. The voices of the clergy are more important than those of the laity, and they talk past each other in a way that is more often reflective of our fractured secular order than of the Gospel.

Internal rifts must be addressed before any religion can present itself as a peacemaker in world affairs. This is an ongoing struggle. Indeed, no religion or Christian denomination is impervious to such tensions. In October 2017 an Anglican Inter Faith Commission was created at the Anglican Communion's Primates' Meeting in Canterbury, England. According to the Episcopal News Service, the Archbishop of Canterbury, Justin Welby, said that "the issues

16. https://en.wikipedia.org/wiki/Catholic_Common_Ground_Initiative.

of interfaith strain, stress, even conflict, are global, they are generational and they are ideological."[17] In part, tensions between the Episcopal Church in the United States and the Anglicans in the United Kingdom and other countries stem from the ordination of a gay bishop and the marriage of same-sex partners. More recently, in July 2018, polarized reactions erupted when Episcopal Church leaders in the United States passed a new rule allowing a parish priest to preside at a gender-neutral marriage rite even though the local bishop may oppose same-sex unions. Some members of a church will wonder how a religion like Christianity can boldly profess that it stands for peace and harmony regionally or globally when it cannot resolve the divisions that exist within its own ranks.

Furthermore, there is evidence of an insurmountable rift at the top levels of the hierarchy in the Catholic Church. Some cardinals from various countries as well as within Vatican offices have publicly opposed and brazenly reprimanded Pope Francis for his attempts to instill fresh interpretations of such subjects as liturgy, marriage, family life, homosexuality, and climate change. How many lay Catholics are no longer willing to take moral advice from the bishop of Rome or any bishop? According to Eric Hodges, a senior priest from Melbourne, Australia, "Over the last 50 years Western culture has dramatically changed. Contemporary culture is secular and pluralist. Authority, once derived from status, now must be won. Where bishops once had the last say, they are now just another voice in public debate."[18]

The fragmentations found in the secular world also exist within the same congregation of a church. Disagreements over laws in the United States that challenge religious liberties have caused a

17. "Global Anglican commission to tackle inter-religious tensions" (October 6, 2017), Episcopal News Service, https://www.episcopalchurch.org /library/article/global-anglican-commission-tackle-inter-religious-tensions.

18. Eric Hodgens, "Spare a Thought for the New Archbishop," *LaCroix International* (July 23, 2018), https://international.la-croix.com/news/spare -a-thought-for-the-new-archbishop/8113.

wide range of reactions within almost every denomination. Consider how some of the evangelical churches and other Christian denominations in the U.S. are split when it comes to issues regarding human life, gun control, capital punishment, and religious liberty. In June 2018 the Initiative for Catholic Social Thought and Public Life hosted a conference called "Though Many One: Overcoming Polarization Through Catholic Social Thought." The discussions focused on how to dialogue about the divisions within the Catholic Church in a civil manner.[19] One theory that emerged was that any discourse dealing with these tensions will be ineffective if the agenda is so designed that opposing groups are expected to surrender their values. The idea was that diverse groups should come to a middle or common ground on which they can approach a fruitful compromise. To do so requires that disparate groups listen to one another.

The situation is not entirely bleak. Innumerable Catholic organizations and movements in the United States continue to serve as strong advocates for people who are poor and ostracized for whatever reason. And there are many outstanding bishops who promote and practice charity in the wider community. Archbishop Raymond Hunthausen (1921–2018) was exemplary in this regard. He was willing to risk his career and his standing among his brother bishops by opposing gender inequalities and criticizing U.S. defense budgets. Father Michael Ryan remembered Hunthausen with these words: "As a bishop he was called to be a unifier, but he came to know that being true to God and conscience can sometimes lead to division."[20] Tearing down the fences to find a common ground

19. See Michael J. O'Loughlin, "Catholic Leaders Confront Polarization but Skirt Polarizing Issues at Georgetown Forum," *America: The Jesuit Review* (June 8, 2018), https://www.americamagazine.org/faith/2018/06/08/catholic -leaders-confront-polarization-skirt-polarizing-issues-georgetown-forum.

20. Michael Ryan, "Archbishop Hunthausen Was a Man of Prayer, A Man of God," *National Catholic Reporter* (July 23, 2018), https://www.ncronline .org/news/people/archbishop-hunthausen-was-man-prayer-man-god.

today is not easy even for bishops who have enjoyed, for many centuries, the uncontested trust of their members.

In an ever-developing technological world the so-called "cyber militias"—loosely related gangs of trolls and bullies that are motivated by extreme rhetoric online to attack and threaten their perceived ideological enemies in a vicious way—cannot be overlooked as agents in the spread of vitriolic hostilities. It has been substantiated now that election campaigns and voter results in the United States have been the target of influence by outsider interests, mediated by the Internet. Also, by using the Internet extremist Catholic movements have demonstrated that they have the power to pressure bishops and organizations to cancel lectures and concerts by credible speakers, authors, and artists. Mean-spirited bloggers and trolls use social media to alarm and entice church leaders into adopting status quo strategies with regard to the role of the church in society. In some cases, bloggers post bitter attacks based on alternative facts to demean individuals who are doing good work and destroy their reputations. They take no responsibility for the falsehoods they spread but, rather, place the burden of proof on those they have wantonly attacked. Faggioli describes this unfortunate period of church history as the "age of anger."[21]

This is where we are. How do we get to a new place? Each of the following chapters is linked to the well-researched understanding that our built environments shape human behavior. The architectural and artistic settings for worship can help heal divisions when they are designed to unite a congregation of clergy and laity without distinction or physical compartmentalization that compromises their common identity and mission. When people are gathered around the altar table as a collaborative assembly of God, it will become clear that everyone present is called

21. Massimo Faggioli, "Catholic Cyber-Militias and the New Censorship," https://international.la-croix.com/news/catholic-cyber-militias-and-the-new -censorship/5923?utm_source=Newsletter&utm_medium=e-mail&utm _content=29-12-201.

not only to celebrate the indwelling of the Spirit in the assembly but also to help close the rifts that exist in the world around us. Disagreements over architectural styles are not helpful in this regard. What matters is the understanding that liturgical action around the altar table is linked to what happens outside the church walls.

3. Reformations Redux

"The primary and exclusive aim of the liturgy is not the expression
of the individual's reverence and worship for God."
—Romano Guardini

Establishing a common ground in matters pertaining to church art and architecture will not by itself lead to the elimination of the cultural wars in the religious or secular worlds. Nevertheless, there is reason to believe that church art and architecture can play a role in forming communities for mission by increasing their sense of graced solidarity—with one another, with all people, and with creation. A more united faith community can work wonders in the public sphere to correct the inequities and counteract the ideologies that divide people. This cooperative effort emerges from the relationships that members of a faith community develop not only with one another around the communion table but also with people not at the table—especially those who are disadvantaged economically, socially, and in need in any way. It is grounded in a congregation's collective moral response to the biblical call to work for the common good. One might think that listening to the word of God and sharing in a holy communion would automatically diminish or even eliminate divisions within our faith communities. We might speculate that having a sense of a united front would inspire entire congregations to take to the streets in proactive work for justice, peace, and the common good in our society. Unfortunately, it is not that simple. The act of worshiping God by

itself is not a remedy for the ills of humanity. When we honor and thank God for God's abundant mercy, it should remind us that we still have work to do.

Although liturgical rituals can take place anywhere, they traditionally occur within a building purposely designed to accommodate a certain style of worship. The forms used for praising or honoring God can unify people, but they can also generate alienation and division in the large church community. Robert Hovda (1920–1992), a well-known social activist and liturgical sage, contended that it takes a long time for a congregation to learn how to worship together. The ritual actions that occur in a church are shaped by many factors: The full-bodied participation of the worshipers, the proclamation of scriptures, the content of homilies, the performance of music, the presentation of gifts, the bidding prayers, the prayers of thanksgiving, and words of commissioning or sending forth together make up the liturgical experience. These elements create a matrix within which acts of regeneration, forgiveness, healing, and communion occur. They simultaneously affirm whatever is the dominant culture, meme, or customs of a congregation. In an ecclesiological context these attributes are reflectors of the membership's understanding of its organic self, its belief system, and its current mission. Strangely enough, worshipers are responsible for shaping the liturgy and also the place of worship that will affect their spiritual, sacramental, and social actions. We are shaped by what we shape.

In today's Catholic Church, for example, the intramural disputes over the style of worship, the translation of texts, and which Order of Mass to use are sadly dubbed the "liturgy wars." Massimo Faggioli asserts that theological extremism has become mainstream and has been accelerated by the movement known as the "reform of the liturgical reform."[1] This is a serious problem. Worship, which influences the behavior of faith communities in

1. Faggioli, "Polarization in the Church."

the public square, now sadly is being used as a means of bolstering a conservative or liberal agenda when dealing with specific secular and religious issues. These internal tensions are not helpful in fostering healthy relationships within a congregation, not to mention the ongoing reformation and renewal of the church at large. Intramural rifts can also sap the energy of the faith group as it works for the common good in society.

There are those who dispute the existence of polarizations in the church at the grassroots level. In a recent issue of *America* magazine, playwright and actor Joe Hoover, SJ claimed that the "church in the United States is not divided, it is not polarized, it is not at war with itself." Hoover stated that Catholics do not have the time to be concerned about "liturgical styles, homosexuality, Vatican II, priestly genders, Mass translations or what kind of pills a woman can morally ingest."[2] He may be right in pointing out that most Catholics do have more urgent things to worry about in their personal lives. He may even be right in thinking that small groups of Catholics are more vocal than most. And he is correct in referring to the good work done by Catholic missionaries, social workers, educators, and health care providers. Nevertheless, the slow and steady exodus of believers from the Catholic Church and other Christian churches cannot be overlooked. The disaffection, expressed by young and old members alike, is precisely linked to issues pertaining to worship and justice.

It is now apparent that not everyone in the Catholic Church's hierarchy embraced the sweeping updating of the church ushered in by the Second Vatican Council.[3] That pastoral conclave called for a radical movement away from an older perception of the

2. Joe Hoover, "No, There Is Not a Civil War in the Catholic Church," *America: The Jesuit Review* (August 27, 2018), https://www.america magazine.org/faith/2018/08/27/no-there-not-civil-war-catholic-church.

3. See Piero Marini, *A Challenging Reform: Realizing the Vision of the Liturgical Renewal, 1963–1975*, ed. Mark R. Francis, CSV, John R. Page, and Keith F. Pecklers, SJ (Collegeville, MN: Liturgical Press, 2007).

Catholic Church as a powerful, autocratic, and self-centered institution fortified against the outside world. The Council called Catholics to open their hearts and minds in dialogue with the world, to respect and learn from other faith traditions, and to cooperate with other religions to improve the human condition. The bishops at the council produced documents that exhibited a constructive and welcome balance between the pastoral and doctrinal strengths of the church. However, a reaction against the council's reforming vision emerged among some bishops even before there was a chance for the church at large to reap the benefits of the full implementation of the proceedings.

Today, no bishop who is canonically responsible for a diocese in the United States was present as a voting member at the council. This makes sense, of course. The council ended over a half century ago. However, it also means that bishops who are now the chief liturgists in their local churches do not have a first-hand experience of the spirit that prevailed at the council. Small groups of bishops argued then, and others continue to do so now, that the council ruptured continuity with the traditions of the church and divorced itself from original sources. There should be no reason why a spirit of *aggiornamento* and true *ressourcement* cannot live side by side as "twin streams of renewal,"[4] yet the renewal itself is contested by some as a "wrong turn" that needs to be corrected. The architectural manifestation of a determined retreat to previous ages is found in those areas in the U.S. where pastors and bishops approve plans for remodeled or new churches that replicate those designed *before* the council. It is as if they wish to make a statement that "nothing has really changed."

Although the advancements and transformations inaugurated by the council are regarded as indisputably positive and encouraging

4. This expression was used in *Walking Together on the Way: Learning to Be the Church—Local, Regional, Universal*, Agreed Statement of the Third Anglican–Roman Catholic International Commission, No. 3 (Erfurt: SPCK, 2017).

by most Christians of all denominations, various Catholic voices continue to resist the teachings found in the sixteen documents published at the council. The eminent historian of the council Joseph Komanchak found in his research that some theologians said just "recently" (fifty years after the council!) that it was still too early, perhaps, to draw conclusions about the impact of the pastoral awakenings of the council. Komanchak wrote in 2015, "Some are using the texts in a way that other people believe betrays not only the Council's intentions but what it actually said."[5] Regarding this situation Archbishop Emeritus Rembert Weakland asked a poignant question about continuity: "What are the precise criteria by which one can judge which elements of the past must be retained and their growth fostered? Without such criteria, continuity becomes a vague and subjective process."[6] I would ask, just how far back will this process of "looking in the rear-view mirror" go? Is Trent and the Tridentine liturgical synthesis its final destination? Will it retreat to a medieval time preceding the Council of Trent? Or will it perhaps retreat further to recover older and even more traditional settings for the Eucharist? One might legitimately ask: Why is it that church buildings today are not modeled after the simple, more domestic Christian house churches that predated the imposing imperialistic basilicas?

A well-known example of liturgical tension has been institutionalized by the policy Pope Emeritus Benedict XVI put into place in 2007 restoring the free use of the rites as they were practiced prior to the council, alongside the rites as they were reformed in light of Vatican II. Benedict's apostolic letter *Summorum Pontificum* (called *motu proprio,* which means it is issued by the

5. Joseph A. Komonchak, "Interpreting the Event of Vatican Two," in *The Contested Legacy of Vatican Two: Lessons and Prospects*, ed. L. Boeve, M. Lamberigts, and T. Merrigan (Leuven: Peeters, 2015), 1–5.

6. Rembert Weakland, "The Liturgy as Battlefield: What Do 'Restorationists' Want?," *Commonweal* (January 11, 2002), https://www.commonweal magazine.org/liturgy-battlefield.

Pope's own hand) permitted the liberal use of the Mass and all of the rites of the sacraments as they were in 1962, before the council reformed the liturgy. The result is that we now have a set of rites that contrast and conflict with the standard ordinary rites (the Missal was originally published in 1970 and has been updated most recently in 2002) in terms of textual translation, music, vesture, calendar, ritual action, and the architectural setting for the Mass. The stated justification for the permission to use the older rites, which were untouched by the reforms of the council, was to satisfy the faithful "who remained strongly attached to this usage of the Roman Rite, which had been familiar to them from childhood" and who desire "to recover the form of the sacred liturgy that was dear to them."[7] Yet, this irenic pastoral vision seems not to have taken into account that the council really did make a difference in how we understand, and therefore how we celebrate, the liturgy. Liturgical scholar John Baldovin, SJ wondered why the pope did not "take pains to insist that those who adopt the Missal of 1962 should be clear about their allegiance to church teaching, in this case, Vatican II."[8] Baldovin raises this reasonable question because many of those who are delighting in the pope's permission are critics not only of the liturgical reform but also of the council's other teachings. "This document will only give them hope that the last forty years can be reversed."[9] Unwittingly, perhaps, the permission to use the so-called Extraordinary Form of the rites has fueled more division in a church already split into conservative and progressive branches. This is a big price to pay for satisfying the nostalgic appetites of a small group of

7. Benedict XVI, *Summorum Pontificum* (On the Use of the Roman Liturgy Prior to the Reform of 1970), July 7, 2007, http://w2.vatican.va/content/benedict-xvi/en/motu_proprio/documents/hf_ben-xvi_motu-proprio_20070707_summorum-pontificum.html.

8. John F. Baldovin, *Reforming the Liturgy: A Response to the Critics* (Collegeville, MN: Liturgical Press, 2008), 132.

9. Baldovin, *Reforming the Liturgy*, 132.

Catholics that, many believe, will fade sooner than later. Of course, it may be that the continued celebration of rites untouched by Vatican II was the goal all along of those who lobbied for this change—quite apart from a pastoral concern for those who were attached to the older rites from their childhood. Faggioli remarked, "We are well beyond the point when Catholic theologians and liturgists worried about the appearance of a new 'bi-ritualism' within the Catholic Church: thanks to Benedict, a bi-ritual Roman rite is now a *fait accompli*." Faggioli continued, bi-ritualism is "aimed at a new generation of traditionalists, born after 1964."[10]

A more recent voice advising Catholics about the correct way to celebrate the liturgy comes from Cardinal Robert Sarah, the current prefect of the Congregation for Divine Worship in the Catholic Church. He recently suggested in his preface to a new book by Federico Bortoli[11] that the practice of taking the Eucharist in the hand is unsuitable and the "work of the devil." Although his words were applauded by some, many mainstream commenters were appalled by this apparent broadside on an accepted and innocuous liturgical practice. Rita Ferrone commented in *Commonweal* magazine, "One must reluctantly conclude that Cardinal Sarah—despite holding a mainstream office—really does not speak for the mainstream of the church." In her critique, Ferrone enumerated some of Sarah's previous efforts at leadership (such as advocating Mass celebrated facing east rather than facing the people, delaying Pope Francis's plan to allow women to participate in the Holy Thursday foot washing, and misrepresenting the pope's call for local bishops' conferences to take responsibility for liturgical translations) as further proof that "what he really does best is sow

10. Massimo Faggioli, "Extraordinary Divisions," *LaCroix International* (August 9, 2018), https://international.la-croix.com/news/extraordinary-divisions/7004.

11. Federico Bortoli, *The Distribution of Communion on the Hand: Historical, Juridical and Pastoral Profiles* (Siena, Italy: Edizioni Cantagalli, 2018).

division." She concluded that the cardinal's comments on communion in the hand "reveal either an appalling ignorance of or an indifference to liturgical history . . . he is disparaging the faith of many centuries of Christians."[12] The back cover of the cardinal's own book, on liturgical silence,[13] includes other fulminations against various liturgical practices, and provides evidence of the discord in church circles. Yet, Sarah is described by one reviewer as "one of the most spiritually alert churchmen of our time." Another reader described the book as "a treasure chest of wisdom." It would be a real shame if future historians were compelled to record that it was the worship of God in the twenty-first century that fractured the church into pieces.

Ferrone and others agree there is little doubt that those responsible for the ritual performance of the sacramental system of the Catholic Church would benefit from learning more about the art of celebrating according to the so-called Ordinary Form—the rites as they were reformed after Vatican II. There are countless examples that reveal a lack of understanding of the Mass, much less about how to go about gracefully enacting it in a decorous and hospitable way. However, the current liturgical dissimilitudes among worshipers, presiders, teachers, and members of the hierarchy, along with the diverse inclinations of the church's lay membership about improving worship as well as the church's role in society, make the search for a common ground in church art and architecture difficult but not impossible to achieve.

12. Rita Ferrone, "Cardinal Sarah Does It Again," *Commonweal* (March 23, 2018), https://www.commonwealmagazine.org/cardinal-sarah-does-it-again.

13. Robert Sarah, *The Power of Silence: Against the Dictatorship of Noise* (San Francisco: Ignatius Press, 2017).

4. The Common Good

"Your people honor me with their lips
but their hearts are far from me."
—God, cf. Matthew 15:8

Some might be thinking now that the aim of this book, to search for a common ground in church art and architecture as well as worship, is unrealistic. How can we do this? Perhaps the answer may be found in how the church serves the common *good*. Our relationships with one another and with strangers are the focus of deep concern within the Christian faith tradition. We can turn to the Bible to see that the connection between worship and social action is an ancient one. In Isaiah 1:10 the author reports that God was dissatisfied with the Israelites because of their failure to do what is just in God's eyes. God warned them, "learn to do good, seek justice, rescue the oppressed, defend the orphan, plead for the widow." God was unimpressed with any sacrificial offerings and prayers that were unaccompanied by good works. The implications of this passage for today are clear: a congregation may not praise God and ignore the human rights of others. To worship God *is* to work for justice and peace. Otherwise, ritual performance is nothing more than an empty ceremonial act. The eucharistic liturgy, and the liturgies of all the sacraments, rehearse the congregation for engagement in works of justice. This is why learning to do liturgy as one body, united in Christ, is so important. The divine imperative for justice nakedly reveals the true identity of the assembly and its leaders.

Concern for the common good is a not a new idea. Plato and Aristotle argued that what is good for the state must be linked to what is beneficial for the individual. The apostle Paul urged his followers not to tend only to their interests but also to the needs of others. The fourth-century Christian writer John Chrysostom admonished his listeners, "Not to enable the poor to share in our goods is to steal from them and deprive them of life. The goods we possess are not ours, but theirs."[1] Thomas Aquinas suggested that the goals of any civilization should be to serve all the people of that society. And, later, the eighteenth-century philosopher Jean-Jacques Rousseau developed a social contract whereby citizens would be codependent on one another to meet their needs. Yoni Applebaum, senior editor at *The Atlantic,* contends, however, "Americans have never agreed on when to prioritize the needs of individuals and when their collective project should come first."[2]

Philosopher and educator Maxine Greene observed that this is an age in which previous value systems have been forgotten or abandoned and that there are multiple competing viewpoints on how to achieve a common good. She wrote, "We cannot assume that there is any longer a consensus about what is valuable and useful and what ought to be taught, despite all the official definitions of necessary outcomes and desired goals."[3] If this is true, what then becomes of the social doctrines embraced by religious groups? How do faith communities maintain a moral voice amid political rhetoric that disregards every core principle of humanitarian comportment? Most churches continue to agree in principle that working for the common good is a high priority. But members

1. St. John Chrysostom, *Homily in Lazaro* 2, 5: PG 48, 992, cited in *Catechism of the Catholic Church* (Allen, TX: Thomas More Publishing, 1994), 587.

2. Yoni Applebaum, "Is the American Idea Doomed?," *The Atlantic* (November 2017), https://www.theatlantic.com/magazine/archive/2017/11/is-the-american-idea-over/540651/.

3. Maxine Greene, *Releasing the Imagination: Essays on Education, the Arts and Social Change* (San Francisco: Joffrey-Bass, 1995), 3.

of different political parties sitting on the same pew bench in church have different methods for reaching that goal. Some churches issue declarations to help congregations work for the common good. For example, the Evangelical Lutheran Church in America issued a social teaching statement back in 1991 called "The Church in Society: A Lutheran Perspective."[4] It declared, "Along with all citizens, Christians have the responsibility to defend human rights and to work for freedom, justice, peace, environmental well-being, and good order in public life."[5] The *Catechism of the Catholic Church* repeats a statement found in *Gaudium et Spes*, the Declaration on the Church in the Modern World, which was released at the end of Vatican II. The common good is "the sum total of social conditions which allow people, either as groups or as individuals, to reach their fulfillment more fully and more easily" (CCC 1906–09).

Unfortunately, the reality is that the idea of a common good may be an obsolete ideology. Religions have failed to find a reasonable postmodern voice in the public sphere. Andrew Latham, a political scientist at Macalester College, points out that Christians in the United States once shared an understanding of what was necessary for people to reach fulfillment, a general consensus that would also create "an informal alliance between church and state." However, Latham warns, some religions are still using dated doctrines in an effort to maintain a decisive voice in the public realm, and this approach is not working very well. He calls it a rupture between church and society.[6] It would not follow, in

4. For a copy go to https://elca.org/Faith/Faith-and-Society/Social -Statements/Church-in-Society?_ga=2.200030830.1137698596.15384 94268-1239980356.1538494268.

5. *The Church in Society: A Lutheran Perspective* (Chicago: The Evangelical Lutheran Church in America, 1991), 5.

6. Andrew Latham and John R. Bowlin, "Is the Common Good Obsolete? An Exchange," *Commonweal* (November 16, 2016), https://www.common wealmagazine.org/common-good-obsolete.

my estimation, that any religious cohort would impose its particular ethical agenda on society. It does mean, however, that a congregation could join the strength of its own convictions regarding the common good with other cohorts—religious or not—to heal the wounds of a broken world. Unfortunately, the link between the ritual act of honoring God and a persistent social action response from congregations is not commonly taught in homilies or faith formation programs. How many times have you heard a preacher denounce corruption in civic or ecclesial institutions? How often does a pastoral leader publicly condemn child abuse or capital punishment or unfair wages? It is not enough to hear the mantra "God loves you" without doing something to bring assistance to a disadvantaged person. John Kleinsman, law professor at the University of Wellington, wrote, "Any quest to recover the notion of the common good cannot be achieved by either returning to, or holding onto, a more traditional account of morality."[7] Kleinsman suggested a rereading of moral doctrines in light of the documents of Vatican II, particularly *Gaudium et Spes* (The Church in the Modern World). He pointed to that document because it urged Catholics to read "the signs of the times" and "to respond to them by entering into honest and sincere dialogue" with others.[8]

Church art and architecture fit into this discourse. When a building is designed to bring worshipers together as equals and when sermons, art work, and song lyrics are provocative reminders of the congregation's social responsibilities, then hopefully the same worshipers will find ways to set aside differences and learn to work together for the common good. In practice this means that preachers have to pay attention to current events, music ministers

7. John Kleinsman, "The Common Good in an Age of Moral Hyperpluralism: A Catholic Bioethical Perspective," *Victoria University of Wellington (NZ) Law Review* 44, no. 2 (2013): 345.

8. Kleinsman, "The Common Good in an Age of Moral Hyperpluralism," 345.

have to choose songs that mirror refreshed theologies, artists have to craft images that speak of social inequities, and the architecture of the building must resonate with the ever-evolving relationships among God, clergy, and laity. This means that nothing in the church building, veiled or visible, should suggest that some people are more blessed or more important than others in the same space.

In later chapters I will explain more fully how the arrangement of spaces in a church and the artifacts within it can foster full, fruitful, conscious participation in the liturgical act and works of social justice. That sequence of congregational activity—worship and advocacy for human rights—will keep the paschal event a *tour de force* in promoting the common good. The built environment has the power to shape our lives whether at home, in the office, a classroom, a theater, or a church building.

In this context, designing the architectural and artistic setting for liturgical rites is a tremendous responsibility. It is not simply an aesthetic exercise. Further, it does not belong solely to a pastoral leader or designer but to the whole congregation. Architect John Portman once advised, "A building is to meet the needs of all the people, the architect must look for some common ground of understanding and experience."[9]

The architectural style of a church may or may not contribute to the landscape of a particular region; it may or may not be a sustainable edifice; it may or may not be the most significant structure in the neighborhood and, to some, it may or may not even look like a church. However, the design and layout of the interior space does have the power to 1) influence the behavior of the congregation while it worships, 2) engender personal spiritual experiences as members of the Body of Christ celebrating the mystery of faith, and 3) encourage full, active, conscious participation in charitable works that will serve the common good. The

9. Nanu, "101 Inspirational Quotes from Famous Architects and Artists," *Archtopia* (January 30, 2011), https://www.archtopia.com/2011/01/30/101 -inspirational-quotes-from-famous-architects-and-artists/.

emergence of new liturgical practices is not limited to a single period or generation. The reform of the liturgy, like the church itself, is a continuing task. Liturgical scholar Edward Foley, one of the editors of *A Commentary on the General Instruction of the Roman Missal,* once remarked informally, "New liturgical books will come along soon enough." Worship renewal may be a slow and tedious affair, but it is ongoing and deserves periodic scrutiny. The same is true for our houses of worship. It makes no sense to try to pour new wine into old wineskins.

5. Where in the World is God?

"God? Oh. God comes along much much later!"
—ten-year-old Jacob

When he was about ten years old I took my great-nephew Jacob to the Rose Center for Earth and Space at the American Museum of Natural History in New York City. Inside there is a long spiral ramp that traces the history of the known universe, a topic of great interest to young Jake. As he was racing up the winding walkway, examining the time frames, I stopped him and asked, "What role do you think God played in creation?" Jacob looked at me quite puzzled and replied, "God? Oh. God comes along much much later!" He was probably thinking of Jesus of Nazareth who did come along later in the history of the universe. Jake's precocious response, however, made me wonder how an understanding of the cosmos and the presence of God is expressed architecturally and artistically in houses of worship.

In some churches there is a skylight, dome, or cupola overhead. This *oculus Dei* or *Oyo de Dios* suggests God is looking down upon the congregation from a heavenly perch. Some ceilings are painted with multitudes of stars to evoke the heavens or a particular constellation. An image of the *Pantocrator* in the demi-dome of some apses could serve as a reminder that the ruler of the universe is watching over the people below. It seems to be in the collective Christian mindset that praise is directed toward a God who physically resides above and beyond everyday reality. Is this way of

thinking about the creator of the universe in synch with contemporary astrophysics or theology? Does it matter to the congregation one way or another? What is significant is the message that the design of churches transmits regarding the celebration of relationships between God and creation—connections that are remembered and affirmed in acts of worship and charity.

Used as an adjective to describe God, the word "transcendent" means unrivaled, incomparable, or unparalleled. We rely on our imaginations to visualize or even identify with such peerlessness. Even when used as a noun, "transcendence" is not a geographical reference that requires spatial definition or boundaries. Nevertheless, as black theologian James Cone (1938–2018) wrote about finding God in the midst of injustice and murderous acts, "the transcendent and the immanent, heaven and earth, must be held together in critical, dialectical tension, each one correcting the limits of the other . . . God's Word is *paradoxical . . .* it is here and not here, revealed and hidden at the same time."[1] To say God is part of us and we are part of God is a holistic expression. It helps us realize how much the living God is inextricably woven through our entire being and through the totality of a never-ending creative process that has not yet reached perfection. Yet, most often, sermons, prayers, and hymns, art work and architecture continue to portray God who is out there somewhere, far outside our being.

The earliest images of the Christ looked like a weary but responsible shepherd in the midst of his flock. After imperial influences altered the church's system of governance, Christ started to resemble an emperor or king who was the new conqueror. This image was fashioned in vivid frescoes and glistening mosaics. Do the depictions of God in your church portray the incarnate One who walks with you on your journeys or One who reigns over you

1. James H. Cone, *The Cross and the Lynching Tree* (Maryknoll, NY: Orbis Books, 2011), 156.

like a king? And what about the building? Does the interior of
your church suggest that God is an extrasolar aristocratic ruler or
an affectionate mother who comforts her child (Isa 66:13)? Litur-
gical theologian Don Saliers wrote about intimately experiencing
the wonder of God. He listed the senses of delight, truth, awe, and
hope and how to carry them into our worship of God. "We must
deal, then, with the relations between the physical senses, feelings,
more complex emotions, and the *sense* of God. It is still true that
spiritual knowledge of God comes through the physical senses in
the Spirit-gifted social body we call the church."[2]

Prior to Vatican II, the liturgical movement of the early twen-
tieth century reawakened the forgotten notion of active and con-
scious participation while at worship. The nudge was so strong
that it would soon require modifications to liturgical texts, music,
and the interior setting of churches. Over time and rather slowly,
new and reordered[3] places of worship in many Christian denomi-
nations were designed to engage the assembly and the clergy in
the performance of rituals that celebrate sacramental encounters
with God in a communal setting. After Vatican II, and in response
to it, most congregations moved the altar and ambo more into the
midst of the church, if not exactly into the true center. Now, how-
ever, there is evidence in some dioceses in the United States that
a "reform of the reform" movement described in a previous chap-
ter is taking shape architecturally, reversing these developments.
As this trend evolves, emphasis is being placed on creating more
distinct, ornate sanctuaries or chancels including communion rails,
baldachins, and tabernacles. These vestiges from a much older
but not original understanding of liturgy and church architecture
do not represent the full complement of contributions from Chris-
tian history and tradition.

2. Don E. Saliers, *Worship Come to Its Senses* (Nashville, TN: Abingdon,
1996), 14.
3. I am using the word "reordered" to refer to modifications made in older
churches to accommodate the implementation of current worship rituals.

In mainline churches, such as the Catholic Church, the existence of an artistically embellished area (chancel, sanctuary, presbyterium), distinct and separate from the congregation, implies, both aurally and visually, that the liturgy is administered from that area. That precinct is often described as a symbolic and eschatological reference to a holy of holies, an eternal heavenly city, where God dwells. Some interpreters suggest that the far end of a cruciform church symbolizes Christ the head of the mystical body.[4] Others argue that a long and narrow nave leading toward the sanctuary symbolizes a linear, undeviating processional path toward heaven. Although this idea is seen by some as salutary, others find it problematic. For example, John Haught, systematic theologian at Georgetown University, remarked that "an excessive preoccupation with the 'next world' . . . can wither our hopes and divert the ethical passion necessary to building *this* world."[5]

How do such allegorical interpretations of a church design come about? Generally they emerge as part of a historical process that is not always clear or unidirectional. A monk from the Monastery of the Holy Cross, Chevetogne, Belgium, once explained the meaning of the iconography and architecture in that community's Byzantine church. He noted that, over time, various features in churches were described in ways that the original members or designers never intended or even thought of. One could argue that the fourth-century ecclesiastical historian Eusebius (260–339 CE) and his passionate panegyric about the Cathedral of Paulinus in Tyre (ca. 315 CE) consciously intended to depict Christ as a heavenly emperor. Eusebius wrote that the building was furnished "with thrones high up, to accord with the dignity of the prelates . . . in the middle the Holy of Holies—the altar—excluding the general public from this part too by surrounding it with wooden

4. See, for one example, Steven Schloeder, *Architecture in Communion* (San Francisco: Ignatius Press, 1998).

5. John F. Haught, *Resting on the Future: Catholic Theology for an Unfinished Universe* (New York: Bloomsbury Academic, 2016), 20.

trellis-work."[6] No one, however, could possibly come to the conclusion that Eusebius intended his description to serve as a template for constructing all future churches.

Likewise, how do we know if the Roman African Augustine of Hippo (354–430 CE), in his discussion of the human pilgrimage from the earthly city to a heavenly one,[7] was thinking that all church buildings thereafter should be architectural and artistic expressions of a triumphant City of God? The same question could be asked about the apocalyptic Book of Revelation. John of Patmos wrote a politically charged commentary on the nature of things in the Roman Empire and then offered a fantastical vision of a new Jerusalem where the Lamb of God was worthy of praise instead of the emperor. John entered a place that is not a temple but a "heavenly courtroom"; the seats are arranged in a semicircle around the throne (a reference to the emperor's chair) located in the center of the room and surrounded by a tribunal. And while it is easy to imagine graphically this centralized layout, one must ask: Did the author at all intend that chapters 4 and 5 should serve as a figurative model for the design of future church sanctuaries? Was John suggesting that the heavenly throne described in the Book of Revelation should become a tabernacle tower beneath a lofty ceremonial canopy surrounded by statues of angels?

The scriptural references to a new Jerusalem do provide a vivid eschatological vision of God and humanity dwelling together. According to Scripture, Jerusalem was a symbol of where God lived; it was thought to be the center from which life flowed out for the world. Isaiah mentions Jerusalem when speaking about a new heaven and earth (Isa 65:17-19). In Hebrews 12:22 there is reference to a heavenly Jerusalem. The texts from Matthew 4:5 and 27:53 call the new Jerusalem a holy city. In the Book of Revelation

6. Eusebius, *The History of the Church from Christ to Constantine*, trans. G. A. Williamson (New York: Penguin Books, 1981), 394.

7. Augustine, *The City of God*, ed. Vernon J. Bourke (New York: Image Books, 1958).

it is described as the paradise of God (Rev 2:7) and a counterpoint to the evil world of Babylon (Rev 18:1-24). These references and others describe longings for lasting peace and joy during particular periods of history when the followers of Christ were exploited by divisions and terror.

The idea of a sacred city has exercised a hold on the human imagination. Throughout history other major cities in the world have been thought of as some sort of a new Jerusalem. Eleventh- and twelfth-century writers declared major population centers in Europe to be "sacred." The revival of the medieval city centers was made possible because of diverse contributions. Wealthy patrons, church leaders, academics, mystics, musicians, and artists conceptually engineered and funded the construction of abbeys, universities, and great cathedral buildings. Even today, whether in a sprawling megalopolis or an intimate country town, the local chamber of commerce will advertise that its municipality is the best place to live, to raise a family, to get a job, to retire. What city today does not claim to be safe from crime, to offer equal housing, to have great schools, houses of worship, concert halls, and museums, and—perfect year-round weather! Sounds heavenly!

While allegories like the ones that refer to a new Jerusalem have driven the design of churches for a long time, other less figurative concepts have been largely neglected. How does a church building celebrate the Body of Christ substantially present in every baptized individual? How does the interior design teach that God is still at work in the ever-unfolding cosmic enterprise? Are we content to imagine that we will someday cross over or march forward single-file into a new but remote city of God? Perhaps children, women, and men who are stuck in Brazilian favelas, Jordanian refugee camps, and Arizona detention centers want just a little bit of paradise right now.

So much depends on the language used in an attempt to grasp who God is and where God dwells. Ultimately there is no final answer. The theologian and liturgical scholar Kevin Seasoltz (1930–2013) wisely wrote, "The expression of Christian faith

always involves a tension between the human modes of commu-
nication and the transcendent God who is mystery, the God who
cannot be confined by any human images or categories."[8] Is it
possible, then, to create noble, organic, simple, symbolic, and
beautiful churches to house the worship of God without relying
on dualistic classifications? Is it possible to design places of wor-
ship in which everyone in the congregation, laity and clergy alike,
can see the beauty and grace of God aglow in one another's faces
even more powerfully than in a mosaic of Christ the King?

8. Kevin R. Seasoltz, *A Sense of the Sacred: Theological Foundations of
Christian Architecture and Art* (New York: Continuum, 2005), 343. Empha-
sis added.

6. Cosmic Realities

"Everything that is in the heavens, on the earth, and under the earth,
is penetrated with connectedness, penetrated with relatedness."
—Hildegard of Bingen

Usually God's dwelling place, the "City of God" or "Heavenly City," is expressed in church art and architecture as a remote place. Where did this idea come from? It may be helpful to back up a bit and briefly consider the biblical sense of the cosmos and what our Hebrew ancestors thought about heaven and earth. This review will help us appreciate that the information we have about the known universe today is far more advanced than the perceptions of the Israelites and their neighbors living in Canaan. As theologian John Haught reasoned, prior to the scientific revolution Catholic thought presupposed a static, vertical, and hierarchical understanding of the cosmos.[1]

Haught is correct. The earliest Hebrew people believed that God dwelled above them in the distant heavens. They may have felt that God was detached from them and that God was made known by presence and absence. Nevertheless, they described their encounters with God as theophanies, experiences in which God's presence, ordinarily hidden, was made manifest. Theophanies might occur in nature's places such as rivers and deserts, on mountains, in fire and wind. Later, during their treacherous

1. Haught, *Resting on the Future*, 19.

wilderness wanderings, they would take comfort in feeling God's symbolic companionship in more tangible and specific ways. God's presence was made known in a burning bush, a tent, on a ladder, in a portable tabernacle, and then, as they entered the land they were promised, in temples erected according to detailed instructions.

The early Christians who were part of the Jewish tradition would have inherited these ancestral narratives about experiences of God. They also were familiar with the hierarchical arrangement of the heavens, the earth, and the underworld. For example, astronomer Ptolemy (ca. 100–170 CE) continued to propose a geocentric universe in which the earth was in the center surrounded by the sun, the moon, and the planets. The most familiar New Testament reference to heavens was when Jesus referred to his father in heaven (Matt 6:9). Did Jesus believe his father lived in the skies above? According to biblical scholar James Rowe Adams, the New Testament writers may have used the heaven imagery "as a way of pointing to the most profound human experiences in this life: being connected with all other human beings and all other creatures, who have the same father in heaven."[2]

It would be hard to pinpoint exactly when the popular understanding of the cosmos began to change. Most sources suggest that the scientific revolution occurred between 1550 and 1700. Nicholas Copernicus (1473–1543) described a sun-centered (heliocentric) universe. The contributions of Johannes Kepler (1571–1630), Galileo Galilei (1564–1642), and Isaac Newton (1643–1727) sparked further explorations of the cosmos that continue today. NASA's Hubble Space Telescope, for example, shows us countless galaxies that contain a sun like our own. Given what is now known about the ever-expanding and contracting universe, it is regrettable that an ancient and prescientific perception of the known universe

2. James Rowe Adams, *The Essential Reference Book for Biblical Metaphors: From Literal to Literary* (Cleveland, OH: Pilgrim Press, 2005), 138.

continues to dominate the way Christian places of worship are designed. New Zealand theologian Murray Rae writes: "Dualistic conceptions of the world in which spirit is good and matter is bad are prominent across many human cultures and have left unfortunate traces in the tradition of Christian theology, too."[3] Although the current contributions of astrophysicists do not eradicate past perceptions of God's manifestations in creation, they do prompt us to revisit those assumptions.

Try this exercise right now. Take a sheet of paper and draw two rectangles side by side. Now sketch the Hebrew notion of the vertically layered universe by placing heaven at the top of one box, earth in the middle of it, and the underworld below it. In the other rectangle, draw a traditional church building alongside your sketch of the universe, using it as a model. You will see that the holy of holies (heaven) is at the top end of your church. It is separated from the rest of the building, where the people are located, in the middle of your sketch. Where do you sit in church today? Where do your clergy sit?

The placement of a sanctuary at one end of the church in order to imply an "end of time" destination, or the locus of eternal life, a new Jerusalem, where the Son of God is risen and reigns, continues a line of thinking that is challenged by contemporary cosmology.[4] Furthermore, this plan suggests that the congregation is on the way to a paradise that, it is claimed, cannot be experienced on earth because, in dualistic terms, earth is actually an evil place. Of course, perfect fulfillment and bliss cannot be achieved on this fragile and deeply troubled planet (although there are wondrous elements here to be enjoyed); but we need not cling to the idea that all faithful people are going to end up in some place that exists elsewhere. Why not use our "Catholic" imaginations

3. Murray A. Rae, *Architecture and Theology: The Art of Place* (Waco, TX: Baylor University Press, 2017), 23.

4. Schloeder, *Architecture in Communion*, 175–76. Schloeder offers historical and cosmological reasons for the orientation of church buildings.

to envision the accomplishment of peace and harmony in this known universe? Perhaps our churches ought to envision a cooperative strategy for caring for others and our planet here and now.

When one layers this ancient cosmology onto the social reality of our churches, the result is even more problematic. The area defined by artistic and architectural embellishments in a church is usually, if not always, considered a place for the clergy of the church who conduct liturgical rituals from that area. In some Christian traditions the prelates are also considered to be the sentinels guarding the portals to the City of God. These hierarchs, some believe, are the ones who also outline in rigorous terms how citizens of earth may gain entrance into a heavenly city. Yet, this takes us far afield from the actual teachings of the New Testament. Scripture scholar N.T. Wright explained it this way: "Heaven is not the Christian's ultimate destination. For renewed bodies we need a renewed cosmos, including a renewed earth."[5]

Theologian Ilia Delio asserts that the profound dualism that still runs through much of Christian thinking has been unhelpful to catholicity. She wrote, "The older cosmology set the eternal celestial realm in opposition to the terrestrial scene of change and decay; the gradual 'hierarchy of being' approached perfection as it approached the Divine." She continues, "but the new cosmology erased the distinction between corruptible and incorruptible and applied uniform natural categories to the whole universe."[6] Haught believes that a new interpretation of creation does not negate a creed that asserts God as the creator. He wrote that it does add a layer of thinking of "current scientific awareness of a universe that is clearly far from being completed."[7] Liturgical scholar Catherine Vincie adds, "We cannot simply go

5. N. T. Wright, "Jesus' Resurrection and Christian Origins," in *Gregorianum* 83, no. 4 (2002): 615–35.

6. Ilia Delio, *Making All Things New: Catholicity, Cosmology, Consciousness* (Maryknoll, NY: Orbis Books, 2015), 23.

7. Haught, *Resting on the Future*, 3.

forward blithely oblivious to the evolving insights of our scientific community."[8]

There is still a disconnect, however, between the indisputable findings of astrophysicists about a universe that is still evolving and the religious doctrines that offer prescientific interpretations of the same realities.[9] According to Haught, although biblical scholarship has corrected the extreme "otherworldliness of traditional eschatological expectations, a dualistic spiritual sensibility dividing this world from the next still hovers over contemporary Catholic preaching, devotional life, and theological reflection."[10] As spiritual writer Richard Rohr noted, "what we call salvation is happening to the whole of creation and not just to humans (Rev 21:1) . . . our inability to recognize and appreciate this [understanding] is a central example of our dualistic thinking and even our narcissism."[11]

Brazilian theologian Ivone Gebara is more critical and argues that a greater bond between mind and body would eliminate dualities. She wrote, "Dualism is felt to be inadequate in explaining the complexity of reality . . . [it] is turning out to be obsolete and inconsistent in the face of our world's violence, our progress in scientific knowledge, and our contemporary understanding of the universe."[12] The hindrance that keeps religions out of tune with scientific knowledge is most apparent in the liturgies of the church,

8. Catherine Vincie, *Worship and the New Cosmology: Liturgical and Theological Challenges* (Collegeville, MN: Liturgical Press, 2014), 12.

9. I am mindful here of the Vatican Observatory, inaugurated by Pope Gregory XIII in 1582. It is one of the oldest astronomical institutes on the planet and continues to research the ever expanding and contracting universe.

10. Haught, *Resting on the Future*, 115.

11. Richard Rohr, "The First Idea in the Mind of God," *Richard Rohr's Daily Meditation* (February 9, 2014), https://myemail.constantcontact.com /Richard-Rohr-s-Meditation---The-First-Idea-in-the-Mind-of-God--is-to -Materialize.html?soid=1103098668616&aid=3JE1ZkIKdfI.

12. Ivone Gebara, *Longing for Running Water: Ecofeminism and Liberation* (Minneapolis: Fortress Press, 1999), 100.

which Vincie claims are still "reflecting the cosmology of the biblical world and of the Ptolemaic cosmos."[13]

Ancient creation myths can be edited just as the exclusive language that still exists in some hymnals and prayer books has been edited in newer editions. It is not "traditional" to use discriminatory language. It is, however, traditional to remove anything that keeps people apart. Suppose that the language used to illustrate the presence of God in a not-yet-finished universe was *nondualistic* and more relational. It would certainly change the way we think and act. What if it were normative to consider the unrivaled incarnate God to be *one with* the cosmos, the planet earth, and humanity? It could very well change the way we think about our bond with God, one another, and the never ending creative process. What would the ramifications be in terms of architecture for congregational worship? This is the question we will continue to explore. Perhaps your drawing of a church building would change, and with it your spiritual journey.

Architecture and art, like song lyrics, homilies, and prayers, can dissolve the subject-object dualistic way of thinking about God during worship. All we have to do is believe that we are already in a loving and trusting covenant with a generous God. We need not be afraid, then, of worshiping God using relational ritual language to focus on our virtues and the goodness of creation. Focusing on a theology of blessings can help us overcome the doctrinal/catechetical propensity for seeing ourselves as sinful underdogs who just cannot win. Of course we make bad, sometime sinful decisions and need to seek forgiveness and acknowledge the mercy of God. However, when we realize that we have been invited to enter into a partnership with the incarnate God who forgives transgressions without compromise, it will become clear that it is also a summons to promote the common good with works of justice. People need food, housing, jobs, justice now, not after

13. Vincie, *Worship and the New Cosmology*, 23.

they die. In fact, refugees and immigrants are dying by the thousands because they have been robbed of their human dignity.

A dualistic perception of the organization of the cosmos reinforces the notion that the creator God is distant from us. On the other hand, a more holistic, unitive awareness that all things are profoundly interrelated by their very nature implies that we are growing in a loving relationship with an incomparable God who resides in each one of us and even in the dark matter of an unfinished cosmos. What is required is a fresh language that realistically describes this intimate kinship between the creator and creation, an expression that will prompt new possibilities for caring for our planet and for one another. Trappist monk Thomas Keating (1923–2018) offered an alternative to the dualistic way of thinking. He referred to an ancient tradition held by the mystics: "God is not just with us, not just beside us, not just under us, not just over us, but within us, at the deepest level, and, in our inmost being, a step beyond the true Self."[14] Over time, a healthy relationship with God and all that the cosmos comprises will eliminate the culture wars that pit "us against them" and will establish a common good for humanity. To model such a collaboration, a nondualistic plan for designing churches is needed.

14. Thomas Keating, in Richard Rohr, "The Self-in-God," Center for Action and Contemplation (September 18, 2018), https://cac.org/the-self-in -god-2018-09-18/.

7. Hierarchical Relationships

"We must build spaces that do not create barriers."
—Francis Kéré, architect

Church buildings are metaphors. They are architectural and artistic expressions of the people who built them. They resonate with the values and principles of the congregation. There is no reason why houses of worship cannot serve as ministers of hospitality and hope in a world desperate for truth and clarity of vision. On the other hand, church buildings can also reveal any discord that may prevail in the membership and become an image that could compromise the mission and message of that religion. We are familiar with Abraham Lincoln's famous "House Divided" speech in which he echoed lines from Genesis 13:7-8 and Mark 3:25—a house divided against itself cannot stand.

Most worshipers, clergy and lay alike, do not consciously realize that church art and architecture and related design factors can either unite or segregate them during worship.[1] The binary opposition system is so embedded in the language of religion that it goes unnoticed. Yet, it affects them nevertheless. Just as the continued use of dualistic language places God outside our realm of existence and reinforces divisions among human beings, so too

1. Marshall McLuhan once noted that most people are oblivious to what is going on around them and unaware of almost 95 percent of their immediate environments.

a divided worship space reinforces division. Architects continue to assert that churches and other human-built monuments are "sacred" venues that aid in the search for the Ineffable Being. How the presence of God, the workings of the cosmos and the growing relationships among different church members is understood will affect the worship and work of a congregation striving to serve the common good.

The thesis of this book is based on the ecclesiological foundations set forth by Vatican II that emphasize the birthing of new relationships among all human beings, including members of the Body of Christ. Yet, the realization of this ideal is challenging in religious systems that rank people one above the other according to status or authority. Liturgical theologian James Leachman wrote about the sacramentality of the liturgical assembly and how the diversity of roles can be problematic and "mutually antagonistic." There is the "privileged, powerful and highly visible" leader and there are those in the assembly who are "less powerful, less visible and more anonymous." These distinctions "frame classic polarities that have developed and stabilised over centuries." Leachman points out that "the limitation of possibilities, diminishment and even wounding . . . is astounding and often unnoticed."[2]

Here is where the differentiation of ministerial roles, essential in the performance of any ritual, should not be confused with privilege, rank, or predominance. Liturgical scholar Paul Janowiak addressed the alliance between clergy and laity and noted that although the documents of Vatican II indicated that the members of the Body of Christ are the "primary celebrants of the liturgy," other instructions regarding the ministerial priesthood, he argues, "retreat to a sacral model that mediates power to the faithful."[3]

2. James G. Leachman, "Liturgy & Sacramentality: First Perspectives from Process Oriented Psychology," *Studia Liturgica* 47, no. 2 (2017): 186–87.

3. Paul Janowiak, *Standing Together in the Community of God: Liturgical Spirituality and the Presence of Christ* (Collegeville, MN: Liturgical Press, 2011), 135.

Janowiak points out the incongruities between understanding the ministerial priesthood that emerges from "within" a faith community and the standard notion that the ordained person is called "out" of the congregation. Other scholars agree and favor a less iconic and more pneumatological image of the ministerial priesthood that will not necessarily eradicate the office but will cast it in a new and refreshing light.[4]

The ministry-related issue may not be such a divisive concern in other Christian churches that accept the call to service and leadership as an incontestable gift of the Spirit. The Roman Catholic discussion takes the matter of ordination to a different level and centers on what may be described as an early scholastic assumption that an ontological change occurs in the one being ordained. The *Catechism of the Catholic Church* refers to this moment as the conferring of an "indelible spiritual character" on the person (CCC 1583), an enduring attribute or "character" that is also experienced in someone who sacramentally celebrates his or her baptism and confirmation in a faith community. Not one of these permanent marks, however, should be considered an indication of privilege or rank. The Bishop of Albany, Edward Scharfenberger, observed that "priesthood and consecrated life are not about rank, but relationships; not about achievement, but sacrifice; not about power, but service."[5]

This is the key issue when thinking about church design. Sacramental celebrations are not intended to divide the members of the church according to unequal grades of influence or distinction but to gather them together in the loving embrace of God. Nevertheless, the celebration of most liturgies makes it clear that some members of the Body of Christ are afforded prominence in terms

4. For one example see David Coffey, "The Common and the Ordained Priesthood," *Theological Studies* 58 (1997), https://journals.sagepub.com /doi/abs/10.1177/004056399705800201?journalCode=tsja.

5. Edward B. Scharfenberger, "Another Way of Loving," *The Evangelist* (April 26, 2018), 5.

of dress, processions, posture, and location. I leave it to scholars to provide a more critical examination of the ministerial priesthood acting in the person of Christ and not in the person of the whole church. The purpose of this book is to examine the ways the architectural setting for worship can unite the membership of the church. We read in the Constitution on the Sacred Liturgy that although there are "distinctions arising from liturgical function or sacred Orders . . . no special preference is to be accorded any private persons or classes of persons whether in the ceremonies or by external display" (SC 32). Worship is an action of the whole assembly joined together with Christ, the head of the mystical body, united in the praise of God and in service to others. How the liturgical ritual takes place is of utmost importance because, as liturgical scholar Mark Searle (1941–1992) reminded us, "The role of the sacraments is not to deliver God to us, not to package the One whom the world cannot contain, not to 'confer' grace, but to deliver us to the place where God can be God for us."[6] My point is that the architectural setting for worship, in most places, continues to say the opposite.

A prayer leader or presider who sits in the first row of the assembly during worship presents a very different model of liturgical leadership than one who sits in a chair far removed from the congregation. There is no known algorithm that even remotely suggests that maintaining distance from the congregation, and a lofty distance at that, is an essential factor in leading that assembly in worship. The placement of the altar or communion table in the midst of the worshiping assembly is another visual indicator that the ritual action occurring at that furnishing is carried out by the whole congregation. Similarly, placing the altar table in a separate area, where only the clergy can approach and surround it, depicts

6. Mark Searle, *Called to Participate: Theological, Ritual, and Social Perspectives*, ed. Barbara Searle and Anne J. Koester (Collegeville, MN: Liturgical Press, 2006), 39–40.

the liturgy as a ritual belonging to and enacted by the clergy while everyone else watches.

Posture during the liturgy is another tell-tale gauge of the differences that exist in a congregation at worship. The 2017 brouhaha over professional athletes and cheerleaders kneeling during the United States national anthem at the beginning of a game serves as a good example. Their posture was understood to be a protest against the country and a gesture of disrespect toward what the American flag symbolizes. In fact, they were demonstrating against the injustices in society, especially racist ones. When some people kneel while others stand, the question of unity is raised. How many times have you seen a large of number of clergy stand around the altar table during the eucharistic prayer while the worshipers, in the nave section of the church, kneel in humble submission to the liturgical action? Although kneeling can be considered an act of reverence in some cultures, in the United States standing is considered a sign of respect. It could be argued that kneeling, especially during and after the institution narrative, is a way of acknowledging the substantial presence of Christ in the sacrament.[7] But how does one honor the real presence of Christ in the assembly at that same time? The celebration (or confecting) of the Eucharist by the mystical Body of Christ is not the time for adoring the sacrament. There are other Catholic rituals for doing that.[8] When different members of the assembly (that is, clergy and laity) assume distinct postures during liturgy, their body language becomes an agent of division during worship. In this instance, one wonders why any zealous return to liturgical origins *(ressource-*

7. Actually, liturgical scholars point to the consecratory nature of the whole eucharistic prayer and not just a few words.

8. See the Roman Catholic document *Holy Communion and Worship of the Eucharist Outside of Mass* (1973), https://www.liturgyoffice.org.uk /Resources/HCW/HCWE-Introduction.pdf, and the ritual book *Order for the Solemn Exposition of the Holy Eucharist* (Collegeville, MN: Liturgical Press, 1993).

ment) would disregard the *orans* position—the prayer posture that was normative for clergy and laity for about the first thousand years of Christianity!

Generally, there is nothing inherently wrong with the concept of hierarchy. Societies and institutions possess hierarchical frameworks designed to serve the common good. Ideally, people are selected or elected to leadership offices because they have demonstrated they have certain charisms and can preside in a trustworthy ardent manner over the affairs of a group. (Perhaps it is time again for the whole diocesan family to choose who their bishop should be.) A serious problem develops when some members of hierarchies become autocratic or begin to think they are entitled to privileges not shared with other members of the group. On August 25, 2018, Pope Francis met with Jesuits in Dublin and responded to a question about widespread abuse in the church. He stated the root of the problem is "a Church that is elitist or clericalist, an inability to be near to the people of God."[9]

Let me be clear: the hierarchical nature of any religion is not broken or disavowed when the clergy leaders of worship sit, stand, or kneel alongside other members of the congregation. When I use the term "clericalism" I am not referring to the formal leadership roles practiced in many religions. Religions, like other human institutions, need wise, honest leaders. Instead, I am focusing on a deeply ingrained "clerical culture" that promotes or bestows upon ordained individuals a privilege and status not shared with the laity. Perhaps "patriarchy" is a more suitable term for describing the how some clergy members understand and exercise their roles in the community.[10] Hierarchy is not the same thing as clericalism;

9. "It Is Not Enough to Turn the Page. Life Must Be Given Anew," *La Civiltà Cattolica* (September 13, 2018), https://laciviltacattolica.com/it-is -not-enough-to-turn-the-page-life-must-be-given-anew/.

10. Southern Baptist churches deal with tensions based on their doctrines that state that only men are qualified to lead churches and families while at the same time they advocate women's equal worth.

we know of examples that challenge such a misleading equivalence. On the anniversary of his episcopal ordination, Augustine of Hippo balanced authority with humility. He said, "For you I am a bishop; but with you I am a Christian. The former is a duty; the latter a grace. The former is a danger; the latter, salvation" (Sermon No. 340). How many of us remember Pope Francis on the night of his election asking the enormous crowd in St. Peter's Square to pray for him, to bless him, before he blessed them?

Liturgical theologian Louis Bouyer (1913–2004) offered an interesting example of how clergy and laity can converge during worship. He wrote about the "typical" Syrian church in which "after the service of the scripture readings and prayers, all of the clergy, taking with them the offerings of the faithful, go to the East, while the congregation reassembles itself *around* the altar for the eucharistic meal."[11] Bouyer continued, "The presence of the clergy among the faithful, in the primitive churches as in the synagogues, emphasizes the fact that, in spite of its role of leadership, the 'action' remains a collective action in which all take part together. . . . There is not a worship of the clergy performed for the passive attendance of the congregation, but a congregational worship in which all pray together in the mediation of the word communicated by the ministers, and participate with them in a common eucharist."[12]

The research of Dennis Smith (1944–2017) and Hal Taussig on Greco-Roman meal customs and how they may have influenced early Christian agapes is helpful here. These scholars remind us that "although social stratification was a component of ancient Greco-Roman banquets there was also the sense of social equality among the diners as well . . . an elaboration of the idea of social bonding. From this perspective there developed the view that the

11. Louis Bouyer, *Liturgy and Architecture* (Notre Dame, IN: Notre Dame University Press, 1967), 34–35 (emphasis added).

12. Bouyer, *Liturgy and Architecture*, 56.

meal tended to break down social barriers."[13] Hierarchy of its nature is not a direct cause of exclusivity and privilege during worship. Various roles are carried out by different ministers according to their respective gifts and callings. The problem is, rather, that status and privilege become the defining attributes, rather than service. Author Joe Holland observed, as did Leachman, that "clericalism" is the big "structural problem with deep historical roots, and one that reproduces itself from one generation to the next."[14] Archbishop Emeritus Weakland pointed to those clergy leaders who "freely accentuate the hierarchical nature of the liturgy as a mirror of the hierarchical nature of the church itself but subordinate the role of the people to their pre–Vatican II position. This way of de-emphasizing the role of the People of God assembled spills over into architecture as well."[15]

The interiors of church buildings can be equitable places for worship *without* abrogating the hierarchical nature of the church or completely disavowing older architectural styles. Many clergy have already taken measures to eliminate boundaries in the churches they serve. They sit with the congregation to pay attention to the Word of God. Like other liturgical ministers they approach ritual furnishings (font, ambo, altar) when they need to. They lead prayers from a place where they can be seen and heard. It would be very helpful if other clergy would examine the manner in which they preside at liturgy, including their temperament and facial expressions. It would be refreshing if they gave some thought to where they sit and stand, how they dress, and what words they use to engage the assembly in prayer. Both clergy and laity will show their wisdom when they agree to talk to each other

13. Dennis E. Smith and Hal E. Taussig, *Many Tables: The Eucharist in the New Testament and Liturgy Today* (Eugene, OR: Wipf and Stock, 2001), 33.

14. Joe Holland, "Get Rid of Clergy: But Keep Holy Orders," *Commonweal* 145, no. 7 (April 13, 2018): 10.

15. Weakland, "The Liturgy as Battlefield."

about their expectations during the liturgy and the respective duties required of them as they carry out diverse ministries. The impact of the environment for worship should not be excluded from these conversations. Where we worship shapes our prayer. How we pray shapes the way we treat one another.

part two

The Past and The Prologue

8. Traditions

*"Tradition and memory of the past must help us to have the courage
to open up new areas to God."*
—Pope Francis

In an age of troubling polarizations, church architecture and
art can offer people new opportunities for achieving unity. When
the worship of God is rooted in an egalitarian understanding of
membership and ministry, the liturgy itself will be a more effective
agent of peace and harmony. The removal of all imaginary and
real boundaries that divide the members according to rank in their
churches will help to eliminate class distinctions during worship.
Some may object: "But this is not traditional!" It is important to
address this objection. If there are any two words that are guar-
anteed to stir up tensions in a discussion dealing with church re-
form, they are "tradition" and "innovation." In this chapter and
the next I will examine how these terms are germane to the fields
of religion, art, and architecture.

William Sloan Coffin (1924–2006), who was an American
peace activist and Senior Minister at Riverside Church in New
York City, once remarked that the word "tradition" is frequently
used as a euphemism for habit. His comment suggests that a cer-
tain amount of the rhetoric devoted to keeping "the traditions"
and avoiding innovations is based on faulty reasoning. When some
people say "I prefer a traditional-looking church building," it is
not clear what they mean. Are they referring to the fourth, the

sixteenth, or the nineteenth century, or are they simply thinking of the parish church where they grew up? Consider that churches before Vatican II were devotional and not liturgical places. Liturgy was something done by the priest. For some the public liturgy is still a means of practicing personal piety. Sometimes a tradition is not a tradition at all but is, as architect Michael Crosbie wrote in reference to church architecture, "a wish founded on nostalgia, and a comparison: how we remember the way it used to be, compared to something new, something different."[1]

Christians are stubborn. In fact, most human beings are. The word "change" can set alarm bells ringing because it signals a departure from a familiar or habitual way of thinking and doing something, whether that something is religious or not. Those who practice a religion[2] adhere to devotional customs not only in their private lives but also in the performance of public rituals. While playing basketball as teenagers we made the sign of the cross before taking a foul shot. Somehow we thought the ball would certainly swish through the hoop even though no one guaranteed that this Catholic custom would work! Similar eccentricities are noticeable today, not only in sports but certainly in religion. How many of our fathers would make the sign of a cross on their foreheads or tip their hats while driving or walking past a church building? Small acts of personal piety can be comforting.

The public worship of a group, however, goes beyond the private domain and incorporates but also surpasses the role of personal devotion, for it involves large numbers of people who have diverse spiritual expectations and habits. In fact, the very idea of trying to cultivate an appreciation for fruitful, active, and conscious participation in a communal ritual with hundreds, maybe

1. Michael A. Crosbie, "When Is a Mosque Not a Mosque?," *Faith & Form: The Interfaith Journal on Religion, Art and Architecture* 50, no. 4 (2017): 4.

2. The Latin root for the word "religion" is *religio*, which means "obligation" or "bond."

thousands, of other people, often strangers, is at odds with the strong sense of individualism that is a hallmark of modern, post-industrial societies. On the other hand, the temporary acquiescence of one's personal religiosity to the group's ritual order can often create an exhilarating feeling, or at least a sense of being together on the same prayer book page, so to speak. Sometimes Catholicism seems to be, at its core, a very personal, devotional religion. Attempts to encourage "ideologically formed groups of communing catechumens"[3] to worship together as a sacrament of unity often seems unrealistic. Yet, the effort is an urgent one because of the link between common worship and shared commitment to social action.

Some leaders have concluded that finding a common ground that will satisfy all members of a church is, at least on paper, nearly impossible. This is why some avoid sailing into deep waters where waves can swell up and rock the boat. They prefer to stay close to the shoreline, where the currents are calm. Yet, it is a mistaken judgment to think that maintaining or inaugurating religious practices that may have worked in previous ages will satisfy loyal churchgoers or attract new young members. There are many reasons why change is resisted. Maybe it is a formidable challenge for some pastoral leaders to implement something they personally disagree with. Or, maybe they lack the skills and know-how required to manage change effectively. Maybe they are afraid. There are new generations of church leaders who continue to believe that Vatican II was not diligent in maintaining continuity with tradition. They are the ones who are convinced that reforming the reforms is the best course to follow. Unwittingly, they are contributing to the polarizations that already exist in the church.

Research groups have shown clearly that religions need to reorganize and freshen their methodologies in order to respond to

3. This was a favorite assertion of the liturgical scholar Aidan Kavanagh (1929–2006).

the signs of the times. Some will argue that a religion like Catholicism that serves 1.2 billion people on the planet (41 percent of whom are in Latin America) is not required to alter its teachings (doctrines) in order to satisfy what the polls say. Theologian Michel Castro does not agree. "Since the very beginning of Christianity," he writes, "the faith has been expressed anew according to new cultures, and new questions, sensitivities, and realities. . . . A tradition, if it is not to die, must express its convictions in the language of the time: a language that will, therefore, be new."[4]

Let's take a brief look at the meaning of the word "Tradition" (with a capital "T") as it is understood in the Catholic Church and perhaps in other Christian churches as well. According to theologian Yves Congar (1904–1995), the word, as a verb, means to transmit or deliver. In terms of the economy of salvation, Congar wrote that Tradition begins with God as "the absolute Origin, the uncreated Principle, the primordial Source." As the Tradition is handed down (*paradosis*) or communicated throughout history it comprises everything, written and unwritten, that is, Scripture and tradition, "all the Christian realities themselves."[5] The big question is: who, actually, is responsible for transmitting this Tradition?

The bishops in concert with the pope understand themselves to be the ones who are ultimately responsible for the transmission of the Tradition from age to age.[6] However, the Vatican II document *Dei Verbum* (Constitution on Divine Revelation), in addressing the Tradition of the church, points out that the love of God

4. Quoted in Céline Hoyeau, "Can the Catechism of the Catholic Church Evolve?," *LaCroix International* (October 13, 2017), https://international.la-croix.com/news/can-the-catechism-of-the-catholic-church-evolve/6112.

5. Yves Congar, *The Meaning of Tradition*, trans. A. N. Woodrow (San Francisco: Ignatius Press, 2004), 9–13.

6. See Richard R. Gaillardetz, *By What Authority? Foundations for Understanding Authority in the Church*, rev. ed. (Collegeville, MN: Liturgical Press Academic, 2018).

speaks to all people as friends, lives among them, and invites them into communion with the responsibility to transmit the revelation of God through words and deeds. "The Church, in her teaching, life and worship, perpetuates and hands on to all generations all that she herself is, all that she believes."[7] The question remains, how does the interior architecture of a church building reflect this teaching? How do our places of worship express that all baptized persons, ordained and not ordained, are responsible for keeping the Tradition relevant in each age?

The theologian and author Richard McBrien (1936–2015) distinguished between a broader and a narrower understanding of tradition. The broader meaning is the whole process of handing down the tradition from one generation to another through teaching, preaching, Bible study, devotions, and doctrines. The narrower understanding has to do with all of the postapostolic teachings. McBrien wrote, "Tradition [capitalized] is the living and lived faith of the Church; traditions are customary ways of doing or expressing matters related to the faith."[8] Moral theologian Charles Curran adds that even "the Catholic tradition has recognized the need to distinguish the various levels of church teachings because all are not of the same importance or centrality. Some truths are core . . . some are peripheral."[9] A dogma is a definitive teaching of the church. Catholics are required, for example, to believe in the Immaculate Conception of Mary. The word "doctrine," however, refers to a wide range of teachings accumulated throughout the history of Catholicism, including the

7. *Dei Verbum* (Dogmatic Constitution on Divine Revelation) 8, November 18, 1965, http://www.vatican.va/archive/hist_councils/ii_vatican_council /documents/vat-ii_const_19651118_dei-verbum_en.html.

8. Richard McBrien, *Catholicism* (Minneapolis: Winston Press, 1981), 66.

9. Charles Curran, *Tradition and Church Reform: Perspectives on Catholic Moral Teaching* (Maryknoll, NY: Orbis Books, 2016), 253–57.

dogmas. Some of these teachings, such as celibacy for priests, are sources of great tension among Catholics.

The wide range of different traditions (small "t") or customs held by Catholics around the world have resulted in an enormous variety of architectural styles. But, is a particular style of church building actually required to keep the Liturgical Tradition alive? No doubt the customary place for Christian worship since the late third and early fourth centuries, has been in a sheltered place known as a church. However, the enactment of the Eucharist, which is central to the Tradition of the church, has not always occurred in a glorious, expensive church building covered with decorative ornamentation or ostentatious works of art. Think of all the simple, unadorned, flexible and fixed places where the liturgy is celebrated—battle fields, aircraft carrier forecastles, homes, hospitals, and school gymnasiums—all sites of valid enactments of the eucharistic mysteries. In these locations, the conventual layout found in a long narrow church building usually shifts to a more intimate gathering of the assembly around the altar or communion table. Sometimes common sense and hospitality will trump even the most hard and fast liturgical regulations or customary ways of doing things without abrogating the Liturgical Tradition.

The complete historical narrative regarding the designation of worship places in Christian history has not been limited to a singular "traditional" architectural form or a uniform arrangement of interior spaces. It is false to claim that, officially, one style of church architecture is more suitable than or preferred over another in order to maintain the liturgical traditions of the church. That would be a very narrow understanding of the word "Tradition" spelled with a capital "T."

9. Innovations

"Every tradition begins with an innovation."
—Rabbi Peter Rubinstein

In the previous chapter I briefly reviewed the meaning of the word "tradition" and how a narrow understanding of the term can be deceiving. Differing notions about tradition and what it requires of us mark a point of conflict in the church. Certainly, some congregations are quite adept at celebrating liturgy in the Vatican II spirit. Others, driven by habit, nostalgia, or religious reasons, prefer forms that are, in spirit, revisionist. Yet, tradition and innovation are not mutually exclusive.

In this section I will explore how innovation in the field of church art and architecture can complement what may be called conventional or classical design motifs. The art of balancing tradition and innovation requires imagination. To take an example from the history of theology, patristics scholar Hans Boersma showed how Augustine reinterpreted Plato to further his thinking, albeit in dualistic terms, about heaven and earth. Augustine "recognized that the full reality of heavenly participation far transcends the categories of the earthly city. Heaven—the place of Christ's eternal dwelling place—is the place where the church finds both her origin and her destination. . . . [Augustine] was convinced that the Christian faith is about heavenly participation and that this biblical insight allows for some kind of Platonist-Christian synthesis."[1]

1. Hans Boersma, *Heavenly Participation: The Weaving of a Sacramental Tapestry* (Grand Rapids, MI: Eerdmans, 2011), 7.

Innovation presents a challenge to the assumptions of the status quo, and for this reason is usually met with resistance until the breakthrough itself becomes normative. The more radical and bold the innovation, the deeper the resistance. The challenge in the design of houses of worship is how to imagine new models against the background of centuries of standardized and preconceived convictions about what a church ought to look like. This exploratory process will depend on the willingness of church leaders, congregations, and architects to visualize fresh interpretations for worship and church complexes without disregarding valuable lessons from the past.

Here is one theoretical approach. Promotional materials for the 2018 meeting of the American Institute of Architects (AIA) announced that the main speakers would "share their perspectives on designing spaces that are equitable, inspirational, resilient, inclusive, and innovative." The theme for the 2019 AIA convention includes "learning how to push beyond the parameters of 'what is' to 'what can be' "! Can you imagine reading those words in an authoritative instruction on building and reordering churches in any Christian denomination? Think of the possibilities! Do not settle for what is!

Portuguese architect Álvaro Siza remarked in a 2017 interview, "Tradition does not mean closure, immobility. Quite the opposite, the value of traditions is in being open to innovations. Tradition is not the opposite of innovation, it is complementary. Tradition comes from successive interchanges. Isolated cultures that try to preserve their traditions without being open to new ideas collapse."[2] One question to ask those interested in moving to a common ground on church art and architecture is this. Does innovation have a place in the design of church buildings? Does it have a place in liturgical practice? A remedial approach to church design today

2. Vladimir Belogolovsky, interview with Álavaro Siza: "Beauty is the Peak of Functionality!," *ArchDaily* (January 11, 2017), https://www.archdaily .com/803250/interview-with-alvaro-siza-beauty-is-the-peak-of-functionality.

would consider at least three possible tactics. One would be a fall back to what is perceived as the classic order. This appears to be the approach favored by those who believe Vatican II leaped over centuries of tradition. The second method would be a creative response that challenges an existing, well-established way of thinking. This way is a more exploratory way favored by reformers who are willing to move forward. A third, middle ground approach would be a synthesis that balances conventional styles of church architecture with modern ones. I favor this method as an honest effort to move the discussion toward a compromise—one that builds on the achievements of the past but looks to the future.

A recent exhibition in the Met Breuer museum in New York City showed how the Norwegian Expressionist Edvard Munch (1863–1944) broke away from naturalism and embraced French Symbolism. He began to favor emotional experiences over objective observations. Would his personal metamorphosis change the way other artists approached their art? Some were influenced by him, but not all. Was Munch emulating the work of previous artists? Probably. More likely, though, Munch was tapping into a phenomenon rooted deep in his consciousness, a thought, a memory, that put him in touch with something beyond himself that demanded his expression and contributed to his identity.

Isn't this what someone who has faith and hope in God yearns for, a numinous experience, a holy alliance with an ineffable deity, a relationship that gives a person new energy? Once someone touches or is touched by God, a transformation is surely to take place in that person. How can it not? Resting on a mountain top, walking along a beach, traversing a desert, embracing a loved one, or birthing a child are all sacramental and spiritual moments of life-giving transformation. Although lacking the spatial and material traits found in natural environments, some built structures have the potential to provide similarly transformative encounters. Temples, shrines, churches, and cathedrals are considered holy spaces because of various elements of design and because of the ritual activities that take place within them. The ability of artists

and architects to tap into the deepest parts of their consciousness to find creative solutions in the building world is what produces bold and radical innovation. Like Munch, they are moved to explore design innovations that cry out for new expression. Moving to the architectural vanguard will require nothing less than being liberated from convention.

Innovations can transform us, our behavior, and our productivity. Consider the realm of science and how Albert Einstein's (1879–1955) theory of relativity challenged Newtonian physics. He proposed that light, energy, gravity, and matter were all interconnected. His radical idea was a pure innovation that challenged accepted ways of understanding relationships in the universe. We now consider Einstein's theory a conventional way of thinking about space and time. Although he may have been influenced by the research of other physicists and mathematicians who preceded him, his theories were new and, initially, spurned. Now, scientists suggesting that dark matter makes up 85 percent of the matter in the universe face similar skepticism.

It should be possible to grasp in fresh architectural and artistic terms what it means to have a relationship with an inexplicable, incomparable divine being. Melodramatic efforts to design churches as pathways to the otherworldly holy One or to an extra-solar heavenly city may have been effective in the past. In this contemporary period of history romanticism may have a place for those who pine for the "good old days." However, it is hard to ignore the abundance of new information about being in the world and relating to God and to others. There are fascinating facts about unfolding universes and the earth's ecosystem. There are pristine theological indications about how God works in creation. There are new ways for worshiping God that are still untapped. How can any organization, religious or secular, not want to find more ways to breathe in deeply and respond to these extraordinary wellsprings of creativity?

For centuries, writers, artists, musicians, and architects have been seeking ways to express in tangible forms what otherwise

lies unexpressed or even suppressed by some inhibition or societal taboo. Granted, the world, the universe, and all of their wonders remain a mystery. It may be true that, when everything has to be explained in order to be appreciated or understood, there is not much left to wonder about. Yet, human beings want answers to their questions. How exactly do those stars stay up there? Gravity surely has something to do with it, but is there a greater explanation or energy field that continues to stir our imaginations? What exactly is black matter? When I taught religion in a high school I provided a time slot in each class for the students to daydream and then talk to one another about their yearnings. I felt that if these students, who lived mostly in very poor neighborhoods, did not dream they would have no dreams to come true. Why work to erase inequity and other societal ills if there is no ideal or goal in mind toward which to strive? This, perhaps, in a limited way, is what a heavenly city, depicted artistically in some church buildings, is supposed to symbolize. Older theologies depict heaven as an end point—where an imperfect temporal world morphs into an eternal halcyon abode. However, new thinking in the fields of cosmology, philosophy, and theology suggests that the earth and the vast universes are already one. But the task of "repairing of the earth" is precisely the business of humanity. Why gaze on some imaginary place totally outside the realm of reality when there is so much to pursue and accomplish on this tiny blue planet?[3] One approach would be for us to promote an advanced religious fervor that does not focus on human weaknesses and the need to be forgiven. Rather, supposing we began to emphasize the strength of our shared convictions about the presence of God dwelling in both gated suburbs and disease-ridden slums? Bringing this spiritual concept into reality would acknowledge God who "always walks with us on the journey of

3. See Pope Francis's encyclical *Laudato Si'*, May 25, 2015, in which he writes about integral ecology and care for our common home, http://w2 .vatican.va/content/francesco/en/encyclicals/documents/papa-francesco _20150524_enciclica-laudato-si.html.

life."[4] There must be a way to design houses of prayer that moves us beyond past presuppositions about the cosmos, God, humanity, and nature. It would be a process that resonates with more contemporary research.

Church art and architecture serve as mirror reflections of a church community's worldview and commitments over time. Innovations can herald a fresh perception of a faith community in society by balancing traditions with inventiveness. The way to achieve this is dialogical and exploratory. The designer Natasha Jen identifies the problem as one of design methodology. "If you just focus on innovation then you actually fail to look at history and also what we can learn from history."[5] Her premise is that design by *prescription* creates "a kind of prison, in terms of how we can think about things and how we work . . . a very linear methodology-based way of working completely removes other possibilities." She imagines returning to a much older way of working "that is not just going back to old mediums, but rather it's the idea of going back to the very notion of explorations."[6] Jen offers sound advice to church leaders, architects, and artists. Why not explore old ideas precisely in order to interpret them in fresh and energizing ways and not to mimic them in exacting ways? The idea is to avoid designing places of worship by prescription. Subtly or not, such strictures sanction certain styles of church buildings as the only ones that can maintain continuity with the past.

Architectural theorist Nikos Saligaros observes we are on the cusp of an "historic architectural reckoning." His approach to architectural theory is based on history and leans toward "traditional architecture using its typologies in an innovative manner."

4. See this phrase in the four Eucharistic Prayers for Use in Masses for Various Needs, *The Roman Missal* (Collegeville, MN: Liturgical Press, 2011).

5. Natasha Jen, "Design Thinking Is B.S.," *CO. DESIGN* (April 9, 2018), https://www.fastcompany.com/90166804/design-thinking-is-b-s.

6. Jen, "Design Thinking Is B.S."

He believes this theory is rashly judged as one that "merely copies older models, where in fact it is using a well-developed vocabulary to generate novel solutions." Saligaros suggests "that architects who wish to be contemporary ought to drop their deconstructive baggage. They should instead extend a hand to those whom they have formerly disdained and slandered—I mean the traditionalists, and those innovative architects who respect human scale and sensibilities."[7] A problem prevails when a continued reliance on traditional styles of church architecture protects what is perceived to be an unbroken link to the traditions of the church. This approach ignores the fact that history continues. We are not stuck in the past. The dilemma of trying to "stop the clock" is exacerbated when church designs do not resonate with the narratives of the organic, living congregation. Architect Duo Dixon lamented the loss of understanding history in the field of architectural design. "Whether there are 'reasons' for a building being formed or finished in a certain way, the undeniable lens of history is always part of how designers think about what's to be built."[8] Church institutions cannot afford to be reliquaries of bygone periods of history when it comes to worship, social justice, art, and architecture. The evidence is clear—the industrialized West is already moving into a post-Christian modality. Once-loyal church members are searching for new avenues of spirituality.

Like most major faith groups, the American Institute of Architects (AIA) wrestles with its relevance as it seeks new ways to be an authoritative voice in the design world. One strategy is to apply the "research and analytics necessary to explore innovation whenever

7. Nikos A. Salingaros, *Unified Architectural Theory: Form, Language, Complexity: A Companion to Christopher Alexander's "The Phenomenon of Life—the Nature of Order, Book 1"* (Kathmandu, Nepal: Vajra Books, 2012), 27–29.

8. Duo Dixon, "Architecture Ignores History at Its Own Peril," *Common Edge* (April 4, 2018), http://commonedge.org/architecture-ignores-history -at-its-own-peril/.

and wherever it may occur, from either disruptive or progressive sources."[9] A balanced approach to church design today would blend tradition and innovation. Architects would incorporate into modern-looking churches archetypal elements such as proportion, scale, verticality, harmony, lintels, pathways, focal points, circular motifs, and light. "What can be avoided is the intentional and nostalgic use of unsurprising retro-architectural styles that will not (cannot) transport congregations anywhere else other than to the past and without any reference to current realities. They might even blur visions for tomorrow."[10]

9. American Institute of Architects Website, "Are Architects Afraid of Innovation?," The AIA Strategic Council's Innovative Business Models Working Group (September 7, 2017), https://www.aia.org/articles/147631 -are-architects-afraid-of-innovation.

10. Richard S. Vosko, "The Language of Liturgical Space: Archetypes and Clichés," *Worship* 86, no. 1 (January 2012): 40.

10. Memory and Imagination

*"Imagination allows us to break with what is taken for granted,
to set aside familiar distinctions and definitions."*
—Maxine Greene

How can someone be innovative without learning from history and its greatest achievers? Recently I heard the world premiere of the *St. Bonaventure Mass* composed by the Italian conductor Fabio Luisi (1959–). It was written to honor the eight-hundredth anniversary of the birth of St. Bonaventure of Bagnoregio, the patron of my alma mater, St. Bonaventure University. I found it to be an unorthodox but stirring piece that challenged my liturgical and musical imagination. I asked Maestro Luisi if there was any one composer who inspired him. He mentioned (for one) Ludwig van Beethoven (1770–1826), who composed two Masses in his lifetime. I am not suggesting that Luisi copied some of Beethoven's refrains. It is true, nonetheless, that we often hear familiar melodies mixed in with new ones and ask, "Where have I heard that before?" For a long time I wondered why I could not stop humming the song "This is the Night" by popular recording artist Billy Joel. Someone pointed out to me that Joel, a classically trained pianist, repeated the second movement of Beethoven's *Pathétique Sonata* throughout the melody. Perhaps every great work is meant to be borrowed from and reinterpreted in some way.

A similar practice, intentionally or not, happens in the design disciplines all the time. In 1984, Post-Modern architects Philip

Johnson (1906–2005) and John Burgee decorated the former AT&T tower in New York City with a stylized broken pediment, a Chippendale tower.[1] In 2018 the building received landmark status from the New York Landmark Preservation Commission. The architects topped off the PPG Place building in Pittsburgh (also 1984) with Neo-Gothic spires. In both projects Johnson and Burgee sought to mitigate the "less is more" mantra of the Modernists. Their work combined familiar stylistic flourishes with contemporary geometrical ones. But what about religious buildings? In the history of the United States, houses of worship have been designed in many different styles, including variations of Colonial architecture (French, English, German, Spanish). The Georgian and Federalist styles had roots in England and continue to be popular with architects and preservationists. These buildings were based on Greco-Roman classical features. The Neo-Romanesque style appeared quite frequently in Christian church denominations. Likewise, the Neo-Gothic form was popular, albeit often reproduced with Victorian touches.

The same practice of borrowing occurs, maybe more subtly, in the design of modern church buildings. Rafael Moneo, for example, reinterpreted the Mission Style in his bold design for the new Cathedral of Our Lady of the Angels in Los Angeles (2002). Moneo's use of faceted architectural concrete walls is a restrained reference to the adobe churches of the Southwest. Craig Hartman, the lead architect for Christ the Light Cathedral in Oakland, employed the *vesica pisces* shape in his design. The mandorla (almond shape) is formed by intersecting circles with the same radius and is a reference to a fish, a symbol of Christ. The Greek letters in the word "fish" (phonetically, ICTHUS) is an acronym for Jesus Christ, Son of God, Savior. The cathedral is an innovative design based on an ancient archetype. Is the reluctance to build upon

1. The AT&T building became the SONY Tower in 1992 and is now owned by the Olayan Group.

convention with innovation driven by a high regard for what is familiar, or by a lack of imagination? Perhaps it is the fear of challenging the expectations of owners and donors. Author Ariana Zilliakus argues, "The struggle between quality and quantity, especially when pressed by time and money, is possibly one of the biggest barriers stopping architects from achieving originality." She continues with some advice for architects: "True originality may be an impossible phenomenon, but this is nothing to be ashamed of. Take previous ideas and experiences, learn from them, and make them better by combining them with something new."[2] On a deeper level, maybe the desire for familiar forms has more to do with the subconscious. Language scholar Bettina Knapp (1949–2010) wrote, "Architecture as a spatial creation is the outer garment of a secretive and vital system; . . . a nonverbal manifestation of a preconscious condition. It is an expression of a preexistent form that may be apprehended on a personal and temporal as well as a transpersonal and atemporal level. As such, it may be considered archetypal."[3] Our imagination kicks in when we have difficulty understanding or explaining something like eternal life. But memory also plays a role. Much of what we believe to be true today is shaped by preconceived notions stored away in our brains. Unless our thinking is challenged, these notions hold us captive. This is why, for some people, modern churches do not look like churches.

A fascination with past styles of religious architecture could be caused by not being able to envisage new forms or by being beguiled by familiar ones. It would be laudable from an architectural

2. Ariana Zilliakus, "7 Challenges That Prevent Architectural Originality, and How to Overcome Them," *ArchDaily* (December 5, 2016), http://www.archdaily.com/800677/7-challenges-that-prevent-architectural-originality-and-how-to-overcome-them/.

3. Bettina L. Knapp, *Archetype, Architecture and the Writer* (Bloomington, IN: Indiana University Press, 1986), quoted in Vosko, "The Language of Liturgical Space," 57.

perspective if repeating classical architectural features were a means to enhance new Post-Modern church buildings. It would be less admirable if the trend to construct churches in heirloom styles classified anew as Neo-Renaissance Revival, Neo-Romanesque, or Neo-Gothic was merely to reverence a very restricted period of church history. It would be even more questionable if plans perceived as benchmarks of tradition were developed solely as expressions of revanchism or to satisfy the personal pietistic leanings of church leaders and donors gripped by nostalgia.

It's altogether possible to balance old forms with new ones. The incorporation of architectural styles from other historical periods into the designs of contemporary churches is a good compromise, with one proviso: that the interior design of the church will foster full, active, and conscious engagement in the ritual performance of the sacraments in a way that expresses the equality of all worshipers. This was the aim of the liturgical movement of the early twentieth century and was the hallmark of the reform of the liturgy that came out of Vatican II. To take this to the next level would result in designing churches that do not divide congregations during worship with distinct areas for clergy and laity. It would also suggest that more inclusive shapes, such as circles and spirals, would draw the assembly into an awareness of their own mystery. Augustine of Hippo preached about the church as the Body of Christ: "So now, if you want to understand the body of Christ, listen to the Apostle Paul speaking to the faithful: 'You are the body of Christ, member for member' (1 Cor 12:27). If you, therefore, are Christ's body and members, it is your own mystery that is placed on the Lord's table! It is your own mystery that you are receiving! You are saying 'Amen' to what you are, your response is a personal signature, affirming your faith. When you hear 'The body of Christ,' you reply 'Amen.' "[4]

4. Augustine of Hippo, Sermon 272, Latin text in J.P. Migne, *Patrologia Latina* 38:1246-1248; translated by Nathan D. Mitchell. Quoted in *Assembly* 23, no. 2 (March 1997).

The search for common ground in a polarized church is not easy. Christianity, like most religious traditions, relies heavily on the memory of its past accomplishments and teachings as a strong foundation for living in the present. The same is true of how we design our church buildings. The image of what a church is supposed to look like, especially for some descendants of European ancestry, is connected to what "Catholic" looks like. For some, their churches should not look like "Protestant" places of worship. As architectural critic Sarah Williams Goldhagen points out, "What we know about how memories are consolidated in the brain reveals that the physical environment we inhabit in a given experience centrally figures in the memory itself . . . what this means is that the buildings, landscapes, and urban areas we inhabit are central to the constitution of our autobiographical memories, and therefore to our sense of identity."[5]

Artistic narratives that took shape in the Middle Ages to illustrate religious doctrines, scriptural stories, and even folk tales can provide a wealth of imaginative resources for congregations today in their search for artistic and architectural resonance with their own stories. One example is the well-known fifteenth-century icon *The Trinity* by Andrei Rublev. It depicts Sarah and Abraham welcoming three strangers into their tent (Gen. 18:2). That image could easily be used today as a hospitable example of how to welcome immigrants into a place of refuge or sanctuary. As sociologist and prolific writer Andrew Greeley (1928–2013) pointed out, "Catholic churches (some more than others and some hardly at all) are strongholds of the analogical imagination, of stories of God's presence in the human condition."[6] Many faith communities already use their churches as "sanctuaries" for homeless families, strangers, refugees, and immigrants, thus honoring the

5. Sarah Williams Goldhagen, *Welcome to Your World: How the Built Environment Shapes Our Lives* (New York: HarperCollins, 2017), 83.

6. Andrew Greeley, *The Catholic Imagination* (Berkeley, CA: University of California Press, 2000), 39.

Christian call to bring about justice for all peoples. Can church buildings be more than just a place of worship? Edward Sövik's idea for "non-church churches" suggests they can function for other community programs as well. Does this concept shatter the old Christian shibboleth about the purpose of a house of worship? Or is it reminiscent of some cathedrals and monasteries of yesteryear that served as places of prayer, education, artistic performances, and shelter?

Memories and stories that bind dominant cultures and smaller communities together are now shaped, advertised, and transmitted by Snapchat, Facebook, and Instagram apps. What one sees is not always the big picture, the context for the moment. By editing facial features to mask imperfections or boost personas, we can reshape a memory. Often what are known to be undeniable facts of history are subject to alternative and sometimes false or misleading interpretations. Christian truths can also be "edited" by distortions such as fundamentalism. Here's one example. Christians who choose to read the Bible literally conclude that the Book of Genesis offers a convincing explanation of how God created the universe in one work week. Yet, the resilience of religious tradition rests upon its ability to be reinterpreted faithfully in changing contexts. Essayist Marilynne Robinson wrote, "These ancient narratives, even in their differences, are part of a genre whose insight and power are no doubt beyond the full understanding of our modern minds." She implied that affection for these foundational biblical stories most likely will not fade away.[7] Peter Atkins, retired Anglican bishop and cognitive scientist from Auckland, New Zealand, warns, however, "If the corporate memory is not constantly applied and adapted to the new context, the society can be frozen in the past and become unable to attract

7. Marilynne Robinson, review of Stephen Greenblatt's *Rise and Fall of Adam and Eve* in *The New York Times Book Review* (October 6, 2017), https://www.nytimes.com/2017/10/06/books/review/rise-and-fall-of-adam -and-eve-stephen-greenblatt.html.

new members. Nostalgia is a pining for the past in such a way that it shapes the memory by detaching from the context and giving it a form which is a more emotional investment than reality."[8] For us to read the Bible today without taking into account research methods (historical criticism, literary criticism, and so forth) would be like designing church buildings with no regard for current technologies, codes, or, more important, the memories and stories of the current congregation.

Are memories reliable sources of knowledge in an age when so much new information floods our awareness daily? It may not be obvious to everyone that most churches, even modern ones, regardless of denominational identity, continue to incarnate stereotypes of past perceptions of the cosmos. Researchers Seligman and Tierney wrote that "when cognitive psychology emerged, it focused on the past and present—on memory and perception. But it is increasingly clear that the mind is mainly drawn to the future, not driven by the past. Behavior, memory and perception can't be understood without appreciating the central role of prospection. . . . The brain's long-term memory has often been compared to an archive, but that's not its primary purpose. Instead of faithfully recording the past, it keeps rewriting history."[9] A commonplace assumption is that all human beings are innately attracted to familiar forms, stories, and memories. Nevertheless, more recent advancements in human psychology indicate that there is nothing to hold us back from moving into unknown territories, taking risks, seeing things in new ways, challenging assumptions, and making connections between old ideas and new ones. Memory and imagination are important tools when worshiping God and designing houses of worship. To use one without the

8. Peter Atkins, *Memory and Liturgy: The Place of Memory in the Composition and Practice of Liturgy* (Brookfield, VT: Ashgate Publishing, 2004), 76.

9. M. E. P. Seligman and J. Tierney, "We Aren't Built to Live ir ment," *The New York Times* (May 21, 2017): SR1.

other, however, is not an effective strategy for making advancements architecturally or liturgically. Making an investment only to preserve the past will leave congregations no place to go. In fact, they yearn to move forward and to pitch their tents in the land of hope (see Acts 2:26).

11. Philosophical and Theological Influences

"A return to the sources does not mean a return to the past."
—Hans Urs von Balthasar

Most major religions have shown an appetite for innovation in order to protect their traditions. They truly want to offer people an accessible spiritual path that would bring about a sense of purpose and hope in real time. Clergy leaders who do not budge from a fixed position, especially one that they are free to change, will create a quandary for their membership. In this essay I will review some of the influential theories that have contributed to shifts in understanding of the sacramental system in the Catholic religion.

Historians and theologians often refer to three major periods of doctrinal development in the Christian tradition: patristic, scholastic, and modern. I will leap over the first one and turn briefly to the other two. The understanding of God, creation, humanity, church, and sacraments continued to develop after the apostolic era. The rise of educational institutions, abbeys, and great churches coupled with the inquiring minds of curious theologians was essential to the growth of the church in the Middle Ages as well as to the whole of Western civilization. The creative spirit, however, was tempered by turmoil. Endless conflicts, disease, and power mongering characterized this long period of history. The idea that the church could offer an ideal stable model for society was an effective antidote to the uncertainties of life. The power of the clergy to conduct mysterious rituals, acquit sins, and bestow

indulgences was a key attraction for all classes of people. The thought of an afterlife and eternal happiness was irresistible.

Church buildings in the medieval era were constructed and arranged to accommodate a liturgy that was substantially a clerical act. It was performed for peasants and royalty alike who believed they would gain spiritual benefits, graces, and indulgences, just by being there. It is unlikely, however, that anyone who attended Mass in that period thought of the liturgy as a memorial of the paschal mystery. Baptism, confession, and the last rites were key to the sacramental system. Most of the church structures and the art that was in them offered a lens through which congregations could learn about the Bible and connect with God through the lives of the saints. Scholarly investigations into big questions about God, the universe, ethics, causality, and metaphysics may have been discussed at the universities, but they were just not something people talked about at the local pub.

The process of synthesizing diverse ideologies (a syncretism of sorts) happens all the time in human life but more slowly in a theological-philosophical matrix. Scholastic thought, which, in part, explored nature and the cause of things, is usually broken up into several periods ranging from the early Middle Ages all the way up to the present. Theologians such as Bonaventure (1221–74) and Aquinas (1225–74) employed dialectical reasoning (they argued a lot) to investigate avenues for aligning Aristotelian and neoplatonic ways of thinking with Christian doctrines. Theologian Sebastian Madathummuriyil briefly explains how scholastics understood sacramental efficacy: "God bestows grace concurrently upon the administration of the sacraments. The 'giving' of the sacraments reminds the recipient of the grace that is being received from God who acts simultaneously with the sign."[1] But Madathummuriyil adds, for Aquinas "sacramental actions are not mere extrinsic oc-

1. Sebastian Madathummuriyil, *Sacrament as Gift: A Pneumatological and Phenomenological Approach* (Leuven: Peeters, 2012), 19.

casions of grace, but the intrinsic media of it." Aquinas seemed to grasp the relationship between the sacrament as a sign and the reality it signified. Fresh baptismal water effects what it signifies. Fragrant oil rubbed into our bodies can have a healing consequence.

This is where Aquinas and other scholastics inadvertently cast some light on church architecture as a metaphor for a sacramental people.[2] In the Catholic religion a church building resonates with the ecclesiological underpinnings of the church. The cornerstone is Christ. The Eucharist is the ritual act whereby the people of God express themselves permanently in a most essential form.[3] A church building, much like an icon, does not call attention to itself. It is a place that enables a person to move beyond the walls to discover a part of his or her being previously unknown. This liminal experience does not necessarily transport a person to a physical or geographical place (although sometimes a "transformative" experience may require relocating to another city or taking a new job). In any case, the encounter is an opportunity for developing new relationships with God and others in the congregation. The inside of a church, where the sacraments are ritualized, functions as a medium for this relational experience. It can "cause" the members of the congregation to examine themselves as coprogenitors and not the receptors of a sacramental act.

There are some teachings to keep in mind. Christ, the foundational sacrament, is *the* celebrant, the high priest, of every eucharistic liturgy and every sacramental encounter. Worshipers are

2. For a classic inquiry into the relationship between scholasticism and Gothic cathedrals, see Erwin Panofsky, *Gothic Architecture and Scholasticism: An Inquiry into the Analogy of the Arts, Philosophy, and Religion in the Middle Ages* (New York: Penguin Books, 1957).

3. See Congregation for the Doctrine of the Faith, *Letter to the Bishops of the Catholic Church on Some Aspects of the Church Understood as Communion* (May 28, 1992), http://www.vatican.va/roman_curia/congregations/cfaith /documents/rc_con_cfaith_doc_28051992_communionis-notio_en.html.

invited to join Christ in presenting themselves to the Creator God. In doing so they come to realize that the mystery of faith they are memorializing is already present and is theirs to embrace as their own. In this regard, Madathummuriyil's work moves beyond scholasticism to examine the fields of phenomenology, pneumatology, and trinitarian theology as they relate to the sacraments. While he shows an appreciation for the scholastics, who believed that philosophy and theology went hand in hand, he gives notice that: "the diminution of sacramental thinking within the single scheme of Aristotelian metaphysics caused stagnation in the sacramental thinking of the successive period, until Vatican II called for new theoretical paradigms within Catholic thinking. . . . According to the Scholastic paradigm, sacraments are products."[4]

Studies in the field of phenomenology in the nineteenth and twentieth centuries opened doors to contemporary theological explorations.[5] The same thing would happen for architectural theorists who studied phenomenology. The philosophers of this fertile period wrote about "being in the world" and that everything is experienced through human and personal perceptions. They argued against a subject-object hermeneutic that, in a religious context, would render human beings as the recipients or objects of God's sacramental grace. Influenced in part by such phenomenological thinking, the "new theologians" (*nouvelle théologie*) began to refresh old church teachings. They published innovative interpretations of doctrines that were once defined according to a precise, yet restrictive, categorical way of thinking.[6] These theologians were not interested in eradicating the teachings of Aquinas

4. Madathummuriyil, *Sacrament as Gift*, 26–27.

5. Some of the familiar names include Edmund Husserl (1859–1938), Martin Heidegger (1889–1976), Simone de Beauvoir (1908–1986), Paul Ricoeur (1913–2005), Jürgen Habermas (1929–), and Julia Kristeva (1941–).

6. Among these scholars were Henri de Lubac (1896–1991), Jean Danielou (1905–1974), Hans Urs von Balthasar (1905–1988), Yves Congar (1904–1995), Karl Rahner (1904–1984), Marie-Dominique Chenu (1895–1990), Louis Bouyer (1913–2004), and Edward Schillebeeckx (1914–2009).

or other scholastic thinkers. Rather, by acknowledging the need for a new hermeneutic, they searched for ways to make Catholic doctrines accessible and intelligible to the world of their time. Hans Boersma, a critic of Modernism, theorized that those theologians were convinced that a "reinterpretation of the tradition was required . . . to counter secularizing trends that were making inroads in twentieth century France."[7] Further, Boersma surmised that the theologians saw in "the Platonist-Christian synthesis a sacramental ontology that they believed had been lost through the modern separation between nature and the supernatural. As a result, a *nouvelle théologie* set out to reintegrate the two by pointing to the sacramental participation of nature in the heavenly reality of Christ."[8] In 1939, Hans Urs von Balthasar (1905–1988), who, like Karl Rahner (1904–1984) and Bernard Lonergan (1904–1984), sought to bring about an intellectual/theological perspective to the modern period, mildly rebuffed scholasticism when he wrote, "in any case, must not everything living grow and change? Even the earthly body of the Church?"[9]

Contemporary theologians have continued to advance the universal call to holiness articulated by the teachings of Vatican II. Pope Francis indirectly bolstered those lessons in a homily: "The path to holiness is simple. Do not go back, but always moving forward . . . And with fortitude."[10] Sacramental theologian Kenan Osborne outlined several departure points for a sacramental theology in the third millennium that is based on the "new theology." In one example he referred to the neoscholastic use of biblical texts as a "basis for the institution, meaning and causality of the sacraments."

7. Boersma, *Heavenly Participation*, 16.

8. Boersma, *Heavenly Participation*, 16.

9. Hans Urs von Balthasar, "Retrieving the Tradition: The Fathers, the Scholastics and Ourselves," *Communio* 24 (1997): 347–96 (trans. Edward T. Oakes, SJ [Orig.: 1939]), 354.

10. "Pope Francis: Holiness is a journey that takes courage, hope and daily conversion," *America* (May 24, 2016), https://www.americamagazine .org/issue/pope-francis-holiness-courage-hope-daily-conversion.

He wrote that this thinking distinguishes between the physical and metaphysical definition of a sacrament, a way of thinking that "makes the seven sacraments epiphenomenal to human life and the human environment."[11] Osborne explained that this outdated theory fit in well "with the two-storied universe of nature and grace." Such dualistic thinking reinforces the idea that a sacramental experience of God is a "product" devised outside the human understanding and has to be administered by a mediator. Osborne continued, "In third millennium sacramental theology, the primordial relationship between ritual sacraments and the Incarnation and the foundational relationship between ritual sacraments and the church, must be developed." He argued, "If scholastic onto-theology is the form in which sacramental life is presented to the new generations, sacramental life will be seen as meaningless."[12] The attitudes of many younger Catholics today are good examples of Osborne's prediction.

Phenomenological ways of thinking provided a launching pad for assessing a postmodern sacramental hermeneutic. The theological discourse continues to evolve and is now focused on the third Person of the Trinity. This pneumatological approach to the sacraments is rooted in biblical texts as well as the teachings of early Christian writers and later scholars. Roger Haight agrees with the role of the Spirit in human activity when he observes, "the church thus depends historically and sociologically on the Spirit who acts within the members and in the community as a community, in deed, as the body of Christ. The Spirit constitutes the inner transcendent or divine dimension of the community."[13] The church affirms and celebrates the presence of God using a sacramental matrix that requires constant readjustment. Updated

11. Kenan B. Osborne, *Christian Sacraments in a Postmodern World: A Theology for the Third Millennium* (New York and Mahwah: Paulist Press, 1999), 44.

12. Osborne, *Christian Sacraments in a Postmodern World*, 49.

13. Roger Haight, *Ecclesial Experience: Christian Community in History* (New York: Continuum, 2008), 86.

methods of teaching will help to explain the unconfined and un-predictable activity of the Spirit at work within the entire Body of Christ and the world.

French theologian and pastor Louis-Marie Chauvet offered a more candid opinion about rejuvenating a neoscholastic approach to the sacraments: "How are we going to avoid stumbling against their scandalously empirical consistency as the symbolic place where God becomes enfleshed in our humanity?" Chauvet called it "a folly so difficult to sustain that believers are constantly tempted to domesticate it into human wisdom: the sacraments then become the principal means by which the institution serenely displays and thus perversely manipulates (in good faith, by the way—out of habit) the emblems of its legitimacy and social domination."[14] This is not the only critique of the neoscholastic interpretation of sacraments. Theologian Joseph Martos concurred with Chauvet and others when he boldly called for deconstructing sacramental theology and then reconstructing Catholic ritual. "If Catholicism is to remain a vibrant faith in the future, therefore, it must rethink its ritual policies and allow for the rethinking of what happens in and through its religious rituals. Otherwise it is des-tined to become a church of beautiful ceremonies that have little relation to the lives that people actually live."[15] Much of what has been theorized about the relationship among a triune God, human beings, and creation will remain theoretical until there is an au-thentic assessment of the sacramental system that resonates with the everyday lives of people. This, in part, has been realized, to take one example, in the evolution of liberation theology in Latin American countries. The movement began as a moral response to social injustices and thrust the church into a political battle against dictatorial regimes funded by wealthy families and/or crime

14. Louis-Marie Chauvet, *Symbol and Sacrament: A Sacramental Re-interpretation of Christian Existence*, trans. Patrick Madigan and Madeleine Beaumont (Collegeville, MN: Liturgical Press, 1995), 83.

15. Joseph Martos, *Deconstructing Sacramental Theology and Re-constructing Catholic Ritual* (Eugene, OR: Wipf and Stock, 2015), 298.

syndicates. Liberation theology, Black theology, and feminist-based theologies offer models to congregations seeking ways to work against social inequities and prejudices.

Sacraments are relational experiences that reveal how the incomparable, peerless, transcendent God operates within the cosmos and all of humanity. Churches that have a sacramental system to celebrate God's gifts have a right to scrutinize the intentions of its members without discriminating against them in any way. Everyone who believes in God experiences God in multiple ways. God initiates. God forgives. God heals. God sustains. God marries. These actions are made visible through the ministry of a church that is in a healthy relationship or covenant with God. To call the church a sacrament is to say, borrowing from Thomas Aquinas, that the people of God effect what they signify. That is, both clergy and laity together are active, conscious participants in the paschal event, the ongoing work of God in real evolutionary time.

This brief review shows how various developments in theological and philosophical thought can affect the understanding of sacramental acts.[16] As the comprehension of the sacramental system continues to develop from age to age, so too must the environments for worship be transformed in order to resonate effectively with refreshed theologies and ritual practices. As long as lay Catholics see themselves as liturgically and sacramentally subordinate to their clergy, they are less likely to comprehend that they too are, with Christ the high priest, the celebrants of their own mystery of faith. Catholics will also neglect to see that their acts of worship and interventions against social inequities, carried out together with their clergy, comprise one and the same response to a divine invitation. The call to worship God is a summons to live as ambassadors of peace and justice in their communities.

16. See, for example, Siobhán Garrigan, *Beyond Ritual: Sacramental Theology after Habermas* (London: Ashgate, 2004).

12. Ritual Performance

"Rituals are the social acts basic to humanity"
—Roy Rappaport

Theological and philosophical theories coupled with precon-ceived notions can affect the way people understand worship. A bishop once asked rhetorically: "But, doesn't liturgy take care of itself?" His presumption, that the celebration of sacraments depends only on following the rubrics contained in the liturgical books, is still held by many clergy and some laity as well. Anyone who stud-ies liturgics and is involved in planning worship knows that this bishop's postulation does not reflect an adequate understanding of the power of ritual. There are diverse opinions about how to enact liturgical rites—what texts to use, what hymns to sing, who gets picked to do what, when and where each ritual action is celebrated. Although there are options within liturgical law that lend themselves to radical adaptations in certain pastoral situations, there are those who say, "Let's just follow the book." These different approaches to worship and the assorted convictions about the proper environ-ment for worship are just two reasons to search for a common ground. The liturgical performance of sacramental rites in the life of a Christian is the subject of this chapter. Because the field of ritual studies is so sweeping and sophisticated, I will touch only on those contributions relating to the environment for worship.

Christianity and other major religions have demonstrated a deftness for keeping abreast of secular-societal meanderings. Most

pastoral leaders want to respond in ways that are appropriate and spiritually fruitful. Understanding and appreciating prevailing cultural realities is essential in this effort. Some denominations will read the signs of the times with open eyes and look for ways to adapt without undermining their core values and principles. Ritual language, verbal and nonverbal (a baptismal bath, a biblical text, a communal meal, orchestrated movements, music, art work, and architecture), both shapes and is an expression of the congregation's identity: who they are and what they believe. The vocabulary of ritual can also affirm the good work the group is doing in the larger community. Ritual performances are sensory experiences. They touch the bodies, minds, and spirits of the worshipers, transforming them as creatures of God, reshaping them as members of the Body of Christ and energizing them to return to their neighborhoods to advance the gospel.[1] A serious question arises when the rituals no longer resonate with and challenge the identity of the congregation. Some liturgies are so rote, so predictable, they could easily be carried out by automatons. What if the doing of liturgy fails to inspire assemblies? The artful celebration of sacramental rituals is something an entire congregation can learn to do, so that the salt does not lose its flavor.

Tweaking a tradition and its accompanying ritual actions will not cut off a religion from its roots. However, it may be just the thing needed to keep a religion relevant in turbulent times. This is a strategy that mainline religions need to study as they see many of their members heading off to nondenominational congregations. Ronald Grimes, scholar and author on ritual studies, noted that "ritual actions are sometimes used to ensure that treasured persons or paradigmatic historical events are not forgotten." This is true in those churches that have rituals designed to keep the memory of Christ alive. Further, Grimes continued, "Rituals are devices

1. See Bruce T. Morrill, *Bodies of Worship: Explorations in Theory and Practice* (Collegeville, MN: Liturgical Press, 1999).

for hanging on to values, making sure they are honored."[2] Sometimes pruning away nonflourishing vines is required to make the entire vineyard more productive and the fruit more appealing. Grimes acknowledged, "Rituals are rendered traditional by constant micro-changes, but when changes occur in sufficient volume or frequency, participants may be forced to recognize that their rituals are in fact dying or need reinventing."[3] There are data that suggest that organized religions are at a juncture in history when a radical reformation is required in order to survive.

In their examination of Greco-Roman meal customs, biblical scholars Smith and Taussig showed how these customs shaped early Christian table rituals. In another research project the authors addressed how a group's determination to survive required flexibility. "Although there may have been different interpretations of what the meals meant, borrowing from various traditions and models, including the Last Supper, the "early Christian communities exhibit a great deal of creativity in their adaptations of meal traditions to fit their own special social situations."[4] The authors also remind us that the missionary Paul is the only one who tells his listeners to repeat the ritual as a way of remembering the death of Jesus (1 Cor 11:23-26). Vatican II called for the radical adaptation of liturgical rites and the education of Catholics about a nobler and simpler way of worshiping God. Although the decision to reform the liturgy affirmed decades of liturgical renewal, many revisions are still not completely implemented or understood. The performance of sacramental rituals is essential in any congregation. The reason, in part, is that rituals transform people by pulling them out of their comfort zones and lifting them up to new spiritual horizons.

2. Ronald L. Grimes, *The Craft of Ritual Studies* (New York: Oxford University Press, 2014), 313.

3. Grimes, *The Craft of Ritual Studies*, 314.

4. Smith and Taussig, *Many Tables*, 44.

A ritual is often described as a repetitive pattern of behavior that uses verbal and nonverbal symbols to convey familiar meanings to a group that are necessary for the group's survival.[5] The ritual performances of the cohort were perceived as a set of stipulated choreographed actions that incorporated various disciplines or languages—sights, sounds, colors, ritual tools, light, gestures, postures, movement, materials, and so forth. The ritual playbook provided a lens through which the ancient narratives and belief systems of the society would be remembered and fortified. Remember the aphorism, "Repetition is the mother of all learning," drummed into us as children? Rituals have always required an unbridled imagination to keep them relevant from age to age regardless of cultural challenges, yet they also require repetition.[6] To fully engage with and be transformed by the ritual demands full and intentional participation. One cannot be an outsider or an observer of a ritual action and expect to be changed by it. Liturgical theologian Louis-Marie Chauvet wrote that "interiorization is one of the fundamental conditions of ecclesial participation in the liturgy."[7] Watching someone swim may be pleasant, but until you jump into the water yourself, swimming remains just a refreshing thought.

Current ritual studies in the human behavioral sciences offer another understanding of liturgical performance and its role in shaping and sustaining congregations. It is one that challenges the notion that repetition is essential for rituals to have staying power.

5. The thinking was based on the classic texts of Émile Durkheim, Mircea Eliade, Arnold van Gennep, Mary Douglas, Suzanne Langer, Claude Levi-Strauss, and Victor Turner.

6. Aidan Kavanagh once mused, "Communities do not cohere around lecture halls but everyone loves a parade!" He meant that catechisms cannot compete with the church's ceremonies.

7. Louis-Marie Chauvet, "Are the Words of the Liturgy Worn Out? What Diagnosis? What Pastoral Approach?," *Worship* 84, no. 1 (January 2010): 30.

Scholars and practitioners[8] now accept the theory that rituals are actually more effective when they include interruptions, surprises, and reversals. Feminist theologian Janet Walton, who taught theology students how to create and perform diverse rituals at Union Theological Seminary in New York, described what interruption, for example, can do to the ritual performance of a liturgy. "Interruption disturbs, wakes us up, and makes possibility tangible . . . it shakes our certainties, invites change."[9] Walton, who now works as a worship consultant for Christian and Jewish congregations, also observed that "liturgical traditions are always under active construction, molded by what is passed on through the multiple textures of our dwelling place."[10] That "dwelling place" is a reference to the diverse narratives that worshipers possess—some personal, some communal—that are not expressed or prescribed in our ritual books. According to Walton, when rituals are too familiar, too repetitive, too prescribed, they lose their power to transform people and need to be rebooted.

Liturgical scholar Nathan Mitchell, using the work of the anthropologist Catherine Bell (1953–2008) and other theorists, outlined the distinctions between the older and newer understandings of ritual.[11] It used to be thought that rituals transmitted information to consolidate the group's meaning. Ritual assured continuity of identity because it resisted change. It was firmly fixed in form and content. It also established boundaries, determining who is in and who is out. Mitchell's summary in this instance is helpful in observing the connection between a compartmentalized arrangement

8. To name a few alphabetically—Edward Foley, Ronald Grimes, Gordon Lathrop, Nathan Mitchell, Bruce Morrill, Don Saliers, Richard Schechner, Jonathan Z. Smith, Kristine Suna-Koro, Janet Walton, and Linda Woodhead.

9. Janet R. Walton, "Dwelling in Possibility," in *Proceedings of the North American Academy of Liturgy* (2009): 33.

10. Walton, "Dwelling in Possibility," 33.

11. Nathan D. Mitchell, *Meeting Mystery: Liturgy, Worship, Sacraments* (Maryknoll, NY: Orbis Books, 2006).

of churches into naves and sanctuaries and the older understanding
of ritual. The familiar, unexamined architectural setting for liturgy
had been so customary for centuries it is still considered normative.
What has challenged this presupposition?

Catherine Bell wrote, "Post-conciliar ritual style places more
emphasis on the communal aspects of the liturgy by enhancing the
understanding and participation of the laity, although the sacra-
mental focus is not abrogated . . . ritual is a means by which
people 'express' themselves, while the basis for spirituality and
community are thought to reside within each . . . person, not in
an external institution."[12] Going even further, Mitchell points out
that the postmodern view of ritual performance anticipates that
older structures of identity (this would include architectural struc-
tures) will become more flexible and reordered. Rituals would be
designed to meet a certain need and to question universal forms of
action in a way that would challenge the very identity of the group.

To describe the church as a sacrament of unity does not mean
that all members will have the exact same experiences during the
performance of the liturgy. Nor does it mean that a congregation
must cohere around a single ethical issue or vote for the same
politicians. Liturgical theologian Richard McCall wrote, "The point
of performance is that it allows for a variety of experiences, of
effects, even in the context of a single, unified act." The experi-
ences, however, are not "mutually exclusive," according to McCall.
He suggests that even the liturgical event cannot be limited to a
single set of words or gestures. In a nod to the power of the me-
dieval liturgies, McCall states that it was not necessarily a "clerical
monopoly." The Mass as a form of popular piety was meaningful
to the people of that era. They participated fully in the performance,
although not in the way participation is expected in today's litur-
gical rites. McCall suggests that the differences can be discovered

12. Catherine Bell, *Ritual: Perspectives and Dimensions* (New York:
Oxford University Press, 1997), 216.

"by examining the liturgy *as enacted.*"[13] Such a close scrutiny may reveal a gap between the lived experiences of the congregation and the language of the rituals prescribed for them.

Ritual expression is often framed in terms of familiar tasks such as translating texts, rehearsing a sermon, composing music, training new ministries, crafting art, and designing churches. But another component is now considered even more important, one that has to do with feelings and perceptions. Phenomenological studies regarding the importance of the human body in a liturgical context are surfacing as key to liturgical praxis. Walton asserts that the predominant role of the body in ritual language is often overlooked or avoided. She gives the reason for this glaring oversight: "bodies are too erotic, uncontrollable, embarrassing, too much trouble, too intimate, too personal." Nevertheless, as Walton insists, "bodies express the heart of each person's particularity, each one's distinctive contribution to the larger body of community and of the cosmos."[14] The formulation of a ritual requires attention not only to the usual practical details but also to the identity of the ritual makers. Rituals that acknowledge and name the beauty and the potential of the human body, as well as the ugly assaults inflicted on them, will alert the congregation to the joys and sorrows experienced in the community. And it will remind them of God, who is there in the midst of it all. A ritual performed by the congregation resonates not only with their ancestors in faith but also with the stories of the living members, who have yearnings for the future. In a similar vein, professor of architecture Thomas Barrie notes the symbiotic relationship between "sacred" spaces and ritual making. His understanding of the impact of the built environment on worship relies less on the empirical assessment of human experiences (often the conclusion of a single person or

13. Richard D. McCall, *Do This: Liturgy as Performance* (Notre Dame, IN: University of Notre Dame Press, 2007), 109.

14. Walton, "Dwelling in Possibility," 35.

research group) and more on sensual perceptions and interpretations of individuals.[15]

Sacramental rituals are manifestations of the unique spiritual transformations occurring in each of the members of the assembly and in the corporate body as well. The belief that the effectiveness of a sacrament is caused by Christ (*ex opere operato Christi*) has unfortunately translated into a one-size-fits-all approach to liturgy. The phrase refers to the idea that sacraments are efficacious in and of themselves and do not depend on the virtue of the minister. Yet, it has always been claimed that the fruitfulness of a sacrament depends on the disposition of the one who is receiving it. The reliance upon the power of Christ alone to effect what a sacrament symbolizes is a notion that has often been misunderstood and borders on magic.[16] It has also been the rationale for simply "reading the Mass" out of the Missal. Sacraments are intended to be communal rituals because the individual wants the whole faith community to know she or he is ready to celebrate a personal experience of the loving presence of God, be it healing, forgiveness, matrimony, communion, or graduation. It may be a weak analogy, but if I made a "hole in one" while golfing alone, who would believe me? Sacraments are celebrations of the big changes, the transitions, that are going on in the life of a person and the individual's testimony that there is a divine being at work behind the scenes. Bell comments: "the basis for a liturgical community is not ascribed to anything in the social, historical, or cultural environment, nor to simple obedience to traditional church hierarchical authority or customs. Rather, the liturgy implies that the basis for community can be evoked from within each person, both expressed and fully realized in the shared activities of the rite."[17]

15. See Thomas Barrie, *Spiritual Path, Sacred Place: Myth, Ritual, and Meaning in Architecture* (Boston: Shambala, 1996).

16. See the early work of George S. Worgul Jr., *From Magic to Metaphor: A Validation of the Christian Sacraments* (Mahwah, NJ: Paulist Press, 1980).

17. Bell, *Ritual*, 218.

The intentional adaptation of a liturgical ritual and its architectural setting so it resonates with the signs of the times is a challenge. This is especially true for religions accustomed to using prescribed ritual prayers, formularies, music, art, and architecture borrowed from another period of church history. Smith and Taussig wrote that the "traditional way of looking at liturgy has often limited our efforts to revitalize it. Liturgy has come to be dominated by an over-concern for the idea of 'orthodoxy' or correct doctrine."[18] Sacramental theologian Osborne agreed with this assessment when he wrote, "Suppressing cultural imagination in the area of liturgy by insisting that imported laws and rubrics are followed, even when meaningless, defeats the purpose of liturgy and leads to serious disorder and dysfunction."[19]

The careful synchronization of all the components of ritual action will include words, music, various symbols, bodies, postures, gestures, and movements that manifest the relationship between worship and social action. As long as denominations want to erect houses of worship, the interdisciplinary fields of art and architecture cannot be underestimated or overlooked as partners in this ritualistic relationship. They are vital elements in the praise of God wherein all the members of the congregation are invited to participate.

18. Smith and Taussig, *Many Tables*, 16.
19. Kenan Osborne, *Orders and Ministry* (Maryknoll, NY: Orbis Books, 2006), 26.

13. The Paschal Mystery Remembered

"It is your own mystery that you are receiving!"
—Augustine of Hippo, Sermon 272

How does the church memorialize the paschal event, which is the central mystery of the Christian faith? Full engagement with this mystery requires more than just being present in the church building. Because the liturgical celebration of the paschal mystery regularly occurs in a unique setting, it is important to see the relationship between church art and architecture and the remembering of that Christic event.

I once arrived late for a funeral of a well-known lay person and sat with other people in the back row of the small church. Many concelebrating clergy occupied the pew benches in front of us. At the start of the eucharistic prayer the assembly knelt down, but the clergy in front of us did not. Every one of them remained standing, making it impossible for the rest of us, who were on our knees, to participate fully, although we could hear what was being said. In the United States, during this time of the liturgy, priests stand and the rest of the assembly kneels. However, I wondered how to square this with another teaching that states that all members of the mystical Body of Christ are partners in the church's worship and mission. Does the fact that the Catholic Church, like some other Christian denominations, is a hierarchical one mean that the clergy participate in the liturgy in ways that are different from the rest of the assembly? Or does this disparity telegraph the

message that baptized members of the church are, in fact, divided into two classes?

Pertinent teachings from *Sacrosanctum Concilium* address the unity of the Body of Christ at worship in a Catholic congregation. "In [the liturgy], complete and definitive public worship is performed by the mystical body of Jesus Christ, that is, by the Head and his members. From this it follows that every liturgical celebration, because it is an action of Christ the priest and of his body, which is the church, is a preeminently sacred action" (SC 7). This means that the liturgy is celebrated by the congregation with its clergy. However, the more significant sentence in the Constitution reads, "It is very much the wish of the church that all the faithful should be led to take that full, conscious, and active part in liturgical celebrations which is demanded by the very nature of the liturgy" (SC 14). The Constitution also addresses the question of divisions in the assembly. "Liturgical services are not private functions but are celebrations of the church which is 'the sacrament of unity,' namely, the holy people united and organized under their bishops" (SC 26). How, then, does the environment for worship draw the congregation into the celebration of its own mystery as one Body of Christ?

The paschal mystery remembered refers to the incarnation, the life, the mission, the sacrifice, the passion, death, resurrection, ascension, and foretelling of the second coming of Christ. Theologian Ron Rolheiser explains that the Hebrew word for remembrance is *zikkaron*: "The idea is that a past event can be remembered, ritually recalled, in such a way that it becomes present again and can be participated in."[1] This anamnesis or memorialization is key to understanding why a twenty-first-century Christian congregation is invited to participate in the paschal event in an active and conscious manner. By fully engaging

1. Ron Rolheiser, "The Eucharist as Sacrifice" (March 18, 2001), http:// ronrolheiser.com/the-eucharist-as-sacrifice/#.XAfac8SZZTY.

in the enactment of the ritual (through body, senses, mind, and spirit), the participants plunge into and become one with the very paschal event they are remembering. It is not external to their being. They are one with it. This engagement sustains the identity of the church as the tangible Body of Christ here on earth. Theologian Thomas Rausch observed, "Thus, the Christian life becomes modeled on that of Jesus and his paschal mystery . . . it is particularly in the liturgy of the eucharist that we are drawn into and experience the saving mysteries of Christ's obedient life, suffering, death, resurrection, and ascension."[2] Rausch laments, however, that "regrettably, many Roman Catholics have narrowed the Eucharist to a celebration of Christ's sacramental presence, to an individualistic communion with him, while conservative Catholics talk about the 'miracle of transubstantiation." Rausch continues, "There is little sense of the liturgy as drawing us into the paschal mystery of Christ's passion, death, resurrection, and ascension to glory."[3]

This critique could be applied to the funeral mentioned above in which the liturgy appeared to be the almost private or personal prayer of the clergy while others watched and listened. Carrying out the role of a reader, a cantor, or a communion minister, or singing hymns, psalms, litanies, and acclamations is not enough to alleviate what is architecturally obvious—the laity are spectators. This is especially true at concelebrations at which only ordained men may distribute the Eucharist during the communion rite. The reduction of the laity to the role of spectators was something that Vatican II was particularly concerned to avoid. As the Constitution on the Sacred Liturgy states, "The church . . . spares no effort in trying to ensure that, when present at this mystery of

2. Thomas P. Rausch, *Eschatology, Liturgy, and Christology: Toward Recovering an Eschatological Imagination* (Collegeville, MN: Liturgical Press, 2012), 55.

3. Rausch, *Eschatology, Liturgy, and Christology*, 128.

faith, Christian believers should not be there as strangers or silent spectators" (SC 48).

The whole congregation is invited to participate, through the means of a ritual, in the paschal event or mystery that is already in existence. The assembly does not create the paschal mystery by means of its ritual making. Christ has no beginning or end. Nor is the liturgy the sole "work of the people," because Christ the priest is the main celebrant at every eucharistic liturgy, a gift of divine origin. The response to this sacred and free endowment is expressed when the assembly joins Christ in an offering to God and displays a willingness to work for the common good of all people like Jesus of Nazareth did.

For the sacrament of unity to be experienced during worship, participation in the liturgy must be inclusive. The "language" of the liturgy—ministries, texts, lyrics, art, movements, and architecture—is significant in this regard because it will either pull people together in the act of worship or it will separate them. Designer Kate Holmes spoke about the meaning of being "in or out" of the group in this way. "I took a look at the words 'inclusive' and 'exclusive,' and the root of both is *claudere*. It's Latin for 'to shut.'" Exclude is to shut out. Include is to shut in."[4] The environment for worship ought to invite and include everyone in the ritual action. At the funeral I described above, the allocation of space, albeit in a small, long, and narrow church, divided the congregation physically and psychologically. Consider that the same segregation is exacerbated in large cathedrals and churches in which only the clergy occupy the sanctuary or chancel.

It is possible, however, to create a worship environment in which everyone present for liturgy will recognize that they are participating in Christ's paschal event, which is theirs by baptism

4. Kat Holmes, in Mark Wilson, interview with Kat Holmes, "What You're Getting Wrong about Inclusive Design," *Innovation by Design* (April 4, 2018), https://www.fastcodesign.com/90166413/what-youre-getting -wrong-about-inclusive-design?utm_medium=email.

(SC 14). How is it done? First, it is essential just to show up to be with other Christians to praise God and agree to assume Christian responsibilities in the world. Second, it is important to listen to the Word of God, reflections, homilies, and personal testimonies about how to carry out the missionary work entrusted to the church. Third, inspired by the Word, the congregation gathers food for the hungry and brings ceremonial gifts to the holy table— bread, wine, themselves. Madathummuriyil refers to the wealth of signs and symbols that are in play during the liturgy. "The signification that is made in a particular liturgy is not the imagination of an individual or a group, but is the collective memory of biblical communities which is handed down through millennia, carried in text, rite and symbols."[5] He insists that all the members of the congregation are the "servants and guardians" of this pre-existing gift. This understanding of engagement with Christ's mission, Christ's paschal enterprise, is difficult to achieve when the liturgical act and the space set aside for it, in the words of Holmes, shut some people out.

What happens after the assembly brings their gifts to the table is also important. Seldom is the transformation of the congregation discussed. There have been many attempts to explain the transubstantiation of bread and wine, but little has been said about the substantial metamorphosis going on in the living Body of Christ standing there in church. Rolheiser observed, "What is supposed to happen at the eucharist is that we, the congregation, by sacrificing [giving up] the things that divide us, should become the body and blood of Christ."[6] This communal transformation unites the congregation as it worships God and seeks to mend the fissures in the church and society.

Renewed as the Body of Christ, the congregation grows in its understanding that its next task is to make possible the transfor-

5. Madathummuriyil, *Sacrament as Gift*, 269.
6. Rolheiser, "The Eucharist as Sacrifice."

mation of the world, especially those underprivileged, under-nourished, unclothed, unhoused, undocumented people. Active conscious participation in the eucharistic liturgy seals our relationship with God, an everlasting covenant. It also joins us to other creatures as well. Liturgical scholar Julia Upton considers this link as essential: "Because the liturgy is a living reality, it will always require attention so that the community can deepen its experience of the Lord [*sic*] and its service to the world." Upton continues, "Active participation in the liturgy, therefore, would result in active participation in society—especially serving the poor and most vulnerable."[7]

How does the congregation come to realize that its active, conscious participation in the paschal event is not expressed merely by engagement in a liturgical ministry? How can the church come to understand that worship of God *includes* works of social action? Jesus asked his followers if they could drink from the same cup he drank from (Matt 20:22). He dared them to accept the costs and risks of discipleship—a challenge we seldom hear in sermons. The writings of Mark Searle continue to be a sobering reminder of what participation in the liturgy means. Regarding the early liturgical movement of the nineteenth century, "its proponents saw it chiefly as a means for revivifying Catholic life and for preparing Catholics to take an active role in the reshaping of contemporary society."[8] Searle points out, however, that the two major Vatican II documents on the church (*Lumen Gentium*) and on Revelation (*Dei Verbum*) "failed even to mention the Church's sacramental and liturgical life. This omission meant that a sense of the intrinsic link between liturgy and social action was largely lost in the immediate postconciliar period."[9] In his work Searle understood participation in the liturgy

7. Julia Upton, *Worship in Spirit and Truth: The Life and Legacy of H. A. Reinhold* (Collegeville, MN: Liturgical Press, 2009), 98–100.
8. Searle, *Called to Participate*, 2.
9. Searle, *Called to Participate*, 11.

as an act that gives the church a foundation for social action, "bringing people to the liturgy so that they might be empowered to go out and change the social order."[10] That the Council did not emphasize this ministry strongly in the Constitution on the Sacred Liturgy either is one of the reasons why many, though not all, Catholics hear few homilies and reflections on the connection between worshiping God and working for justice. Some homilists are either unaware of these omissions or are simply afraid of challenging their congregations.

The difficulty of promoting participation in liturgical rituals to build up the common good is complicated by the strong strains of narcissism and individualism haunting and damaging societies everywhere. In a religious context, liturgical theologian Bruce Morrill's study on political and liturgical theology is useful. He describes the attitude of clergy and laity as a hindrance to grasping how the kingdom of God is realized on earth specifically in the church gathered for the eucharist. They "approach and perform the Eucharist on the basis of their own agendas." Morrill suggested that for most people the liturgy is dominated by an "eschatological *doctrine*." He wrote that worshipers are more concerned about their ultimate destiny (or their immediate problems) rather than about understanding the liturgy as an act that is "markedly differ- ent . . . independent, from their daily ways of thinking and acting."[11] Morrill's assessment affirms why the definition of a congregation as an egalitarian collective of people committed to the common good of society is a worthy ideal. The proposition that the liturgy and the worship environment might unify worship- ers (think of the liberals and conservatives in your congregation) will not make sense to people who are distracted by their own agendas. This was problematic for Peter Atkins, who studied how

10. Searle, *Called to Participate*, 12.

11. Bruce T. Morrill, *Anamnesis as Dangerous Memory: Political and Liturgical Theology in Dialogue* (Collegeville, MN: Liturgical Press, 2000), 105.

the brain operates as a memory bank during liturgical rituals and can influence the way people perceive what is going on in their midst. "The rise of the doctrine of the individual in which, in part, the individual scoffs at the corporate experience, and the failure to see the importance of corporate worship for the health of the total community, had led to a position by which symbols have lost their life-giving powers."[12]

I often think that most laity and clergy consider worship to be more of a personal act of devotion than a communal act of thanksgiving. The 1941 *Baltimore Catechism* urged Catholics to "assist at Mass with reverence, attention, and devotion" (No. 363). Little was mentioned at that time concerning the Eucharist as a transformational work of the whole congregation. Imagine hearing a homily on how active, conscious participation in the liturgy will cause a reshaping of your own life and that of others? Maybe some people do not understand the Eucharist as a change agent in their own lives or as a call to discipleship. However, here is an encouraging counterpoint. In their research about social group behavior Rachel E. Watson-Jones and Cristine H. Legare complemented the theories of Smith and Taussig, who investigated early Christian table customs. Watson-Jones and Lagare suggested that the performance of rituals can provide reliable markers of group membership, exemplify the loyalty of individuals to the group, advance cooperation with social coalitions, and increase social group bonding.[13] An egalitarian architectural setting for worship will manifest the equal stature of all members of the church. Standing together on common ground, they will shape and be reshaped by the liturgy. As the refreshed Body of Christ, they will tap into the strength of their partnership to heal and nourish the world.

12. Atkins, *Memory and Liturgy*, 106–7.

13. Rachel E. Watson-Jones and Cristine H. Legare, "The Social Functions of Group Rituals," *Current Directions in Psychological Science* 25 (2016): 42–46.

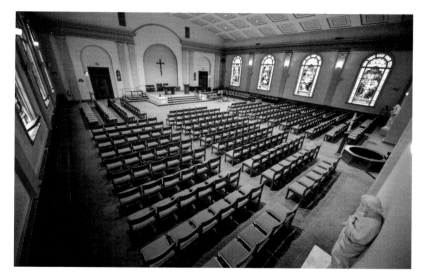

Figure 1: St. Vincent de Paul Church, Albany, NY. Before renovation.

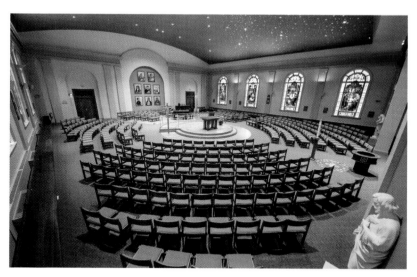

Figure 2: St. Vincent de Paul Church, Albany, NY. After renovation.
Liturgical Designer, Richard S. Vosko, Hon. AIA.

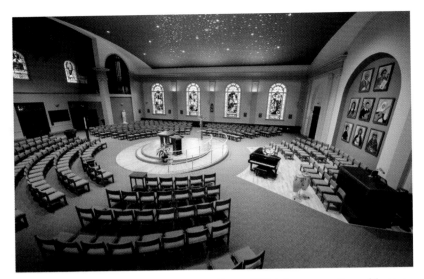

Figure 3: St. Vincent de Paul Church, Albany, NY. After renovation with new icons installation.

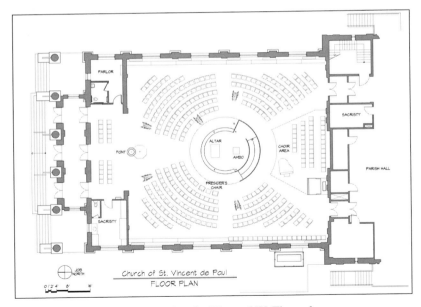

Figure 4: St. Vincent de Paul Church, Albany, NY. Floor plan.
Project Architect, Lacey Thaler Reilly Wilson LLP.

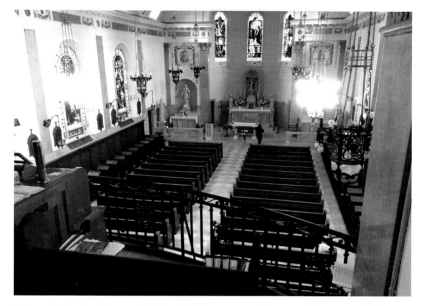

Figure 5: Butler Memorial Chapel, Marymount Convent, Tarrytown, NY. Before renovation.

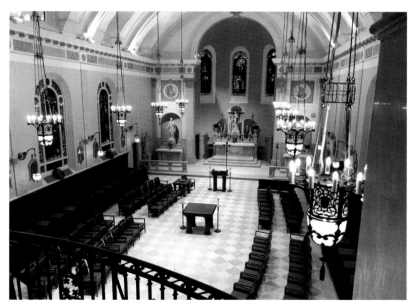

Figure 6: Butler Memorial Chapel, Marymount Convent, Tarrytown, NY. After renovation. Liturgical Designer, Richard S. Vosko, Hon. AIA.

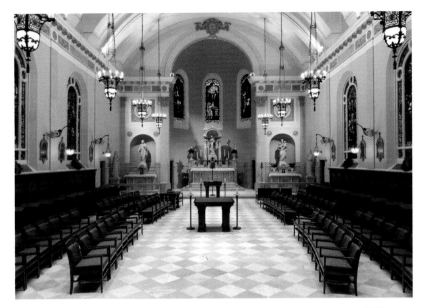

Figure 7: Butler Memorial Chapel, Marymount Convent, Tarrytown, NY.
After renovation.

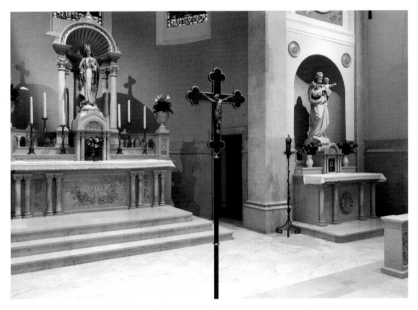

Figure 8: Butler Memorial Chapel Art Work, Marymount Convent,
Tarrytown, NY.

part three

Shaped by
What We Shape

14. Architecture for Worship: What Matters Most?

"What counts more than style is whether architecture improves our experience of the built world."
—Ada Louise Huxtable

Church interiors are pivotal in shaping the way people worship. A basic question about architecture for congregational worship is this: What matters most inside a church building? In the next chapter I will examine how church designs can help people worship God who is both immanent and transcendent.

What Matters Most? It is clear that much of the discussion surrounding the environment for worship focuses on what style of art and architecture is more suitable for liturgical practice. This is a prickly question not only for pastoral leaders but also for those design professionals who specialize in religious architecture. One assumption is that the interior of an edifice must complement the external form architecturally and artistically. A purist might argue: "Victorian on the outside means Victorian on the inside." Another perspective, the one I adhere to, would applaud the incorporation of traditional design principles into a contemporary liturgical church building. This approach would prompt a dialogue between different periods of architectural history and modern lifestyles.

In liturgical terms the interior does matter. It matters even more than the exterior. Certain styles of architecture will shape the aesthetic feel of the space as well as the ritual performance of the sacraments. The worship experience will be vastly different

depending on the location of the altar table and ambo vis-à-vis the seating plan for clergy and laity. In a Neo-Gothic building, for example, to be true to a Gothic floor plan, the interior would include a longitudinal nave, perhaps with transepts. The sanctuary would be at the apsidal end of the building, a traditional location for the choir, altar, and clergy.[1]

A structure with Neo-Classical or any other distinctive stylistic features, however, does not necessarily have to be long, narrow, and unidirectional. For example, it could be designed like a rotunda where the altar table could be placed beneath a central dome or oculus. The entire assembly, clergy and laity, would then be arranged around the altar beneath the symbolic "eye of God." The nave and sanctuary spaces would be combined into a common ground for worship. Realistically, there is no reason why the interior of any church, traditional or Post-Modern in style, could not be arranged to draw worshipers fully, consciously, and actively into the ritual action as celebrants of the paschal mystery that belongs to them. The alternative plan is to create a long and narrow nave in which the seats all face in one direction, making it impossible for worshipers to see the presence of Christ in each other's faces.

Historically, churches in the United States are built in a variety of forms. To be clear, I am not suggesting that any of these structures should be shuttered or demolished because of their styles. Some people will always be more comfortable in a "traditional" church in which the sanctuary is at one end of the space and in which the liturgy is enacted for them. And they have a right to seek them out. What is interesting is the rising trend of reordering churches that were modified years ago in the spirit of Vatican II. It is justifiable to update a building in terms of its materiality,

1. In many Gothic churches in the European Union the altar has been relocated to the crossing, where the transepts meet the nave.

utilities, or embellishments. It is harder to comprehend why a second reordering recasts the building into a preconciliar layout that introduces older architectural and artistic accretions that either were never there, or may have been removed once before. Further, curiously, newer places of worship are being designed in more "traditional" forms. Three recently completed cathedrals are examples of this trend. The Cathedral of the Holy Name of Jesus, Raleigh, NC (2017) is described as Romanesque Revival. The Cathedral of the Sacred Heart of Jesus, Knoxville, TN (2018) is referred to as Renaissance Revival. The Co-Cathedral of the Sacred Heart in Houston, Texas (2008) has an eclectic design. Although this building is classified as Post-Modern, it is a mélange of Italian Romanesque and Neo-Gothic features. The interiors of these buildings are laid out in a pattern in which the sanctuaries and naves are distinct sections separating clergy and laity during the liturgy. In these buildings, and especially during a concelebrated liturgy, the clergy will stand around the altar table while the laity kneel and watch the ritual performance. Of course, congregations are free to construct these types of worship spaces if they wish. The important question is why this trend is occurring at this point in our history.

The penchant for such ancestral forms might be a nostalgia for traditional buildings, an interest in creating spaces to house a more traditional liturgy, or both. After all, many people in the United States do listen to "oldies" music, watch classic black-and-white movies, and collect antiques. Why shouldn't they favor older church buildings? Jeanne Halgren Kilde, who researches religious architecture, sees this inclination as a strain between formalism and nonformalism both in ecclesiological and liturgical terms. She wrote, "For these traditionalists, the replication and reinterpretation of [for example] Roman architecture in particular signals an appreciation for a traditional Rome-centered faith and leadership." Halgren Kilde refers to this preference as a debatable one and says that "the question of just what it means to 'revive' a historical style

is far from clear."[2] In a different opinion, Archbishop Weakland wrote that some church leaders have interpreted the desire for traditional forms as a rejection of *anything* that is modern, whether it is music, art, dance, poetry, or architecture. Further, and on another level, the attraction to older forms of worship could signal a repudiation of the post–Vatican II liturgical reforms.[3]

Admittedly, however, it is a challenging task to modify an older house of worship without destroying the innate architectural and artistic style of the building. Making the transitions in a church that has strong architectural forms and artistic features will require sensitivity and imagination. The need to reorder them is important because they were originally built for rituals that are no longer universally practiced (unless, of course, the congregation favors a form of liturgy that was once abrogated but now has been authorized for use). In her study of eleventh-century English churches, medieval historian Helen Gittos wrote, "functional requirements can result in different architectural solutions; architectural motifs may be retained, and their functions modified, even when they have lost their original purpose; the liturgical ideal may not coincide with architectural reality, especially where older buildings are adapted."[4] Halgren Kilde regards churches as dynamic and powerful Christian spaces when she writes, "Buildings are not static. Congregations alter and remodel their buildings to address changing social or liturgical requirements, changing understandings of the worship and its role in the Christian life, changing technological advancements, changing trends and styles." [5] These two perspectives, on eleventh- and twenty-first-century churches

2. Jeanne Halgren Kilde, *Sacred Power, Sacred Space* (New York: Oxford University Press, 2008), 196.

3. See, for example, Weakland, "The Liturgy as Battlefield," 12.

4. Helen Gittos, "Architecture and Liturgy in England ca. 1000: Problems and Possibilities," in *The White Mantle of Churches*, ed. Nigel Hiscock (Turnhout: Brepols, 2003), 91.

5. Halgren Kilde, *Sacred Power, Sacred Space*, 200.

respectively, pinpoint the tensions surrounding the reordering of churches designed in a different age to accommodate a liturgical practice that has changed and will continue to evolve in the future. As theologian Gilbert Ostdiek once remarked, "Liturgical space is not . . . an inert object; it is a 'lived space.' It is an integral part of the complex symbol system of ritual enactment."[6]

The interior of a church building is more significant in a conversation about architecture for congregational worship because it has the express purpose of housing a liturgical performance. Paul Goldberger, former architectural critic for *The New York Times*, offers this viewpoint: "To think of buildings only in terms of exterior shape, materiality, lines, color and relationships to nearby buildings is to overlook other dimensions." He continued, "Whatever form it takes, interior space will almost always provoke a greater emotional response than the outside of the building does."[7] Employing Goldberger's observation, one can assume that what ultimately matters most to human beings is not the physical environment but the events that take place there, the relationships formed there.[8] A church may be a beautiful backdrop for a wedding, but it is the celebration of a marriage contract between two human beings that is momentous. Interior spaces of church buildings can establish and reinforce the covenantal relationships between God and humanity. They can also link people to one another in solidarity. Regarding these experiences, architect Jeanne Gang understands the built environment in terms of creating or improving relationships. "What are the opportunities for

6. Gilbert Ostdiek, "Architecture and Space," paper presented in the Liturgical Hermeneutics Seminar of the North American Academy of Liturgy, January 8, 2016.

7. Paul Goldberger, *Why Architecture Matters* (London: Yale University Press, 2009), 111.

8. See, for example, the classic work by Christopher Alexander, *The Timeless Way of Building* (New York: Oxford University Press, 1979), 62.

people to interact? How can buildings spark new relationships?"[9] Although the reordering of older churches presents a challenge to the imagination, there are ample opportunities to design all places for worship in ways that will bring people together. The willingness to take some artistic and stylistic risks is an important facet of this undertaking. The construction of a new church provides an opportunity for architectural and liturgical innovation.

9. Vladimir Belogolovsky, interview with Jeanne Gang: "Without an Intellectual Construct Life is Boring," *ArchDaily* (November 2016), https://www.archdaily.com/798677/jeanne-gang-without-an-intellectual-construct-life-is-boring.

15. Architecture for Worshiping God Here and There

"Architecture is not a static building—it's a living organism."
—Balkrishna Doshi, 2018 Pritzker Award Recipient

God Here and There. The second perplexing question about post–Vatican II architecture has to do with worshiping God who, mysteriously so, is thought to be both here and there, present and absent. Some commentaries claim that more contemporary settings for liturgy, especially those with centralized plans, highlight the assembly's involvement in the ritual. The argument is that the true focus of a church building should be a unidirectional one in which the congregation's gaze is oriented to an area that symbolizes a heavenly city, the eschatological destination for the worshipers. The use of dualistic language (discussed in an earlier essay) to describe where God dwells is no longer adequate unless one wishes to dwell solely in the world of religious imagination. Binary opposite terms do not nurture a more relational, less iconographic experience with an incarnate God who continues to shepherd all human beings and creation at large. Studies show that church goers are looking for liturgies, music, and sermons that help them develop or restore relationships.[1] Younger

1. See, for example, the Pew Research Center (http://www.pewforum.org /religious-landscape-study/), the Public Religion Research Institute (https:// www.prri.org), Barna Group (https://www.barna.com), and the Hartford Institute for Religion Research (http://hartfordinstitute.org).

generations are seeking transformative experiences that give them a sense of hope, purpose, and belonging. It is debatable that both a traditional and a contemporary liturgy can satisfy these yearnings in the same way.

Some Christians rely on metaphorical language to describe the church building as the people of God, living stones, who are visible signs of an invisible heavenly household. In a very imaginative way the stories of the Bible begin in a fruit-filled garden and end in a splendid city. However, there is no temple in either place—only God's people. One could argue that a large number of churches on this planet are inadequate resemblances of what the City of God might look and feel like. Is the eternal megalopolis comparable to an elaborately decorated mansion? Would a simple house serve as a better model of heaven? Are the biblical references to the eternal city taken too literally? There is, after all, an imbalance in the quality of church architecture almost everywhere in the world. Some houses of worship are extraordinarily finished with expensive materials purchased and shipped from distant sources. Other churches might be constructed more simply, using environmentally friendly materials produced and delivered locally. Perhaps more attention needs to be given not to "temple" construction but to the building up of a radiant people of God.

Questions about God, being, and nature provide a different perspective regarding church architecture as a place for sacramental engagement. A place of worship confirms a community's partnership with an incomparable, ineffable God in everyday life. Mircea Eliade (1907–86) wrote, "Life is not possible without an opening toward the transcendent . . . human beings cannot live in chaos."[2] Worshipers are not spectators in the ever-evolving unfinished cosmic enterprise but actors, coworkers with God and one another. Realizing that we are one with creation, we might

2. Mircea Eliade, *The Sacred and the Profane: The Nature of Religion* (New York: Harper Torchbooks, 1959), 34.

assume more responsibility for saving the "only home we know." The worship of God, an act of sacrifice and thanksgiving, is carried out through a ritual action. The entire congregation enacts this liturgy; not just a few. This gathered cohort, by definition, is already the substantial Body of Christ because of its baptism. The liturgy may continue to transform the assembly, inspiring it to work for justice or reconcile itself with others. However, liturgy is not a quantifiable vessel of grace that is delivered to the worshipers by mediators as if they, the members, were not blessed or chosen for a purpose beforehand. Liturgical rituals are affirmations that something holy and extraordinary is already going on in the life of an individual and a community. Worshiping together raises the awareness of these epiphanies that border on God. Congregants who are inclined to selfishly nurture only their own lives will not want to share their blessings with others who live on the fringes of their communities. The mission of a Christian church is precisely to make the city of God resplendent on earth. The worship of God urges social action.

How do these various understandings of God's nature and role in human life play out in church buildings? If God is considered solely transcendent, then the main architectural and artistic focus in a church building might be remote. The altar, ambo, and presider's chair (or cathedra) will be placed somewhere outside the space set aside for the rest of the assembly. The congregation will have to reach for the ideal city of God outside their own reality. On the other hand, if God is considered more immanent, the focus will be on the very Body of Christ gathered around the altar to enact the rites with their clergy. A church building can resonate with both theologies that assert that God is immanent and transcendent at the same time. The goal is to understand the interior spaces of a church—narthex, nave, sanctuary, chapels—as relational and not divisive, regardless of the building's architectural and artistic style. Theologian Mark Torgerson explained, "Modern church architecture . . . may one day be remembered for the significant role it played in the facilitation of a renewed sense of

the holy God dwelling actively in the midst of people engaged in worship and ministry."[3]

Can there be a common ground? In his comprehensive assessment of contemporary church architecture, theologian and architect Bert Daelemans called for a dialogue between theology and architecture. He wrote that "architecture asks questions that theology is eager to answer . . . and theological questions are often answered by architecture." [4] His methodology is a positive way to observe and evaluate how church buildings create space for encountering the holy One at the same time they serve as functional settings for worship and social outreach. Regarding the discourse over houses of worship that do or do not create a sense of transcendence or immanence, Daelemans suggests that "both aspects of revelation (beyond/within) should not be disconnected, because the Mystery is revealed *for* people."[5] But how exactly is this mystery experienced?

In 2011 a symposium called "Transcending Architecture" was held at The Catholic University of America. A number of theologians, architects, and design professionals offered a variety of opinions on how the built environment and elements within it can generate a liminal or numinous experience. Julio Bermudez, professor of architecture at the university and organizer of the Walton Critic program,[6] reminded the participants that "arriving at the numinous means to have transcended our ordinary state of consciousness and, not surprisingly, the ensuing experience is so

3. Mark A. Torgerson, *Architecture of Immanence: Architecture for Worship and Ministry Today* (Grand Rapids, MI: Eerdmans, 2007), 205.

4. Bert Daelemans, *Spiritus Loci: A Theological Method for Contemporary Church Architecture* (Leiden: Brill, 2015), 2.

5. Daelemans, *Spiritus Loci*, 89.

6. The symposium is part of the long history of the Walton Critic Program organized by the School of Architecture and Planning at The Catholic University of America. It is sponsored by the Clarence Walton Fund for Catholic Architecture in honor and memory of the late Clarence C. Walton, who served as the university's first lay president.

powerful and profound as to cause an enduring transformation
. . . since those who have tasted the transcendent are never quite
the same again."[7] Bermudez argues that the built environment
has the *potential* to create experiences that are extra-ordinary. He
stresses that design professionals must consider studies that deal
with subjective, sensual responses from peers, clients, and others.
However, critics of contemporary church buildings continue to pose
a lingering question: Are modern churches suitable for Catholic
worship? Can they trigger the liminal experience Bermudez re-
ferred to?

There are different opinions about when the Modern period
started and ended. It is generally defined as a late nineteenth to
early twentieth-century movement influenced by advancements
in other disciplines such as the arts, medicine, and science. For
those in the business of architecture, the idea was to break away
from a prevailing emphasis on decorative characteristics in a build-
ing and to focus on functional design solutions. This would not
be an easy task. According to architectural historian Carole Rif-
kind, "Resisting the advances of modernism, traditional design
stubbornly survived the forties and early fifties. A taste for the
familiar was shared by clients who yearned for a return to nor-
malcy after World War II."[8] Gretchen Buggeln, who studied the
development of churches in postwar suburban United States, dis-
agrees. "Modernism in church architecture had its beginnings well
before the postwar period."[9] She would argue that the impetus
started with European architects in the 1920s who were already

7. Julio Bermudez, "Le Corbusier at the Parthenon," in *Transcending
Architecture: Contemporary Views on Sacred Space*, ed. Julio Bermudez
(Washington, DC: Catholic University of America Press, 2015), 89–90.

8. Carole Rifkind, *A Field Guide to Contemporary American Architecture*
(New York: Dutton, 1998), 55.

9. Gretchen Buggeln, *The Suburban Church: Modernism and Community
in Postwar America* (Minneapolis: University of Minnesota Press, 2015),
4. Buggeln reminds readers that the Unity Temple in Chicago by Frank
Lloyd Wright was completed in 1908.

designing new church buildings in revolutionary ways. A good example of what Buggeln is referring to would be Chicago architect Barry Byrne (1883–1967). He was ostracized by some church leaders for his modern Catholic churches such as St. Thomas the Apostle, built in Chicago in 1922.[10] He was not alone. Other architects, such as Louis Sullivan (1856–1924), Frank Lloyd Wright (1867–1959), and Eliel Saarinen (1873–1950), already were breaking the classical mold by designing churches and other buildings in the modern style. In a lecture at the Cushwa Center at the University of Notre Dame, Buggeln suggested that immediately after World War II there was a growing consensus that the art and church architecture of the previous generations were derivative and inauthentic. "This is more intense than simply not liking the fashions of one's parents and grandparents"[11] By the late 1950s, she said, even people in the pews were joining architects and artists to suggest that the recent past's reliance on Gothic styling was 'wrongheaded.' " Buggeln continued to emphasize, "For a worship space to succeed, it needs to support the particular ritual of the denomination." A design needs to be "convenient and meaningful to the congregation as they move their attention to different points of focus in the worship service."[12] Buggeln's observation makes sense when thinking about creating places of worship in a post–Vatican II era. Where should the focus of attention be in order to facilitate the participation of the entire congregation?

Liturgical historian Keith Pecklers added another viewpoint about the expectations of some Catholics regarding the style of church buildings in the 1950s. "Like the modern art movement, the modern architectural movement was a revolt against false architecture that blended assorted architectural styles into one or attempted

10. See Vincent L. Michael, *The Architecture of Barry Byrne: Taking the Prairie School to Europe* (Chicago: University of Illinois Press, 2013).

11. Gretchen Buggeln, "Art, Architecture, and Liturgical Space in Postwar America," in *Newsletter*, Cushwa Center for the Study of American Catholicism, University of Notre Dame (March 2015), 2.

12. Buggeln, "Art, Architecture, and Liturgical Space," 3.

to imitate historical styles of the past—the Neo-Classical, and Neo-Gothic revivals, for example, which had separated architecture from the life of the community."[13] Pecklers's remarks support what has been for a long time obvious to architects, liturgical scholars, and pastoral leaders. They acknowledged the need for the church to gradually let go of architectural settings that were appropriate in a different age for an older form of worship.[14] There are some, however, who do interpret the post–Vatican II "spirit of the liturgy" in a different way and continue to favor more traditional churches and liturgical forms. Architectural critic Sarah Williams Goldhagen explained why there is a continued bias for older building styles: "developers create plans based on what they think the client wants mainly by looking at past preferences. Consumers gravitate toward conventional (boring) designs without thinking very much about them. . . . No one steps back to consider what might serve people better, what people could like or what they actually might need."[15] What is required to help people look forward and not always at what they see in the rearview mirror?

In the field of architecture some historians continue to view the Modern period in glowing terms. Critic Katherine Allen wrote, ". . . modernism came out of a great excitement and joy for the future. . . . With new solutions popping up every day, the future must have seemed almost impossibly bright."[16] Others say the Modern style of architecture is now out of vogue. They are even

13. Keith F. Pecklers, *The Unread Vision—The Liturgical Movement in the United States of America: 1926–1955* (Collegeville, MN: Liturgical Press, 1998), 235.

14. See Jay M. Price, *Temples for a Modern God: Religious Architecture in Postwar America* (New York: Oxford University Press, 2013).

15. Sarah Williams Goldhagen, *Welcome to Your World: How the Built Environment Shapes Our Lives* (New York: HarperCollins, 2017), 40.

16. Katherine Allen, "This Week in Architecture: What Does Modernism Mean Today?" (October 28, 2018), https://www.archdaily.com/904726/this-week-in-architecture-what-does-modernism-mean-today?utm_medium=email&utm_source=ArchDaily%20List&kth=768,573.

moving beyond what has been referred to as a Post-Modern style. Columnist Nicolas Kemper reported on current directions in architectural education: "Postmodernism—an affinity for patterns, colors, basic forms, for ironically quoting history by including, say, a non–load bearing arch or an unnecessary pediment—seemed like a non-sequitur, given our precise moment in history."[17] Kemper was reporting on the frustration among some architects concerned about global problems. They are looking for ways to breathe new life into their professions, to find credible and creative ways to shape how the world looks today.

One can see a comparison with the field of religion. The old way of doing things is no longer working. And a new model is not yet firmly in place. The brighter side of the situation is this: We are in a period of church and architectural history where the research and remarks offered by researchers and practitioners in allied fields offer compelling arguments for exploring new possibilities that stretch the imagination beyond convention. Liturgical scholar Mark Wedig, in commenting on the search for new theological approaches to "divine presence," wrote, "Postmodern theologians especially look for where the persuasiveness and eloquence of symbol, ritual, and language occasion meaningful and poignant truths that are revealed aside from or even through the din and pandemonium of hyperreal display."[18] In his perceptive review of different authors and architects, Wedig concludes, "Humility in design, not hubris, is the religious and architectural answer to the frightening and overwhelming forces of contemporary culture."[19]

17. Nicolas Kemper, "The Postmodern Revival in School Has Architectural Deans Worried: Are Their Fears Well Placed?" (November 19, 2018), http://commonedge.org/the-postmodern-revival-in-schools-has-architecture-deans-worried-are-their-fears-well-placed/.

18. Mark Wedig, "Ecclesial Architecture and Image in a Postmodern Age," in *Transcending Architecture: Contemporary Views on Sacred Space*, ed. Julio Bermudez (Washington, DC: Catholic University Press, 2015), 132.

19. Wedig, "Ecclesial Architecture and Image," 142.

Architects and clergy, who represent two of several influential professions in the world today, need to heed this advice.

The specific challenge for church designers is to learn to incorporate time-honored architectural features into the creation of new places of worship. What a church looks like from the outside is important to many. However, it is precisely the *interior* plan that will shape the way the liturgies are performed by a group. Rituals celebrated in an artful manner become thresholds (limens) to the numinous and, therefore, sources of transformation. Placing a strong emphasis on the symbols employed in the performance of rituals (water, oil, fire, bread, wine, movement, language) will mean less reliance on the nonessential architectural and liturgical accretions that continue to characterize some older church buildings and liturgical celebrations.

16. Tracking Architectural Styles

"Architecture should be able to excite you, to calm you,
to make you think."
—Zaha Hadid

What are the defining elements in a house of worship that shape the ways a congregation can engage in their rituals and experience transformation? In order to answer this question, it is worthwhile to trace the development of what might be referred to as more conventional or traditional architectural styles and to consider why some congregations prefer these forms. Although I am focusing on contributions in the Western world, I am mindful of the magnificent civic and religious buildings constructed in various Eastern and Far Eastern civilizations. There are also superb sites built over time on the African continent, such as those in Egypt or Zimbabwe, as well as the almost mystical settlements and temples along the Mayan, Incan, and Aztec routes in Mexico and South America. These histories are too massive and complex for even a concise treatment in this book. Suffice it to say that those structures provided people with a sense of mystery, beauty, scale, proportion, light, and harmony. Basically, these are the very ingredients that some church leaders and architects say should be incorporated in church design today. I agree.

Tracking the Evolution of Style. Most churches and cathedrals in the United States today were constructed by Catholics who had migrated there from various places during the nineteenth and

twentieth centuries. Assimilation was difficult and these Catholics faced prejudice and hostility from the dominant culture. They were, nonetheless, determined to pitch their tents. They raised the money and, in some cases, they built churches, cathedrals, and schools with their own hands. The architectural style and artistic interiors of the churches were replicas of those in their homelands. These reproductions were helpful as people sought to retain some of their traditions while settling in a new country. Whatever their other merits or drawbacks, these houses of Christian worship provide us with textbook examples of diverse architectural styles. They include Colonial, Mexican Baroque, Neo-Gothic, Zopfstil, Romanesque Revival, Greek Revival, Art Deco, Bauhaus, and the Modern style, to name a few. Today, although the American Christian population is much more mixed in terms of ethnicity and race, the historic and "revival" versions of the Gothic, Romanesque, Classical, Victorian, and Mission styles, with little exception, still dominate the ecclesial landscape.

What are the foundations from which the so-called traditional architectural styles emerged? Innumerable scholarly and practical sources concerned with the principles of architecture are well known. Pythagoras (570–495 BCE) reduced everything to numbers. Euclid (ca. 300 BCE) devised computations to be used in construction. Both Plato (428/427 or 424/423 BCE) and Aristotle (384–322 BCE) thought of architecture in terms of a practical art form that contributed to the common good. However, the most recognizable contribution in Western cultures belongs to the Roman architect and engineer Marcus Vitruvius Pollio (ca. 80–15 BCE). He emphasized three essential characteristics of Greek and Roman architecture—stability, function, and beauty. He also outlined the significance of symmetry, order, arrangement, propriety, economy, and harmonious proportion.[1] It would be hard for any

1. Marcus Vitruvius Pollio, *The Ten Books on Architecture*, trans. Morris Hicky Morgan (New York: Dover, 1914).

architect familiar with history to refute these principles. They have influenced building designs for centuries. The innovative designer will find that these factors are still useful in a contemporary context. In fact, art historian E. H. Gombrich has claimed that people of all generations are somehow innately attracted to these particular rhythms, orders, and harmonies. Others would argue that Gombrich's sweeping inference needs to be modified to take into account diverse cultural roots and individual habits.[2] In a religious context there will also be different ways to perceive a work of art, music, architecture, and literature due to the customary devotional expectations of an individual or group.

Each age has had its different architectural and artistic movements and revivals that would influence the design of churches and the worship rituals in them. The basilican style of church construction, modeled on the public buildings of ancient Rome, was pretty much standard for the first millennium of Christianity. The heavier, fortress-like pre-Romanesque (for example, Carolingian) and Romanesque styles emerged after the fall of the Roman Empire and prevailed between 700 and 1100 CE. From at least the mid-twelfth century onward,[3] the luminous Gothic style and its regional variations materialized and generally was considered the norm up to the beginning of the sixteenth century. Stone masons built these places during the medieval period, but it is hard to know who actually designed abbeys, schools, and churches.[4] During that period interest in returning to more classical styles grew in some provinces and stirred a rebirth in all of

2. See "The Sense of Order: An Exchange," in *The New York Review of Books* (September 27, 1979), http://www.nybooks.com/articles/1979/09/27 /the-sense-of-order-an-exchange/.

3. Some historians claim that the first Gothic cathedral was constructed in Noyons, north of Paris, in 1140.

4. Historians do mention the work of medieval architects such as Master James of St. George (1230–1308), the Norman monk Gundolf (?–1108), Robert de Bellême (1052–1130), and Henry Yeverley (1325–1399).

the arts. Filippo Brunelleschi (1377–1446) is probably the best-known architect from the Renaissance school. He too stressed harmony, proportion, and human scale. Andrea Palladio (1508–1580) employed the symmetry, perspective, and proportions found in ancient temple architecture.[5]

From the sixteenth through the eighteenth centuries other architectural styles surfaced in the midst of growing tensions on the religious front. During this period the power and influence of the Catholic Church was challenged by Protestant Reformers. A Catholic Reformation was launched with the Council of Trent (1545–1563) to restore a sense of unity and its authority. Contentious and bloody conflicts would further divide the Christian church throughout all of Europe. Toward the end of this era a socio-religious-political environment emerged out of the rubble. One development in the seventeenth and eighteenth centuries was the emergence of a new architectural and artistic rhetoric. The decorative and theatrical styles of the Baroque and late Baroque (Rococo) periods was representative of a movement away from the previous eras and especially the orderly Classical period. In an effort to maintain an image and presence in society, the Catholic Church saw value in building more churches. It, too, would move away from the age of the Renaissance and adopt the Baroque and Rococo styles in its churches and palatial properties. Intricate and flamboyant places of worship were lavishly decorated with paintings and sculptures throughout, but the focus of attention would be the ornate high altar. Obviously, these churches and the liturgical performances in them were a far cry from the simplicity of the early Christian house churches and the eucharistic table customs that were observed inside.

Augustus Pugin (1812–1852) favored a return to the Gothic style, which, for him, was a way to recapture the faith and societal

5. Andrea Palladio's *The Four Books of Architecture* stressed beauty and perfection in buildings and influenced architects throughout Europe in the sixteenth and seventeenth centuries.

organization of the Middle Ages. Art critic John Ruskin (1819–1900) published his seven "lamps" of architecture—sacrifice, truth, power, beauty, life, memory, and obedience. The implications for church art and architecture are apparent in Ruskin's treatise. For example, when writing about "truth," he challenged designers to avoid architectural deceits or faux architecture. He warned against "the painting of surfaces to represent some other material than that of which they actually consist (as in the marbling of wood), or the deceptive representation of sculpted ornament upon them."[6] Bernard of Clairvaux had practiced this same counsel in the twelfth century. He deplored the rich appointments in non-Cistercian churches as well as the sculptural adornment of monastery chapels.

Other architectural styles in the Western secular world would emerge between the seventeenth and twentieth centuries. The styles are diverse and geographically widespread. Whatever liturgical customs emerged in one locale or another most likely took place in churches that were hierarchically arranged, that is, with the sanctuary at one end of the space. In some buildings rood screens erected at the crossing would separate the choir and chancel from the nave. New churches, regardless of a particular architectural style, would accommodate the liturgical practice customary in that region. This was the case up to the nineteenth-century liturgical movement. The pioneering enthusiasm for recovering the early roots of Christian liturgy would lead to a gradual but growing interest in reshaping the environment for worship with more attention given to the place of the congregation.

For centuries church buildings, which in some cases were monumental references to a heavenly kingdom, shaped the imagination of the laity, who watched the clergy enact mystical rituals within them. Today, more contemporary styles of churches are shaping

6. John Ruskin, *The Seven Lamps of Architecture* (New York: Dover Publications, 1989), 35.

different behavior patterns by placing more emphasis on worship as a ritual performance carried out by the entire assembly. It may be true that many modern churches lack the scale, proportions, and beauty engineered by architects and artisans of old. The challenge is to find ways to synthesize old forms and new ones. We no longer live in the Middle Ages, or in the Renaissance or Baroque periods, but some church buildings and liturgical practices make us think we do. As Halgren Kilde reminds us, "Modern churches distribute social power between clergy and laity, requiring the faithful to take much greater responsibility for their own religious experience and understanding than in previous generations."[7] Her commentary reinforces the instructions on worship that emerged from Vatican II and the postconciliar liturgical reform. It also applauds the efforts of many congregations to understand what their active role in the liturgy is and how it shapes their behavior in the public square.

7. Halgren Kilde, *Sacred Power, Sacred Space*, 191.

17. Hidden Dimensions in the Built Environment

"We shape our buildings, thereafter they shape us."
—Winston Churchill

A wide variety of architectural styles and building layouts shape the liturgical patterns of congregations in certain ways. There are also less obvious and more subliminal factors that affect the ways a congregation performs its worship rituals. It would be impossible here to summarize all the neuroscientific research that deals with human beings as embodied, active participants in any situation. Here is just a brief review of three different dimensions of this area of study.

Proxemics. Edward Hall (1914–2009) is credited with coining the word "proxemics," a study of the human use of space. It is an important consideration when designing churches intended to draw the assembly more fully into their ritual performances. Hall based his work on the earlier research of the English psychiatrist Humphry Osmond (1917–2004), who studied the long-term effects of institutionalization. Osmond applied the term "socio-architecture" to improve patient settings. Most designers are familiar with research that shows how different spatial arrangements affect adult behavior.[1] A "sociofugal" layout is one that

1. See these classic works: Humphry Osmond, "The Relationship Between Architect and Psychiatrist," in C. Goshen, ed., *Psychiatric Architecture* (Washington, DC: American Psychiatric Association, 1959); Edward Hall,

groups people together in one direction but allows them some privacy. This layout is no longer the norm in most educational settings. Educators are generally critical of lecture halls that are designed so that the entire class is seated facing the instructor. They claim that students learn better through action and interaction than they do by hearing or seeing an instructor. The idea, in educational theory, is to "create an environment in which students actively participate in class."[2] By analogy, a unidirectional seating plan in a church has come into question by church leaders interested in promoting participation in the liturgy. One alternative seating plan is "sociopetal," a more circular, semicircular, or antiphonal layout where people can interact and see one another. There is also less room to hide. Many adult educators see this plan as a more effective environment for learning.[3] I would contend that if worshipers are expected to engage actively in a communal act of worship the sociopetal arrangement of space is more suitable. It is a plan in which the location of the altar and ambo is in the midst of the assembly and draws everyone into the ritual performance as participants and not as spectators. This approach will not necessarily suit people who understand the public worship of God as a private matter or who yearn for an experience of liturgy that resembles private devotion.

Distance Zones. Distance factors also play a role in stimulating the participation of the congregation. How far away from the liturgical focal points is too far, before it is impossible to participate actively and fully in the ritual performance? When someone in a

The Hidden Dimension (Garden City, NY: Doubleday, 1966); Robert Sommer, *Personal Space* (Englewood Cliffs, NJ: Prentice-Hall, 1969).

2. See Rhett Allain, "The Traditional Lecture is Dead. I Would Know— I'm a Professor," *Wired* (May 11, 2017), https://www.wired.com/2017/05 /the-mechanical-universe/?mbid=nl_51217_p2&CNDID=48596675.

3. Richard S. Vosko, "Where We Learn Shapes Our Learning," in *Creating Environments for Effective Adult Learning*, ed. Roger Hiemstra (San Francisco: Jossey-Bass, 1988): 23–32.

leadership role is as close as 12–15 feet (3.65–4.57 m) away from the first row of participants, that "actor" must be mindful of his or her choice of words, the phrasing of sentences, and grammatical and syntactic shifts in voice. At 15–18 feet (4.57–5.5 m) away a speaker will begin to lose physical clarity and appear flat to the assembly. The farther away someone is from the point of action the more likely that person will become a spectator. Although churches are not theaters, they are places in which everyone should be able to see, hear, and move about during various rituals without hindrance. In theater design the best seats are about sixty feet (18–19 m) away from the stage. A sloped or tiered floor would provide better sightlines than a flat one, although this structural provision is not always feasible in every church.

The use of cameras, screens, video monitors, microphones, and sound systems have changed the way people relate to one another within worship. The long-term effect of such technologies on the liturgical experience in any congregation is still undocumented. The emerging nondenominational churches that employ such equipment have been effective, however, in attracting new members. Perhaps the act of going to church is not the only way to have a "liminal" experience. The entertainment industry has become quite proficient in providing transformative encounters, whether in a concert hall, sporting venue, theme park, or online.

If worshipers are expected to engage attentively in a liturgical act, no one should be seated more than 60–70 feet (18.28–21.34 m) away from the altar, ambo, and where the leader of the liturgy is positioned. In churches with seating capacities of one thousand or more, a concentric seating plan will bring more worshipers closer to the center than even a semicircular one. It will also include space for the assembly and other different ministries. In contrast, where there are very enormous congregations, an elongated nave will drastically reduce their experience of involvement in the liturgy.

Perception. Another often overlooked dimension of church design is related to the way we use our senses to engage with the

built environment, the ritual action, and others in the space. As Gernot Böhme poetically notes, "one walks into a church, perhaps off the road or from a sunlit square and is enveloped by a holy twilight or a timeless silence or a cool crypt air."[4] Sadly, for a long time in many Western societies, only two senses—seeing and hearing—have been prized. Touch, taste, smell, balance, and other psychosomatic sensors are considered minor receptors in helping people embody what is going on around them. Yet, all of our sensory experiences in worship are important. The holistic use of as many senses as possible, combined with our memories and imaginations, will help us perceive the architectural and artistic setting for worship as well as the liturgical act.[5]

A sensual experience in one part of the body might even stimulate another body part or sense. Jürgen Haase, a researcher in experimental physics, described synesthesia as an integral form of perception of the built environment, "Firstly, it evokes feelings and secondly it communicates meaning corresponding to these feelings. . . . Powerful architecture is based on synaesthetic conceptualizing and so each building appeals to synaesthetic perception."[6] Ideally, spaces used for ritual performances ought to play with as many senses as possible. It must be realized, however, that every liturgical practice or church interior will not stimulate the congregation or an individual in the same way. Human beings are not alike when it comes to perceptive skills or the

4. Gernot Böhme, "Synaesthesiae with the Scope of a Phenomenology of Perception," in K. Brichetti and F. Mechsner, *Synaethesia: Body–Space /Architecture* 18, no. 31 (2013): 24.

5. See two classic works on perception: Juhani Pallasmaa, *The Eyes of the Skin: Architecture and the Senses* (New York: John Wiley & Sons, 2012); and Gaston Bachelard, *The Poetics of Space: The Classic Look at How We Experience Intimate Places* (Boston: Beacon Press, 1994).

6. Jürgen Haase, "Synaesthesia: A Basic Form of Perception—For Example of Architecture," in K. Brichetti and F. Mechsner, curators, *Synaesthesia: Body–Space /Architecture* 18, no. 31 (2013): 37.

ability to utilize more than one sense. Nevertheless, how members of the congregation perceive their environmental surroundings during liturgy will affect how they engage with the rituals.

Architectural theorist Branko Mitrović wrote about the shifts in philosophical theories that focus on the way people observe and evaluate buildings. He noted that architecture cannot "live in isolation from its intellectual and cultural environment."[7] Before World War II, several philosophers[8] claimed that conceptual thinking and perception are inseparable. That is, the way you conceive something ahead of time affects your perception of it. This was part of the phenomenological tradition that influenced architectural theory. Mitrović wrote that "visual perception of buildings is merely a result of the knowledge and beliefs we already have about them."[9] This theory helps us understand someone who says, "It does not look like a church." That person is making a decision based on his or her preconceived image of what a church should look like. In that case it becomes impossible to evaluate a building based on its own merit.

Other Attributes. A critical view of excessive exuberance in church design was mentioned earlier. However, no environment for worship should be completely devoid of architectural details, creative lighting plans, thermal comfort, good acoustics, stimulating materials, and vivid colors. These enhancements and other factors such as proportion and scale are not luxuries in a house of worship. They all work together in the background to stimulate the senses and support conscious and active participation in the

7. Branko Mitrović, *Visuality for Architects: Architectural Creativity and Modern Theories of Perception and Imagination* (Charlottesville, VA: University of Virginia Press, 2013), 13.

8. For example, Franz Brentano (1838–1917), Edmund Husserl (1859–1938), Martin Heidegger (1889–1976), Hans-Georg Gadamer (1900–2002), Gilles Deleuze (1925–1995), Jacques Derrida (1930–2004), and Félix Guattari (1930–1992).

9. Mitrović, *Visuality for Architects*, 14.

ritual event. As Sarah Williams Goldhagen observed, enriched built environments have the "capacity to shift us out of our ordinary, non-conscious, egocentric points of view . . . and can slide us . . . toward a more conscious state of awareness."[10] This is the objective in any space designed for worship: to draw the entire assembly more deeply into the experience of God, nature, and community in ways that are cognitive, affective, and synesthetic.

10. Williams Goldhagen, *Welcome to Your World*, 284–85.

18. Something Old, Something New

"Each new situation requires a new architecture."
—Jean Nouvel

The search for a common ground in terms of the environment for worship is a slow process because there are such strong feelings about which architectural style is more suitable for the liturgy. Although traditional church buildings are widespread in the United States, modern places of worship are also part of fabric of the religious history of this country today. However, there appears to be a philosophical complication. Karla Cavarra Britten, who is a historian of twentieth- and twenty-first-century architecture and urbanism, observed that "the religious building in the history of modern architecture has at best tended to be understood as a kind of marginal 'counter-history.'" She indicated that some of the foundations for twentieth-century architecture—"new spirit, progress and cultural modernity—are interpreted as being in conflict with the essence of the religious building as representative of more entrenched cultural underpinnings (ritual, memory, historical continuity, cultural identity and tradition)." Nevertheless, Britten pointed out, "there are many remarkably innovative religious buildings in the twentieth century which exhibited a considerable originality in terms of language, structure, material, and the arrangement of space and form."[1] If it is

1. Karla Cavarra Britton, ed., *Constructing the Ineffable: Contemporary Sacred Architecture* (New Haven, CT: Yale University Press, 2010), 15.

true that modern churches can be, by design, transformative places, one can rightly question the zealous reluctance to embrace them as suitable places for worship.[2]

In previous chapters I sorted out some of the key architectural elements considered by some to be essential in designing beautiful churches. These elements have not been entirely disregarded in the construction of modern churches. Some designers now are actually fond of a "new classical architecture." They use abundant light, shadow, color, new materials, and imaginative shapes without sacrificing the more functional purposes of a building. This link between function and form is notable because, generally, in premodern churches "function was not a value . . . it existed in reference to symbol and to transcendent, socially shared values." Embedded artistic flourishes had nothing to do with the structure of the church, but they did create a connection to "transcendent values."[3]

To be clear, the Modern period of design did signal a break from some of the prescriptions that defined older church models. The creation of utilitarian spaces and simpler forms is intentionally devoid of any decorative embellishments. Innumerable examples of churches have been built using nondecorative material language. In this context, two well-known Christian projects have been subjects of intense architectural analysis: the Church of the Seed (Huizhou, Guangdong, China, 2011), designed by O Studio Architects, and Steven Holl's Chapel of St. Ignatius (Seattle, Washington, 1997). Both of these churches play with verticality, light, color, shadow, material, and texture. These elements

2. See Anat Geva, ed., *Modernism and American Mid-20th Century Sacred Architecture* (New York: Routledge, 2018), for insights on how architects approached designing religious spaces that incorporated liturgical changes, evolving congregations, modern architecture, and innovations in building technology.

3. See Adam J. Seligman, Robert P. Weller, Michael J. Puett, and Bennett Simon, *Ritual and Its Consequences: An Essay on the Limits of Sincerity* (New York: Oxford University Press, 2008), 156–57.

combined create a sense of the holy other. Nothing in these buildings conveys a figurative or literal message. Like icons, these two sculptural structures lead the occupant to another place, a virtual and uncluttered spiritual realm. Some medieval monastic chapels and country churches had the same qualities. They were examples of pure form, illumination, verticality, organic materiality, all without embellishments.

 In general, modernist architects and designers have considered ornamentation, carved into or applied to structural elements, to be excessive in terms of the function of a building. Examples of these flourishes would include but not be limited to sgraffiti on walls and acanthus leaves and scrolls, hewn by hand or machine, into Corinthian capitals. Murals, fabrics, and wall paper attached in Art Deco buildings are other examples of adornment. Le Corbusier once wrote that "modern decoration has no decoration," provoking a derision for such embellishments. This is not to say either that unadorned edifices cannot be places of beauty or that architecture with artful accessories cannot be functional. Some have argued the "forced conceptual separation of ornament from function is a relatively recent occurrence in human history."[4] Architect Álvaro Siza offered a way to understand the relationship. "Beauty is the peak of functionality! If something is beautiful, it is functional."[5] According to professors of architecture Deniz Balik and Açalya Allmer, "In the contemporary world of architecture the term 'ornament' cannot be fully grasped or defined . . . as it expands through the immaterial realm of virtual reality by means of digital medium."[6] One example would be the way Holl used non-fixed

 4. See Nikos A. Salingaros, "Ornament and Human Intelligence," in *Unified Architectural Theory: Form, Language, Complexity: A Companion to Christopher Alexander's The Phenomenon of Life—the Nature of Order, Book 1"* (Kathmandu, Nepal: Vajra Books, 2012), 191.
 5. Belogolovsky, "Beauty is the Peak of Functionality!"
 6. Deniz Balik and Açalya Allmer, "A Critical Review of Ornament in Contemporary Architectural Theory and Practice," in *AZ* 13, no. 1 (March 2016): 157–69.

conceptual frameworks or porosity in the early idea stage of his work. Research scientist Sotirios D. Kotsopoulos studies "responsive architectures." He describes Holl's approach to architecture as one that "disregards any fixed architectural vocabulary in favor of an 'initial concept' capturing the essence of design possibilities that he considers unique for each project."[7] In this context, it can be said that Post-Modern designers are proving that ornamentation in contemporary forms of architecture is doable but not in the traditional sense of the term. One wonders if designers of more traditional-looking church buildings are thinking in the same way.

The ecclesiastical-architectural landscape in the United States is now configured with diverse shapes and forms, some plain, some ornate. The majority of newly built denominational and nondenominational churches in the United States are subsets of the Modern style. They may be classified as International, Post-Modernist, Deconstructivist, and even Brutalist efforts. In my opinion, very few of these new churches in the States match the clarity and purity of the sculptural shapes that characterize some churches currently being built in several European and Asian countries. Many, not all, designers and architects now say that the Modern style is out of date by some standards and that even Post-Modernism, with its Neo-Classical flourishes, is passé. Architect and critic Jonathan Hale wrote that the Modernists did not really throw out the past but did cling to an old way of seeing. It was "a time before the dominance of mechanical thought," a way of perception that relied on feeling and intuition. Hale admits there are ways to bring architecture back to life, "to regain the old way of seeing" without returning to "the styles or superstitions of the former world."[8] One of the key approaches submitted in a long

7. Sotirios D. Kotsopoulos, "From Design Concepts to Design Descriptions," *International Journal of Architectural Computing* 6, no. 3 (September 1, 2008): 337.

8. Jonathan Hale, *The Old Way of Seeing: How Architecture Lost Its Magic and How to Get It Back* (New York: Houghton Mifflin, 1994), 166.

list of Hale's ideas is to design buildings composed of related forms infused with a system of proportions.[9]

While some architects may be returning to a design process using classical appendages, others in the past explored even more unorthodox forms. Le Corbusier's (1887–1965) Notre Dame du Haut chapel in Ronchamp, France (1955) is still considered one of the most remarkable religious buildings of this age. The sculptural symmetries, the light, the materials, the verticality, and the colors are examples of what Classicists would hope for in a modern age. The building is not a Neo-Classical structure but continues to stand, alluringly so, as a pilgrim's destination for meditation and reflection. A similar oasis of peace and quietude is the modern monochromatic white Chapel of the Good Shepherd (1977) by Louise Nevelson (1899–1988) in the St. Peter Lutheran Church in New York City. The chapel is often compared to Henri Matisse's Chapel of the Rosary in Vence, France. According to Brooke Kamin Rapaport, a specialist in contemporary sculpture, "As a place of worship, the site became known for its spiritual humanism, a deep sanctity that abstract art can achieve by pervading space."[10] It is clearer that modern architectural forms can engage people in transformative experiences, a key ingredient in the search for the "sacred" in one's life.

The history of architecture suggests that a balance between traditional and innovative design approaches can provide a sense of wonder and beauty. Further, a building need not be constructed for a religious purpose in order for it to provide an experience of awe, silence, beauty, and spirituality. Many new museums, art galleries, and concert halls are attracting great numbers of visitors in ways that their older architectural siblings have done and still do. Whether

9. Hale, *The Old Way of Seeing*, 9.

10. Kadie Yale, "Louise Nevelson's Chapel of the Good Shepherd Restoration Underway," *Interiors + Sources* (November 21, 2018), https://www .interiorsandsources.com/article-details/articleid/22371/title/nevelson -chapel-restoration.

or not the application of Classical features in Post-Modern church buildings will ever become a normative design methodology is unknown. A lot will depend on the initiative of pastoral leaders and design professionals. In a liturgical context, it is too soon to say that either traditional church buildings or contemporary ones will attract younger generations. Nondenominational church leaders admit readily that their memberships are fluid.

Questions surrounding Christian church design create a liturgical and ecclesiological conundrum. This dilemma is related to the broader philosophical and theological discussions summarized earlier that deal with the meaning of sacramental acts. The search for a common ground must also include current theories about architecture as well as its history. What kinds of church interior designs will serve the celebratory moments in the lives of individuals and communities? How do they enable people to publicly acknowledge their experiences of a Holy Spirit acting in their lives? In the new theological way of thinking, the sacraments are not products delivered by clerical mediators. The same would be true for architecture. Church building plans can no longer be "delivered" to a congregation as if the designer had all the answers.

If there can be an agreement that balancing classical forms with contemporary innovations is a step toward a reasonable design compromise, what is left to debate? The answer, in general, has less to do with the architectural style and more to do with the form of worship that occurs inside the church. More specifically, it has to do with the location of the altar table.[11] Will congregations who favor a traditional liturgy ever be comfortable in Post-Modern churches in which the altar is in their midst? On the other hand, how long will progressive congregations continue to worship in older churches that have not been updated liturgically and in which the altar is still far removed from them? Herein lies the main issue.

11. For some Catholics the location of the tabernacle is important as well. I will focus on the altar table.

It is about the symbiotic relationships between history, vision, architecture, art, congregational worship, and social work.

Basically, the whole idea about praising God stems from the conviction, even in light of a nondualistic interpretation of the cosmos, that God is the chief gardener or sovereign architect of all things in creation. This is the God who is worthy of human praise and thanksgiving poured out in Christ and in the Holy Spirit. God's presence in real time is experienced by humanitarian acts and not by wishful thinking (which is different from the virtue of hope). Art and architecture play accidental but important inspirational roles in this entire spiritual process. This is the fundamental reason, architecturally and artistically speaking, why many designers and religious leaders believe proportion, harmony, and beauty are still the essential ingredients in constructing churches. They claim that such edifices serve as points of reference to the creative but elusive genius of God encountered mysteriously in the depths of the unfathomable cosmos and the earthiness of this planet. The search continues for more contemporary houses of worship that will provide this sense of holy ground without ignoring the elements of good liturgical design.

19. Nature's Rotundas

"The power of the world always works in circles."
—Black Elk

Some architects successfully incorporate elements of older styles of church buildings into their designs of new ones. They create contemporary spaces, appropriate to this time, that are functional, engaging, beautiful, and transformative. And they are doing so without resorting to levels of decorative or theatrical trendiness. Theorist Branko Mitrović wrote that "the revival of interest in theories of proportions [in recent decades] was its mystical character—quite inappropriate for the modernist movement—which prided itself on representing the modern era of science and technology."[1] Mitrović is referring to the rediscovery of the Golden Ratio,[2] a mathematical computation considered for ages to be the tool for creating beautiful buildings and works of art. Here is a very brief review of how this Ratio became such a pervasive design tool and why it is becoming popular again in some architectural circles, even while some designers disavow it altogether.

1. Branko Mitrović, *Philosophy for Architects* (New York: Princeton Architectural Press, 2011), 63.

2. Golden Mean, Golden Ratio, and Golden Section are different ways of referring to the same equation. The ratio is symbolized with the Greek letter *phi* and is a number equivalent to 1.618.

Egyptians and Greeks used geometric calculations to design buildings and monuments in symmetrical and harmonious ways. Although Pythagoras (570–495 BCE) believed that everything could be reduced to numbers, perhaps the earliest reference to computations used in construction is found in *Elements*, written by the mathematician Euclid (ca. 300 BCE). Centuries would go by before Leonardo Pisano (1170–ca.1240) presented a self-developing numerical sequence that bears his nickname, Fibonacci. The numbers go like this: 0, 1, 1, 2, 3, 5, 8, 13, 21, 34, and so on. It was discovered that as the numbers increased, the ratio approached what came to be known later as the Golden Ratio (1.618), *phi*. The equation would catch on. Franciscan Luca Pacioli (1445–1517) wrote *The Divine Proportion,* which included drawings by Leonardo da Vinci (1452–1519), who used, consciously or not, the Golden Mean. This benchmark inspired other great Renaissance artists and builders to use similar proportions to create a sense of balance and beauty in their sculptures, drawings, and buildings. Scientists such as Johannes Kepler (1571–1630) would also invoke the Golden Ratio and the Fibonacci sequence in their discoveries.

Later, René Descartes (1596–1650) began studying spirals, circles, and fractals in nature, but it was Jacob Bernoulli (1654–1705) who described the phenomenon as the "marvelous spiral." He discovered that, although the size of a spiral would increase, the shape would stay the same, an occurrence known as self-similarity. Just about all the spirals found in nature are called logarithmic spirals (not to be confused with Archimedean spirals). It wasn't until the nineteenth century that the term "Fibonacci sequence" was coined by the French mathematician Edouard Lucas. More frequently, scientists started once again to marvel at the geometric progressions appearing in nature. The Golden Ratio, often unnoticed, is pervasive in the shapes, sizes, and details of human bodies, animals, plant life, and innumerable aspects of creation. In fact, it is so universal some people truly believe that God actually utilized the Ratio when creating the cosmos!

In spite of the resilience of the Golden Ratio, a controversial counterpoint, written by design critic John Brownlee, referred to the Ratio as a big myth.[3] Although he did not refute the fact that the equation has been used for centuries as a way to emulate the beauty found in nature, Brownlee claimed it is no longer considered a useful tool by design professionals. He interviewed several architects and mathematicians who agreed that numerous alternative formularies are available today. They use them to generate new works of art. There are also online databases of computational designs by which, according to one architect, someone can determine the dimensions of a building and even structural loads. Computer-aided design and drafting programs are commonplace in architectural offices and are useful in creating traditional building types as well as contemporary ones. Brownlee submits that it is now common knowledge among professional designers that to create places of beauty, harmony, and function one does not have to rely on the Golden Ratio. The development of newer technologies and computer-aided design tools will continue. No one uses a slide rule anymore. Designers should use whatever instruments are available to them to create appropriate proportions and scale in church buildings.

Icon writer Brother Adrian Jones remarked, "People are hungry for beauty. Part of the vocation of the church is to be a place of revelation of true beauty."[4] In light of this claim, are there any undisputed, nonsubjective, architectural postulations that may be utilized in the design of churches to make them beautiful? Was novelist Margaret Wolfe Hungerford (1855–97) correct when she popularized the Grecian proverb, "Beauty is in the eye of the beholder"? Her supposition creates a dilemma in determining

3. See John Brownlee, "The Golden Ratio: Design's Biggest Myth," in *FastCoDesign.com* (April 13, 2015), https://www.fastcodesign.com/3044877/the-golden-ratio-designs-biggest-myth.

4. Quoted in Christopher Scott, *Unknowing & Astonishment: Meditations on Faith for the Long Haul* (Oxford: SLG Press, 2017), 9.

whether or not a place of worship or a work of art is beautiful. Whose evaluation is correct? Can creation's wonder and beauty offer a *modus operandi* for designing appealing church buildings? Contemporary poet Annie Dillard observed that "beauty and grace are performed whether or not we will or sense them. The least we can do is try to be there."[5] The ability to perceive what is present in our immediate natural environments takes practice and patience. The grandeur and harmony found in nature are unknown to many people whose lives are fraught with busy schedules and challenging responsibilities. Who takes time to notice the spirals, circles, and fractals found in nature? What about all the other phenomena that can paradoxically delight and damage? Oceanic whirlpools, atmospheric hurricanes, and tornadoes all spin in helical patterns. Our galaxy, like others, also gyrates in the same way. Closer to the ground magnolias, sunflowers, nautilus shells, pine cones, cacti, birds' nests, and red cabbage grow in a combination of spiral and circular formations. Creatures of the earth such as snails have spiral shells and goats have twisted horns. Our ears, fingerprints, and the crowns of hair on our heads are voluted. Why is it that churches are not designed to look more like nature's rotundas?

The cover of this book shows the archeological remains of a round council house in an area called Citânia de Briteiros. It is located on a hill overlooking the Ave River in the municipality of Guimarães (in Portugal). The village is an example of the Castro culture (of Celtic origin) dating to the second century BCE. I chose the photograph because it is an ancient example of a concentric arrangement of a community building. Why is the council house designed in a sociopetal circular plan? One might also ask: What prompted the Oglala Sioux Black Elk to say "the power of the world always works in circles . . . the wind whirls, the round earth spins around the round sun and the round moon circles the

5. Annie Dillard, *Pilgrim at Tinker Creek* (New York: Harper & Row, 1988), 8.

earth"?[6] A circular plan can promote and sustain relationships and communication with one another, with nature, and with God. Marten Kuilman, who studies quadralectic architecture, describes stone circle structures as a search for meaning. "And then, after the colossal stones had found their place in the natural environment again, they were used to bridge the gap between an endless space and the human presence therein The circular movement, with its fixed distance from the center and its possibility of return, is much more suitable for the awareness of a shift and subsequent valuation than the linear movement into infinity."[7]

Bishop Robert Barron spoke of circles in his meditation on Gothic cathedrals. In one of his examples he described the labyrinth as a centering exercise, a way to slow down in life, "a way of looking to the Christ within" oneself. Could a circular church plan provide worshipers with a way to see Christ within themselves? Observing that labyrinths are usually circular, Barron intimated that when on a spiritual excursion "the straight journey might be the shortest, but it might not be the most radiant or the most beautiful."[8] In his article on the symbolism of circular churches, art historian Timothy Verdon noted, "While the more common longitudinal basilicas imply a journey—from the entrance to the altar—the circular form, without beginning and without end, speaks of the infinite: arriving at its center connotes the end of the search, the arrival at the greatly desired port."[9]

6. See John Neihardt, *Black Elk Speaks: Being the Life Story of a Holy Man of the Oglala Sioux*, The Premier Edition (Albany, NY: State University of New York Press, 2008).

7. Marten Kuilman, "Stone Circles," 3.1 in *Quadralectic Architecture*, https://quadralectics.wordpress.com/3-contemplation/3-1-stone-circles/.

8. Robert Barron, *Heaven in Stone and Glass: Experiencing the Spirituality of the Great Cathedrals* (New York: Crossroad, 2000), 96–97.

9. Timothy Verdon, "Basilica and Circle: The Tradition of the Great Churches of Rome," *L'Osservatore Romano* (February 10, 2011), http://chiesa.espresso.repubblica.it/articolo/1346722bdc4.html.

The insights of Barron and Verdon are helpful in grasping, as Black Elk did, that circles have a certain capacity for creating transformative experiences that unidirectional spaces do not. Kuilman's research on circular plans claims that a circle, more so than a rectangle, makes space for inhabitants to experience one another while at the same time it can transport them, perhaps in a more subtle or subliminal way, to a place or an experience that is not *beyond* them as much as it is to be found *within* them. To paraphrase Annie Dillard's aphorism on beauty and grace, *God* is constantly performing, whether or not we will it or sense it; the least we can do is be present when it is happening. Translating this poetic insight into liturgical language, the belief in a transcendent being who encircles and embraces the baptized community gives strength and hope. The assembly moves deeper into engagement with an ineffable Being who is not outside their life experience but in their midst (Matt 18:20).

The claim against centralized or concentric plans for churches is that they are not oriented in a single direction toward a transcendent God, who is denoted by a highly decorated space at one end of a church. Louis Bouyer pointed out that this symbolism "expressed the eschatological expectation of primitive Christianity: the expectation that is of a last day, the lasting day of eternity, in which the Christus victor would appear as the rising sun which will never set."[10] The counterpoint to this dualistic explanation is that the Body of Christ is already really present in the people gathered to celebrate the paschal event that is theirs as a gift from God. In this case the entire church building, a metaphor for the people of God, is designed to convey both the immanent and transcendent presence of God as one holistic experience. God is neither here nor there but everywhere, even though many people have not noticed. The unfinished business for the faith community is to continue to notice the infusion of the radiance of God in all peoples, and to build up the city of God on earth.

10. Bouyer, *Liturgy and Architecture*, 29.

Circular churches are not an anomaly. Some sources show how, at least in some regions in which Christianity was practiced, the altar table was located more in the midst of the assembly rather than in the apse.[11] That the centralized plan did not become normative in the West as the rectangular or cruciform shapes did had less to do with acceptable architectural styles or artistic embellishments than with the ecclesial context. Circles were considered unsuitable for worship because of the clericalization of the liturgy. Kuilman wrote, "The centrally planned, round way of building, found many expressions in later Christian church architecture, but it never became the leading form." He noted that there were "practical problems with regards to the divisions between clergy and laity and the lack of hierarchy in the approach to the altar."[12]

One classic example of a missed opportunity to unite clergy and laity during liturgy may have occurred in a church project designed by Andrea Palladio. In 1576, at the invitation of the Senate of the Republic of Venice, Palladio prepared a centralized plan for the Church of the Most Holy Redeemer (*Il Redentore*) in Venice. It was to be built in thanksgiving for deliverance from the plague that decimated much of the Venetian population in 1575. However, "the Senate rejected the plan in favor of a longitudinal layout which was eventually built."[13] It is not certain if the hierarchy of Venice had any influence in the Senate's rebuff of the original plan. In Palladio's drawing, two columns separated the nave from the choir in the apse, presumably where the altar table would go. This should have pleased the clergy. It is not possible

11. See, for one example, Robin M. Jensen, "Recovering Ancient Ecclesiology: The Place of the Altar and the Orientation of Prayer in the Early Latin Church," *Worship* 89 (2015): 99.

12. Marten Kuilman, "The Circular Church Plan," 3.3.1.1., in Quadralectic Architecture, https://quadralectics.wordpress.com/3-contemplation/3 -3-churches-and-tetradic-architecture/3-3-1-the-form-of-the-ground-plan/3 -3-1-1-the-circular-plan/.

13. Charles Hind and Irena Murray, *Palladio and His Legacy: A Transatlantic Journey* (New York: Marsilio, 2014), 82.

to know whether a designated pilgrimage or votive church such as this one would have absolutely required a long nave. But in any case, the Senate decided.

Palladio's drawing is worth investigating in terms of contemporary liturgical practice. One can easily imagine an innovative church building with Vitruvian features, where the clergy and laity are gathered together all around the altar located directly beneath the dome. Palladio's niches on the perimeter of the rotunda would be designated for adoring the reserved sacrament, making a confession, revering an image of Mary the Mother of God, and embracing a crucifix. It would serve as a worthy example of balancing traditional forms with innovative architectural and liturgical styles.[14]

Spiral and circular shapes, nature's rotundas, are everywhere. The Golden Ratio was conceived to take advantage of these forms, and so to give proper proportion and scale to the exterior appearance of buildings and sculpted elements inside. The same geometries can be utilized computationally and intuitively in the design and arrangement of contemporary church interiors to provide a similar sense of beauty and grace.

14. La Cathedral Notre Dame de las Assomption in Port-au-Prince, Haiti, is designed with a circular liturgical plan by architect Segundo Cardona. It will eventually replace the one completely destroyed by the 2010 earthquake.

20. Religious Art:
A Congregation's Conscience

*"The more formal a work of art is
the less room there is for participation."*
—Jorge Orteiza, sculptor

While writing this chapter I learned about the fire that destroyed Brazil's National Museum in Rio de Janeiro. The tragedy was "an immeasurable blow to Brazil's cultural memory."[1] Museums are filled with artistic narratives that put us in touch with ancient and modern religious and secular societies that have traversed and settled around the globe over long periods of time. They provide clues about lifestyles, rituals, fashion, and dwelling places. Some give us a glimpse of prehistoric eras while others transport us to worlds beyond. The arts provide an essential record of human history. In a contemporary church context, works of art serve several different purposes. Certain items, such as water, bread, wine, oil, and fire, are essential for worship. Vessels are required to hold these elements—a baptismal font, an altar, communion vessels, a brazier for the Easter fire, and so on. These can be, in themselves, works of art and not merely pragmatic tools.

1. Ishaan Tharoor, "Brazil's Museum Fire is a Global Tragedy," *The Washington Post* (September 5, 2018), https://www.washingtonpost.com/world/2018/09/05/brazils-museum-fire-is-global-tragedy/?utm_term=.300ef25a8f28.

Generic works of "religious" art are also found in many main-line churches, although they are not required for conducting rituals. Such art may be used to create a specific theme or provide an environmental framework for liturgical action. The building itself is a sculpted box and can be a formidable work of art. Permanent and temporary artwork may be installed both outside and inside the church. Carvings, textiles, and paintings are commonplace. Other materials, including glass, stone, wood, and iron are also used. Works of religious art are ideally rooted in the memory and imagination of both the artist and the congregation. But they may also be grounded in the Bible, the life of a holy ancestor, a famous civil servant, or a historic or current event. In many parts of the world pious imagery cultivated the spiritual and devotional practices of individuals and, in some cases, entire cultures. For example, testimonies of miraculous occurrences are attributed to a strong devotion to a particular manifestation of the Mother of God or of a popular saint. There are also, however, works of religious art created to make a politically charged moral statement that merit our attention. The reason I choose to focus on this function of art is to show the link between participating in worship and engaging in works of social justice.

Over time, words and expressions in any language group can go out of date and become confusing. The Merriam-Webster dictionary, for example, recently (2018) added *Latinx*, a gender-neutral alternative to Latina and Latino. There have also been evolutions in the terminology used to describe religious art. Words such as ecclesiastical or sacred art are often employed to describe religious and liturgical items as if the words mean the same thing.[2] Yet, they are different. In searching for a common ground

2. It is not my intention to discuss low art and high art in this essay. I acknowledge that some commentaries refer to "folk art" as low art. This type of art is extremely important in countless religious cultures. The *santos* and *bultos* (*revultos*) found in the Southwest Mission churches, crafted by human hands, undoubtedly are wonderful examples of religious folk art.

regarding the role of art in the worship environment there are some important distinctions.

The word "sacred" is formally defined as something set aside for a specific purpose such as honoring a deity. However, it is also used generically as an adjective to describe anything that has to do with worship: sacred space, for example, or sacred art, sacred music, and sacred texts. In reality, however, the only thing that an artist, architect, composer, writer, or liturgist can do is create something that has the *potential* of becoming sacred. In a spiritual context, a sacred experience has a transformative effect on a person's life. The Eastern tradition of writing an icon is described as a sacred work because it involves not only a transformation of materials but the iconographer as well. Works of art down through the centuries have shaped and sustained spiritualities, philosophies, and, in the case of religious works, theological ideologies. They have become sacred not because of their subject matter—God, the mysteries of faith, and so on—but because of their effects.

Of course not every person will be affected or transformed in the same way when producing or encountering a religious work of art. Yet, certain works of religious art do have the capacity to affect the development of the collective or individual moral conscience. By conscience I am not referring merely to emotional responses to a situation or the need to submit to legalities scripted by religious leaders. Moral theologian Thomas V. Berg explains, "Conscience is understood to be a judgment emanating from human reason about choices and actions to be made, or accomplished, or already opted for and performed."[3] In terms of religious art, the work of the artist and the response of the viewer are vital to this process. The extent to which the art will shape the conscience will depend on the intentions of the artist or artisan producing the work. It will also rely on the willingness of the

3. Thomas Berg, "What is Moral Conscience?," in *Homiletic & Pastoral Review* (January 1, 2012), https://www.hprweb.com/2012/01/what-is-moral -conscience/.

person or group to receive or respond to the message contained in the work, or at least their openness to it.

Innumerable studies have been conducted on the psychological and sociological impact of art on a society. Evaluating the effect of religious art on ethical behavior is, however, more challenging. Artistic tastes as well as acts of piety are so subjective, it is difficult to determine which attributes of a work of art affect the spiritual growth and moral development of an individual or a congregation. This quest is complicated by the tremendous unevenness in the quality of religious art work. There is a huge difference between the work of a highly regarded artisan and religious goods mass-produced in factories. Yet, both of these forms, as different as they are, will evoke a response from people.

It is hard to critique any work of art, religious or not, without some sort of aesthetic construct that is not determined by someone's taste. Art theorist Walter Abell (1897–1956) studied aesthetic values in representational art and created a matrix by which to evaluate and appreciate art. Much of his research is still considered important in assessing the factors that make up an art object. He asks these questions. 1) What is the historical context for the art? 2) What is the biography of the artist? 3) What materials and techniques were used to create the piece? 4) What is the intended teleology or purpose of the work?[4] The answers to these questions may reveal more information about the production or the practitioner, yet still leave deeper questions unanswered. Some artists create out of the depths of their consciousness. Maybe Salvator Dali (1904–89) did so in his surrealistic paintings without realizing where the ideas came from. Others may react to a crisis, as Pablo Picasso (1881–1973) did after the bombing of Guernica, Spain, in 1937. Still others use their art to comment on cultural issues. Frida Khalo (1907–54) explored gender, race, class, and

4. See Walter Abell, *The Collective Dream in Art: A Psycho-Historical Theory of Culture Based on Relations between the Arts, Psychology, and the Social Sciences* (Cambridge, MA: Harvard University Press, 1957).

exploitation in Mexico. Georgia O'Keeffe (1887–1986) was struck by the beauty of New Mexico's landscapes. Others just create and have no explanation or rationale for their work.

One powerful example of a somewhat mythical work of art not required for worship was *Phoenix* by the Chinese contemporary artist Xu Bing (1955–). The project was installed in the Cathedral of St. John the Divine in New York City in 2014 and was a colossal attraction for months. Countless worshipers, tourists, and conference attendees saw two huge sculptures, each weighing twelve tons, suspended in mid-air, anchored to the columns along the canyon-like nave. These modern works, fabricated with debris and tools from the construction sites of luxury towers in Beijing, punctuated the traditional Romanesque and Gothic features of this historic cathedral. The artist's intent was to make a political statement about the poor wages paid to migrant workers in China and income inequity around the world. The phoenix is an archetypal symbol of transformation, death, and rebirth through fire. What better title for a work of art that is critical of injustice? *Phoenix* was unique not only because of its sheer magnitude but because it raised awareness about human rights. This example raises a question about the role of artists whose work is not only fitting for religious environments but also serves as a commentary on urgent social justice issues. How many churches allow for this kind of analysis today? How many pastoral leaders would welcome works of art in their churches that focus on provocative issues dealing with child abuse, racism, or discrimination? How well does the religious art in our churches serve to develop the collective moral conscience of the congregation as they gather to perform a liturgy?

The reluctance to use works of art as a summons to work for biblical justice is not new. Art historian James Hadley researched the tensions between bureaucracies and independent-minded modern artists during the Renaissance. Hadley reviewed foundations for establishing a certain genre in church art and explained how the sixteenth-century studio or workshop sponsored by wealthy families was originally a place where artists and artisans

shared ideas and work. Eventually, what became known as the Academy "transformed itself into a mechanism of consensus regarding artistic taste that mediated between competing styles."[5] This led to a control over the production of art. Hadley continued, "For the church, these developments meant that beauty, its primary interest in defining art, at least since the Renaissance, became inexorably linked to the history of taste and, therefore, successive styles as controlled by the Academy."[6]

In this history it is interesting to note that, although the artists were endeared to their wealthy patrons and craved major church commissions, they also sought to protect their artistic freedom. The alliance between the academy, patrons, and hierarchy, according to Hadley, did not stop artists and social movements from "questioning the legitimacy of institutions and organizing against them." Hadley wrote that the artistic community at that time "increasingly insisted upon both its own freedom, and as an agent of social reform."[7] Hadley concluded that "from the perspective of social criticism and art history, the church was ill prepared, or even incapable of responding to the newfound challenge of artistic freedom insisted upon by modernity."[8]

The situation has changed. Vatican II took place in the 1960s, the same decade in which monumental social change was occurring. In the United States, clashes regarding the Vietnam war, racial inequality, and women's rights were just three of many mainstream issues that pulled religion into the public square. National consciousness regarding other injustices, such as the exploitation of farm workers, was also on the rise. Political assassinations shook Americans to the core. In the midst of this turmoil, church leaders

5. James Thomas Hadley, "Ars Gratia Artis: The Freedom of the Arts in the Twentieth-Century Liturgical Reform and Today," *Studia Liturgica* 45, no. 2 (2015): 180.

6. Hadley, "Ars Gratia Artis," 180.

7. Hadley, 181.

8. Hadley, 180.

emerged who began to stress the social gospel through sermons, music, and art. The issues today may be different, but the struggle for justice remains urgent. While some churches do take public stands, many others remain silent. In one constructive example, the main entrance (narthex) of the St. Augustine Cathedral (Tucson, Arizona, 1968) has a wall-to-wall mural depicting social activist saints, such as Francis of Assisi and Teresa of Kolkata. It also depicts people who were victims of violence, such as Maximilian Kolbe and Josephine Bakhita. The tableau, painted by John Alan Warford, serves as a reminder of the connection between praising God at worship and honoring people who suffer ongoing inequities. Unlike this mural, most of the religious art in churches consists of objects of devotion not required for public liturgy. Generally speaking, such images fail to generate social action. Most often they are mass produced with no connection to a real artisan or to the stories or missions of the local congregation. Artists, like architects, have to be encouraged to create works that are congregation-specific. They must be allowed to read the signs of the times and then express those sociocultural issues in their art work.

The primary function of religious art in churches is to create an overarching environment for worship, one that is beautiful and transformative. At the same time, and even more important, religious art can stir up the moral conscience of the assembly as it gathers to worship. As I have argued before, "Art serves the same purpose as a good homily . . . to remind the worshipers of their roots, their tradition as a religious people, and their mission in the world. The arts used in the act of worship or to embellish and enhance the actual space used for worship must also call the worshipers to respond to their vocations,"[9] The symbiotic relationship

9. Richard S. Vosko, quoted in Menachem Wecker, "Beauty in Sacred Spaces Offers Call to Mission," *The National Catholic Reporter* (September 23, 2016), https://www.ncronline.org/preview/beauty-sacred-spaces-offers-call-mission.

among worship, social action, and religious art should be obvious. No matter what the architectural style of the building is, and whatever form the works of art take, the clear direction of the liturgical renewal is that all factors that make up the worship experience must involve the assembly and the clergy fully, equally, in the ritual performance of the paschal mystery. Then, as a sacrament of unity, the congregation will take the mission of Christ into the public square.

21. Liturgical and Devotional Art

*"I look at every piece of furniture and every object
as an individual sculpture."*
—Kelly Wearstler, American designer

In my work as a liturgical designer I have often taken committees on tours of different places of worship as well as pertinent secular buildings. The idea was to help them imagine possibilities for their own church. On one tour we visited a brand new "noble and simple" chapel inside the residence of a religious community. One parishioner remarked quickly on the absence of "art." No one seemed to notice a finely crafted wooden altar table with decorative veneers located right in the middle of the chapel. I asked the group, "Doesn't this furnishing qualify as a work of art?" My question was intended to point out that art in a place of worship is not just something to hang on a wall or place on a pedestal. Liturgical art is different from religious art in that it specifically serves the enactment of sacramental rituals and the personal devotions of the congregation. I consider individual acts of piety as liturgical.

In the Catholic tradition and some others, this broad category of liturgical art may include furnishings such as a baptismal font, cupboards for Scripture books, vessels for holy oils, and a tabernacle for the reserved Sacrament. There will also be an ambo (pulpit), an altar table, seats for the assembly and presiders, and (in a cathedral church) a cathedra or bishop's chair. The artifacts

or appointments include a crucifix of the altar,[1] processional crosses and candle holders, vesture and vessels. Books used for the liturgy (the Lectionary, the Book of the Gospels, the Missal), especially their covers, which will be seen by all, should be works of art as well. And there are the images of holy ancestors who silently join in the worship of God.

Although all of these items are important, there is a distinction between primary and secondary components that make up the liturgical environment. The Greek word *adiaphora* perhaps can help us sort out the differences. The term was used during sixteenth-century Lutheran arguments about doctrines related to justification by faith. The teachings that were not biblically related or did not deal specifically with justification were called *adiaphora*. These matters were not considered essential to the faith. In this way of thinking, some things in the church, such as liturgical colors, the size of a baptismal font, a pulpit, a communion table are just not as important as the act of worship itself. The gathering of the community, the baptismal bath, the proclamation of the Word of God, the sharing of bread and wine (the Body and Blood of Christ) at the table and engaging in social action are things that matter. Here is an example. Instead of debating what color to use during Advent (blue, blue violet, purple), Lutheran pastor Keith Anderson suggests focusing on "counter-cultural waiting, longing and incarnation"[2] as they relate to the issues that matter most to the congregation. This is an important distinction because in many cases more attention is paid to the furnishings, artifacts, and objects

1. A cross "with the figure of Christ crucified upon it" (GIRM 308) may be placed either on or near the altar. It is appropriate that it should remain there even outside liturgical celebrations. This crucifix is different from a processional cross.

2. Keith Anderson, "The Color of Your Advent Candles Doesn't Matter," *Leading Ideas*, The Lewis Center for Church Leadership (November 12, 2014), https://www.churchleadership.com/leading-ideas/the-color-of-your -advent-candles-doesnt-matter/.

of devotion than to learning the art of celebrating the rituals as a faith community.

In the Catholic religion most guidelines speak constructively about art in terms of spiritual dimensions, quality of materials, liturgical functionality, and beauty. The same levels of quality and significance expected in works of architecture and religious art also apply to liturgical items. Sadly, not every church invests in liturgical items crafted by hand. Works of liturgical art, furnishings, appointments, and holy imagery should be designed with proper proportions on a human scale, all relating to the immediate surroundings. Altar tables are designed for a single presider, not for several concelebrants. A mammoth image of Jesus crucified suspended from the ceiling or mounted on a wall will dominate the church interior. But how will individuals interact with it? The early idea for the crucifix in the cavernous Cathedral of Our Lady of Angels in Los Angeles was to hang a colossal piece over the altar table. The notion was withdrawn after consideration of the devotional customs of Latinx peoples and others of kissing and caressing statues of the suffering body of Jesus. A bronze, human-scale crucifix designed by Simon Toparovsky is now inserted in the floor. It is accessible to all who wish to embrace it and, by so doing, relate to or acknowledge the injustices symbolized by that cross. On Good Friday it makes sense to venerate the cross or crucifix that has stood in the midst of the assembly all year long rather than bring miniature ones out of the closet.

The principles that call for original works of religious art and liturgical art are the same. Rather than purchase mass-produced pieces out of church goods catalogues, why not commission the highly talented and gifted artists and artisans who work in a given region? Some pastoral leaders are quick to work with studios who buy their "custom made" sculptures, icons, glass art, vestments, and vessels from companies in other countries. In such arrangements the congregation may never get to meet the artist. And the artist may never get to listen to the stories and expectations of the local congregation. The appropriateness, the quality, and the

theological or historical underpinnings of a work of art are all dependent on the knowledge, inclinations, and tastes of the local church leaders, committees, and architects. But how do congregations decide what art is beneficial to them in their churches? Regardless of stylistic preferences, will those who are responsible for religious and liturgical art take into consideration the short- and long-term impact these pieces will have on the congregation?[3]

It is well known that the appreciation of a work of art by a viewer or listener is rooted in someone's cultural and educational backgrounds.[4] The interpretation of a work of art will also depend on whether a person or group is influenced by a preconceived expectation. Some perceptions are skewed by what is thought to be the acceptable norm in the group. The task facing committees responsible for selecting and installing religious and liturgical art is challenging. It will be hard to find a common ground when the personal taste of some members is overbearing or when multiple devotional customs are popular in the congregation. The question of appropriateness looms large.

It will also be true that when people who have no appreciation for the arts are entrusted with making decisions, the results will be disappointing. Thomas Merton wrote incisively about the absurdity of superfluous decoration. He railed against vestments stitched with brocaded images of the Virgin Mary and an altar table that has a carving of the Last Supper on the frontispiece. He asked why the decoration is necessary when the actual Eucharist is being celebrated on this very altar table. He wrote that such illustrations "are rather vague reminders or suggestions, stimulants for the

3. See Richard S. Vosko, "Finding and Working with Artists," in *God's House Is Our House: Re-imagining the Environment for Worship* (Collegeville, MN: Liturgical Press, 2006), 176.

4. See Mihaly Csikszentmihalyi and Rick E. Robinson, *The Art of Seeing: An Interpretation of the Aesthetic Encounter* (Los Angeles: The J. Paul Getty Trust, 1990), 139. The authors also present theories on the facilitation of the aesthetic experience in terms of space and time.

senses, meant to encourage a pious mood or to induce a sentimental sense of comfort. They have no constructive function, they merely entertain and soothe."[5] Although Merton would allow for artistic license when it comes to shapes and colors he objects to "the *illustrative* convention which harps on pictorial decoration without rhyme or reason, and with no concern for propriety or good sense."[6] A lot of attention has been given to translating texts, composing music, and revising rituals. Similar efforts should be made to educate clergy and congregations in the importance of liturgical art in the worship environment.[7]

Generally speaking, since the emergence of the liturgical movement in the United States, which dates to the late 1920s,[8] modern church architecture stressed simple interiors and a minimalist approach toward free-standing or mounted art forms. On top of this attitudinal shift about art in churches, chapter 7 in the Constitution on the Sacred Liturgy cautioned against the multiplication of images in churches (SC 125). This dictum was interpreted (rightly or wrongly) to mean a reduction or the elimination of statues and paintings and any architectural flourishes that might cause distractions during worship and thus hinder full, conscious,

5. Thomas Merton, *Disputed Questions* (New York: Harcourt Brace, 1960), 265.

6. Merton, *Disputed Questions*, 266.

7. Catholic seminaries generally do not offer courses that link the arts to worship. Others do. Union Theological Seminary (New York), Wesley Seminary (Washington, DC), United Theological Seminary (New Brighton, MN), Institute for Sacred Music at Yale (New Haven, CT), and Graduate Theological Seminary (Berkeley, CA) successfully integrate the arts with worship.

8. *Orate Fratres*, a monthly journal dedicated to the liturgical movement, was first published by the Order of St. Benedict in 1926. The Liturgical Arts Society was organized in 1928 as a national effort to promote the arts, liturgy, and culture. The Catholic Art Association began in 1937. It was an organization of artists and educators interested in exploring the philosophy of Catholic art.

active, participation in the rituals. Again, for some, personal piety remains more important than participation in the community's ritual performance.

Architect Duncan Stroik lamented that "some of the reasons for the lack of the sacred in our modern churches are the absence of unity, harmony, beauty, tradition, symbols, and recognizable imagery. Something has been lost that needs to be regained."[9] Stroik may be right in that there are still many questions about the creation, the incorporation, and the function of art in church architecture. The major challenge is to understand how to integrate liturgical art and religious art with the worship of the community and its mission. In a secular example, the furniture designer Florence Knoll Bassett (1917–2019) employed a "total design" approach to her work. According to Aileen Kwun, Knoll Basset "considered form and whole environments at every scale: from the building structure, to its interiors, furnishings, colors, graphics, material, and textiles."[10] This approach echoes what the liturgical pioneer Virgil Michel (1890–1938) thought about liturgical art. According to Keith Pecklers, for Michel "the relationship between liturgy and art was not extrinsic or artificial but organic. In this manner, art was participative, contributing to and symbolically expressive of the call to liturgical participation which was at the heart of the [liturgical] movement."[11] The problem is also with understanding how ritual performances are carried out. Minimalistic approaches to worship are essentially nonsensual affairs. Paltry works of art that do not serve the liturgy or stir the imagination or call people to works of justice are not helpful in a place of worship.

9. Duncan Stroik, "The Altar as the Center of the Church," in *Adoremus Bulletin* 18, no. 1 (March 2012), https://adoremus.org/2012/03/15/the-altar-as-the-center-of-the-church/.

10. Aileen Kwun, "7 Things to Know about Mid-Century Design Pioneer Florence Knoll," in *Artsy*, May 22, 2017, https://www.artsy.net/article/artsy-editorial-7-things-mid-century-design-pioneer-florence-knoll.

11. Pecklers, *The Unread Vision*, 223.

Liturgical theologian Gordon Lathrop posed a list of observations about art in churches that can help us think through some of the sensitive issues that surround both religious and liturgical art and how they best serve a liturgical community. Lathrop is interested in identifying art forms that, depending on the culture or location, may be out of place "in the meeting: art that is primarily focused on the self-expression of the alienated artist or performer; art that is a self contained performance; art that cannot open itself to sing around a people hearing the word and holding a meal; art that is merely religious in the sense of dealing with a religious theme or enabling individual and personal meditation but not communal engagement; art that is realistic rather than iconic; art, in other words, that directly and uncritically expresses the values of our current culture."[12]

The crafting of religious art and liturgical art for any congregation is a unique vocation that does not draw attention to the artist or artisan or even their gifts and talents. The original work they do for the congregation takes something from them. The commission ought to be a transforming experience for them and, in time, provide the opportunity for transformation in the community. There are some artists who do give of themselves for the common good. I remember having a conversation with the prolific sculptor Robert Graham (1938–2008) when he finished designing the remarkable Virgin and the Great Bronze Doors for the Cathedral of Our Lady of the Angels (Los Angeles, 2002). I asked him, what's next? He replied, "Nothing. I am spent."

12. Gordon W. Lathrop, *Holy Things: A Liturgical Theology* (Minneapolis: Fortress Press, 1998), 223.

The Ministry of Church Buildings

22. Servant Churches I

"The church building is a tool for the work we do in the community."
—United Methodist Pastor Adam Hamilton

Houses of worship minister to their congregations in many ways. They are architectural and artistic storybooks full of innuendoes that play with the imagination. They are functional places for education, social outreach, public rituals, and private devotions. Most important, they are manifestations of a faith community's identity, its ecclesiological fingerprint in the neighborhood. Developing a unique recognizable character has become a strategy for many religious groups who believe it is a way to promote their particular brand of religion. Ironically, just a little more than one half-century after a major *ecumenical* council, Christian cohorts, with some exception, are once again stressing what distinguishes them from one another.[1] Some congregations have resorted to styles of architecture and liturgy born centuries ago to attract seekers or the "nones." Others believe that their traditional identity and accompanying doctrines were blurred or erased by church reforms, and they want to regain those traits. The revisionist approach to liturgy may also explain why some Catholic church leaders are returning to older uniquely Catholic

1. There are several ongoing dialogues between some denominations. A good example of this is found in the Third Anglican–Roman Catholic International Commission's *Walking Together on the Way*.

practices. This may also explain why some younger clergy are making a sartorial statement by donning vestments and clerical attire that were in vogue during the pre–Vatican II eras. In terms of church design, generally speaking, some mainline Christian religions in the United States do not want their places of worship to look "modern" or "Protestant." It would be fair to say that this is, in part, a reaction to the functional but nonaesthetic big-box churches favored by some emergent nondenominational, evangelical, or pentecostal congregations.

In architectural terms, the identity of a church building may be classified as traditional, modern, or eclectic. But until the church building takes on the personality of a live congregation it lacks a "heart beat." It's just another structure, regardless of how it is categorized according to style. What identifies a church edifice as a servant in the community is not its architecture but the people who use the building. It is arguable that any structure alone, unless it is a cemetery mausoleum, a columbarium, a memorial, or a historic structure, will maintain a long-lasting significance in the eyes of the general public. A concert hall or art museum designed by a world-class architect may draw attention early on. However, without a schedule of attractive programs and exhibitions it remains just another venue or a tribute to the donors. Even the nominal presence of a faith community in a church building is not enough to convince the neighbors that this place is there to serve them. The programs developed by a church matter much more than the building, although a structural shelter of some sort is necessary. Those activities and spaces would include worship, education, drug counseling, food pantries, soup kitchens, counseling centers, and second-hand clothing shops, to name a few. Some congregations offer help to refugees and others who are homeless. Faith groups can minister to the local community even without a church building. I once visited such a place in Oslo, Norway, where volunteers fed homeless persons daily. The building reminded me of the urban store-front churches that serve many inner city neighborhoods in the United States. Visitors who suffer from

drug addictions or other ailments are welcome without any discriminatory sanctions. During the simple meal, the Lutheran minister, Carl Petter Opsahl, presided over a service with words and live music. I was emotionally moved during the communion ritual. The same persons who dished out food and beverages earlier brought the blessed bread and grape juice to us, seated at our tables. This experience was another example of the inseparable link between worship and social justice, a connection that is not always emphasized in many Christian congregations.

The Catholic Order for the Dedication of a Church and an Altar publicly claims the building as a sacred place, meaning it is set aside for the worship of God. The ritual also points out how the structure is a "visible sign of the living church, God's building that is formed of the people themselves" (ODCA 1). Churches manifest God dwelling within the people of faith who are "living stones" (CCC 1180). The worship of God is empty if, somehow, the presence of God is not apparent in the good work of the congregation. The building may be a powerful manifestation that the people of God are present in the neighborhood. But there is more. The edifice offers the *possibility* that individuals or groups will encounter transforming experiences in that place. Without a living congregation, however, the church building, in reality, is just a building—even though at one time it may have been dedicated or consecrated to be a "sacred" space. Deserts and mountain tops acquire a hallowed significance when they serve as agents of change or enlightenment. Otherwise they are just what they are—wonders of nature. A church is not sacred simply because a ritual, a document, a pastoral leader, a designer, or an architectural critic designates it as such. Nor is a church sacred because it houses a particular element, such as a tabernacle, font, pulpit, table, altar, or cross. Human beings use these elements to perform rituals that put them in touch with their traditions and visions as they honor God and find ways to be ministers of justice and peace. The furnishings and appointments are not as important as the act of worship itself or the faith of the group. One even begins to question

the significance of liturgical art, appointments, and furnishings when these are compared to the Norwegian soup kitchen experience described above. Many times, after a natural disaster or accident when an entire church and its contents are destroyed, congregational leaders are quick to point out, "It was only a building." It is the people, their faith, and good work that matter most of all.

Although church buildings and the liturgy of the eucharist do not actually create faith communities, these two art forms (the practices of worship and the architecture) can affirm and keep a group together by challenging and reminding the people about their identity, their creeds, and their purpose in the public sphere. A Post-Modern church building will not magically turn people into "modernists," although it may hint that the members are comfortable with that way of life. In the same way, a cathedral built in the Renaissance Revival genre will not create medieval-minded congregations either, although it may suggest that the members are more content with older styles of worship, art, and architecture. Over time, however, a church building—particularly its interior spaces and objects of art—will gradually affect and affirm the identity of the congregation and, thus, influence its behavior. This is why it is appropriate that when an African American congregation moves into a church formerly used by German or Slovak nationals the new occupants will be quick to redecorate the place with art and furnishings characteristic of their own identity.

The discovery of the true uniqueness of a congregation requires spending time with the members, worshiping with them, listening to their stories, and participating in their social outreach programs. This is why architectural critics cannot offer a credible judgement of any place of worship unless they have actually spent time there mingling with the members. It is unfortunate that some writers will shamelessly identify a church as ugly even though the congregation worked hard to build it and is pleased with it. Buildings used by a congregation for worship and other programs will gradually acquire a sacred presence in the neighborhood, but this metamorphosis does not happen overnight. It takes time

for a congregation to transform a neighborhood from a destitute place to a heavenly vicinity. A congregation will not grow if it is stuck in a time warp and shows absolutely no interest in responding to the needs of its members and the world beyond. A flexible faith community with a collective open mind will find ways to adapt. The church building for the former group will reflect their status quo manifesto. But for a community that is constantly changing and advancing as a people of God, a well-designed and flexible church complex will continue to provide an infusion of new life. As liturgical consultant John Buscemi once admonished, "Church buildings aren't Catholic, people are."

Because Christ is the foundational sacrament, and because Catholics call the church the sacrament of unity, the church building also is thought to be sacramental. Marshall McLuhan would say that it is an extension of the community.[2] To function as efficacious sacramental servants to the congregation and its neighbors, church buildings must undergo periodic adaptations and reorderings. A good church leader, like a good government leader, will shift priorities, set aside personal agendas, and act independently of the status quo in order to remain relevant with constituents. If the building is to be a true testimony to the people of God, it, too, will change. This is, perhaps, what Edward Sövik meant when he spoke of the "non-church" church. He argued that a church building must be designed to be more than just a house of worship. There are many outstanding models of new and old churches that both affirm and challenge the identity of the congregation. Although I have served as a designer and consultant for almost 150 houses of worship in North America, I am most familiar with a parish where, for many years, I served as a sacramental minister. The community of St. Vincent de Paul in Albany, New York gathers in a church that resonates with the ecclesiology of the congregation. It is an excellent example of a servant church.

2. McLuhan would say the wheel is an extension of the leg, glasses are an extension of the eye, the computer is an extension of the brain.

The parish is known for its social justice programs and a vibrant liturgical practice. For many years this "intentional" community has welcomed with open arms people from as many as fifty ZIP (postal) codes, especially those who were turned away from other parishes for one reason or another. Built on the edge of a mid-town college campus, the 1908 Greek Revival building (enlarged in 1957) looks like a bank or courthouse. Standing proudly on the street corner, it appears as a steadfast temple of power and stability in the neighborhood. Today, the interior reveals a different story, one that shows the growth and flexibility of the congregation and its leaders. Fr. Leo O'Brien (pastor from 1972 to 2006) was the inspiration for many who became involved in the parish and its ministries. The church was first constructed to accommodate the rituals of the pre–Vatican II church. It had the normal divisions known as the narthex, nave, and sanctuary. The gallery housed the choir and a fine Casavant Frères pipe organ (Opus 1393) that is still in use. At the other end there was a handsome marble balustrade that spanned the front of the elevated chancel. That railing served as a line of demarcation between clergy and laity. The decorative raised sanctuary area was distinct in design and looked more important than the nave. One thousand worshipers faced that end of the building as they stood, sat, and knelt to hear the clergy "say Mass."

After a fire in 1980 the building was reconstructed effectively to include a smaller 400-seat church, offices, meeting rooms, and a parish hall. The neighborhood was gradually changing and so was the make-up of the congregation. The most recent 2014 enhancement of the worship area, orchestrated by C. Elizabeth Rowe-Manning (parish life coordinator from 2007 to 2016) and a talented committee, offers a very different liturgical narrative more in keeping with the members who understand liturgy as something they enact with their clergy. Now the altar is located exactly in the center of the square nave. The assembly, including the peerless music ministry, is arranged in perfect concentric circles around the barrier-free platform. Everyone is surrounded by the original radi-

ant German glass windows and eight large newly written icons depicting older and younger holy ancestors. The liturgy is performed beneath a ceiling painted like a starry sky, reminding the worshipers of their place in the cosmos. The presiding clergy sit in the first row along with members of the assembly.

This liturgical arrangement mirrors the spirit of radical hospitality and inclusivity that has been the hallmark of the congregation for generations. It also reflects the group's collaborative field mission to contribute to the welfare of the city. It operates one of the largest food pantries in the region and participates in a wide range of community outreach programs that support prisoners, immigrants, and refugees. The intimate circular plan energizes the assembly's level of participation during liturgy, drawing everyone into the memorial of their own paschal mystery. One teenager exclaimed, "There is no place to hide in this church!" As worshipers glance across the altar table, in full view of the sacramental elements, they see other members of the Body of Christ across the way. Standing together, with arms outstretched, they pray in spiritual and prayerful solidarity. The eucharistic prayer, proclaimed by a presider, who stands slightly away from the altar table, is the assembly's prayer of thanksgiving. There are no outsiders in this borderless and inclusive environment for worship. The ritual performances that occur in this enhanced church building give hope and strength to the members of this faith community and to visitors. The congregation has grown in its identity as the Body of Christ given for others. This building is a good example of a church that serves its congregation. The renovation conserved traditional architectural features and balanced them with an innovative liturgical plan. There are images of the church in this book. (See figs. 1–4 in the full-color section.)

The Butler Memorial Chapel in the Marymount Convent, Tarrytown, New York, is another good example of a similar all-embracing floor plan. The Religious of the Sacred Heart of Mary reordered their chapel to locate the altar table more into their midst. They wanted to enrich their participation in the worship of

God and bring members of the community with different abilities together into the same space. The sisters also did not want to remove any of the traditional works of art that constituted the innate architectural style of the chapel. (See figs. 5–8 in the full-color section.)

Some will contend that the church and chapel described above, or any other one designed with a similar all-embracing floor plan, focuses too much on the assembly and not on God. It is important to acknowledge again that although God is honored during worship, the eucharistic liturgy is not something directed at a distant Being. It is a memorial of Emmanuel, God who continues to walk with us. Sacramental liturgies are ritual acts of thanksgiving for the gift of faith and for the mission of the incarnate Son of God. Worship is also a covenantal response to the gospel challenges to secure the relationships in and among God's people here and now on earth. A church building that effectively ministers to the assembly is a structure designed to pull clergy and laity together, physically and psychologically, during worship. Such environments will also inspire the same assembly, mindful of its common bond, to advocate for others.

Yes, the idea behind constructing beautiful churches is to remind people that the God of all creation is both immanent and transcendent, and that God's graces are invincible, everlasting, and available to everyone. However, it makes little sense for a community to think of God only as eternally residing in a distant heaven or to strive for an imaginative but fictional City of God somewhere else. What the world needs now are people willing to work for justice and peace without expecting a reward for doing so. Already existing elaborate churches have not been persuasive enough to attract young generations who claim they can be moral people and advocates for justice without the help of institutionalized religion. In this context we have to ask pointedly, what theology, what ethic, what Christian life does the church building reflect? Roger Haight offers a viewpoint about the symbolism of church buildings. In his study of the Christian community he writes, "they express the general corporate experience of the Christians that the church

provides a social space in which God can be encountered as immanent to human life in history. The Spirit is both prior to the community and made available through it."[3] Haight implies that Christians transmit the presence of God in society and that their churches are enablers in this mission. In the next chapter I will focus specifically on how a church building can be a servant to the local congregation and the larger community.

3. Haight, *Ecclesial Experience*, 87.

23. Servant Churches II

"The greatest among you will be your servant."
—Matthew 23:11

The city of Rotterdam in the Netherlands was almost completely leveled by German bombs in 1940. The devastating loss of lives and properties left a scar on the city but did not thwart the rebuilding effort. Since then, some buildings were restored to a prototypical prewar Dutch architectural style. However, for the most part, community leaders departed from tradition and chose a modernist cubist style of architecture (Nieuwe Bouwen) to bring life back to its urban centers. Today Rotterdam is a refreshing example of an architectural renaissance.

One such example is the Pauluskerk (St. Paul's Church). Originally built in the 1950s, it continues to serve as a shelter for people who are refugees, homeless, unemployed, seeking asylum, or addicted to drugs. Dutch Protestant minister Hans Visser was the visionary who turned the church into a safe place for those living on the edge of society. The church building, however, went through a metamorphosis. The original church was demolished in 2007 during the redevelopment of the neighborhood and the construction of the new Central Station just blocks away. In 2013, British architect William Alsop (1947–2018) designed the new church as a multifaceted polygon. The building includes a chapel and what is called The Diaconal Center for counseling, resting, and networking. Bread, coffee, and tea are available daily. A full meal is

served once a week. The Pauluskerk is an extraordinary example of a servant church and the way responding to human need goes hand in hand with honoring God. In this case, a place for worship and an outreach center are both under the same roof.

Capitalized or not, the word "church" can be thought of as both a people and a building. It may be a helpful exercise to personify church buildings in order to see them anew as humble servants. I would like to characterize the church (both the building and the people) as one body that welcomes, forgives, heals, unites, and remembers.

My perspective arises from my Catholic background. I hope, however, that other Christian churches can make similar comparisons and analogies and thus recognize new possibilities in their own buildings. This exercise is part of my search for a common ground that will bring many different congregations and faith traditions together. Proselytism is not intended. I am mindful of the admonition by Gordon Lathrop: "In the quest for Christian unity, we cannot simply insist on our discipline for other churches . . . [but] in the quest for renewal, we cannot avoid what is to be renewed."[1] Lathrop argues that diversity in liturgical practice should not deter the search for unity among Christian groups. A common ground really has no boundaries.

The Church Welcomes.
"And the streets of the city shall be full of boys and girls playing there" (Zech 8:5).

Rampant shootings took place in the West and South sides of Chicago and other cities during 2018. Innocent children are gunned down while they play in the streets. Many refugees and migrants have no work and no place to live. Children are ruthlessly separated from their parents and guardians as part of misguided government

1. Gordon W. Lathrop, *Central Things: Worship in Word and Sacrament* (Minneapolis: Fortress Press, 2005), 10.

policies concerning immigrants in the United States. Although religious buildings are not primarily designed to serve as asylums from such atrocities, they can be places of safety and welfare. When elected officials mandate programs that deny strangers basic human rights, faith communities must come to the rescue. In his homily on the Gospel of Matthew, St. John Chrysostom (349–407) echoed the words of James 2 and admonished his listeners to honor Christ's body. "Then do not scorn him in his nakedness, nor honor him here in the church with silken garments while neglecting him outside where he is cold and naked."[2]

Some religions use the word "sanctuary" to describe the entire nave; others like the Catholic Church, refer to the sanctuary as the place for presbyters (the presbyterium) and their assistants. Some religious leaders, however, are courageous enough to declare their churches, cathedrals, and chapels as true places of sanctuary. In doing so they offer a welcome to strangers, as Sarah and Abraham did when they greeted three unknown visitors to their tent (Gen 18:1-15).

Some congregations will say they cannot provide night shelter because of space limitations. St. Boniface Church in San Francisco offers a counterexample. That congregation has participated in the Gubbio Project, which provides blankets, hygiene kits, and socks to around 150 people who rest in the church nave each weekday. No questions are asked. No forms are filled out. The founder of the Project, Doug Pierce, said: "The whole sanctuary becomes a tabernacle when it's filled with the poor . . . The sanctuary is where Christ is."[3] A medieval example of such hospitality

2. St. John Chrysostom, "Don't Adorn the Church & Ignore the Poor" (excerpt from Homily 50, 3-4, PG 58, 508–509), *Crossroads Initiative* (August 28, 2018), https://www.crossroadsinitiative.com/media/articles/dont-adorn-the-church-but-ignore-the-poor-john-chrysostom/.

3. In Wyatt Massey, "Churches Answer the Call to Shelter the Homeless," *U.S. Catholic* (February 2018), https://www.uscatholic.org/articles/201801/churches-literally-answer-call-shelter-homeless-31271.

is found in the Cathedral of Our Lady of Chartres in France. Docents usually point to the floor near the main entrance and close by the famed labyrinth. They explain that early in the morning, before worshipers arrived for Mass, workers would wash down the slightly sloped surface where homeless people slept the night before. The gray water flowed into the front yard. This is another model of a church building acting as a minister of hospitality.

Whether or not it is used as a homeless shelter by day or night, an inviting lobby in a church can serve to remind the congregation that hospitality is a key characteristic of the Christian mission. A servant church building that expresses this trait ideally will have ample parking or be near mass transportation. It will have well lighted, safe walkways, visible signage, and welcoming, barrier-free main entrances.[4] There will be easy access to restrooms and child care areas. If there is no space in the church proper, the congregation might use other areas to shelter, feed, and counsel people.

The Family Promise[5] movement is a project in which multiple faith traditions work together to prepare temporary shelter for homeless families. First established in 1986 by Karen Olson, this Interfaith Hospitality Network is now a nationwide movement. About 200,000 volunteers from 6,000 congregations nationwide provide services to more than 50,000 homeless and low-income people annually. Imagine if the Christian way of living began first with social outreach programs that then led to the worship of God? Worship would be an act of giving thanks to God for the call to be advocates for human rights. Starting with the worship of God is no guarantee that the congregation will step up to serve those in need living in the shadows of their church.

4. Rabbi Aaron Siegel reminds us that a congregation's webpage is the new front door and that Twitter, more so than Facebook or Snapchat, is the more effective weekly bulletin.

5. See the Family Promise Story at www.familypromise.org.

The Church Regenerates.

"We were all baptized into one body" (1 Cor 12:13).

Membership in a church is one way to find meaning in one's life. It offers possibilities to establish rewarding relationships. This is especially true for those who are active in a church's various programs. The nonjudgmental embrace and support of a community is also something that young people are desperately searching for. In the Christian tradition the ritual of baptism marks a person as a "priest, prophet, and king" [*sic*] in the community. It also celebrates a formal initiation into the life of the church. In one of my building projects the committee was adamant that the baptismal font should not block the main aisle where processions begin. They were thinking about wedding marches! How did they not know that the baptismal water bath is an experience shared by all church members; that it is a major step taken before any other sacramental celebration?

The Christian water bath is part of the initiation rite that follows a catechetical period and continues with an anointing in the Spirit and a sharing in the Eucharist. An abundant amount of recycled, heated, rippling ("living") water is used to baptize the elect by submersion, immersion or infusion (a pouring of water over the body).[6] An appropriately scaled container of this "holy" water, that is, a baptismal font that allows for all the ritual options, is customarily located in or near the main entrance to the church. In that space it serves as a reminder of each member's baptismal entrance into the church. Placing a baptismal font near the altar table today "so everyone in the congregation can see" is an anomaly in the overall history of liturgical practice and should be avoided. It is another misunderstanding of the church's symbol system.

6. See The Orders of Infant Baptism (1968) and The Christian Initiation of Adults (1972) on the options for baptizing children and adults. Both of these rituals may be ordered from Liturgical Press, https://litpress.org/.

It would be easy to say that a vessel for water is not as important as the water itself or the faith of the individual. Yet, water is a fluid that needs to be contained and directed for various purposes—cooking, drinking, washing. During the water bath, families, friends, and little children are invited to gather around the font full of clean, fresh water. In very large churches the use of closed-circuit cameras and environmental projections will make it possible for everyone to witness the ritual.

Congregations must allow water, a multilayered symbol of life and death, to be what it is in order for it to serve the congregation effectively. Although described in Scripture as a ritual of "dying and rising with Christ" (Rom 6:1-10), no one expects a person to drown during the baptismal rite! On the other hand, a minimalistic use of water and oils during this initiation event and at other times (the sprinkling rite and confirmation liturgy) overlooks the importance of learning the "art of celebrating" any ritual. Handsome vessels for the holy oils are not concealed in the sacristy closet but housed in attractive cupboards (ambries) near the font or another convenient location.

The Church Forgives and Heals.

"Get rid of all bitterness, rage and anger, brawling and slander, along with every form of malice. Be kind and compassionate to one another, forgiving each other, just as in Christ God forgave you" (Eph 4:31-32).

In 1986, Howard J. Hubbard, then Bishop of the Diocese of Albany in New York, led a historic Passion/Palm Sunday reconciliation service between Christians and Jews in the diocesan cathedral. During that event Bishop Hubbard apologized for the church's age-old prejudices and hurtful actions against Jews.

How do members of Christian congregations reconcile their sins against one another and others in society? The Catholic tradition has a rite whereby an individual can make a confession to a ministerial priest at almost any time and receive sacramental

absolution.[7] There are two other forms of this rite that focus more on the corporate nature of sin (Isa 6:5). One form, usually enacted during Advent and Lent in a parish, includes an opportunity for an individual confession of sin within a communal celebration that also includes proclamation of the Word, preaching, examination of conscience, a litany of repentance, and an expression of collective praise and thanksgiving for God's mercy and forgiveness. The ritual for a general absolution is the third form, allowable in times of crisis or danger, imminent death, and the unavailability of enough ordained confessors to hear individual confessions within a reasonable period of time. The Penitential Act at the beginning of every Catholic eucharistic liturgy, though not designed as a communal reconciliation rite, is one of the many ways Catholics acknowledge their need for God's mercy.

Every Catholic church building has at least one reconciliation chapel. This small room is set aside only to be used as a place where someone can read a Scripture passage, confess sins, discuss a suitable penance, express remorse, and benefit from the absolution prayer of the church. It is not an all-purpose storage room! Nor is it a "box." Usually located near the baptismal font at the main entrance to the church, each chapel is furnished with a meshed grille to allow the penitent to remain anonymous, if desired. There are chairs for the confessor and the penitent on both sides of this screen. Kneelers are customary but not required. The chapel should be accessible for persons with different abilities. The installation of doors with inlaid lattice work can provide some reassurance about creating a safe environment for penitents and confessors. Some argue that the "confessional" box was the sixteenth-century innovation of Charles of Borromeo and is not necessary today. During communal reconciliation liturgies penitents are accustomed to sitting with the ministers at different "open" locations in the

7. Other Christian denominations have similar rituals, but they are not referred to as "sacraments."

body of the church, making the entire assembly area a place where God's mercy is celebrated.

In a related way, many religions have rituals for the healing of individuals who are suffering from various illnesses or psycho-somatic problems. "Are any among you sick? They should send for the church elders, who will pray for them and rub olive oil on them in the name of the Lord" (James 5:14). Again, in the Catholic Church a ministerial priest will anoint anyone who is seriously ill or in danger of death. The sacrament may also be celebrated with someone preparing for surgery. The ritual serves to remind the person that Christ is present to them in times of sickness or ill health, and it draws the attention of the faith community to Christ's presence in and with them in their suffering. The support of the community in the form of caregivers, health care professionals, and anyone who accompanies the sick is likewise important. Thus, the church building serves as the usual place for the entire con-gregation to celebrate the rite. The "oil of the sick" used in this sacrament is kept in a cupboard (ambry) with the chrism and the oil of catechumens.

24. Servant Churches III

*"Religious, congregational, individual, and community memories
are embodied in church buildings."*
—Jennifer Clark, historian

The Church Unites.

"They came to know him in the breaking of the bread" (Luke 24:30).

Betsy Rowe-Manning, former parish life coordinator at St. Vincent de Paul Parish (the one described earlier), often tells this short story about an experience she had in the church one Sunday. A couple approached Betsy as she was serving Communion. Their young son, still not old enough to take Communion, was casually trailing behind them. After the parents shared the sacrament, the little boy stepped forward, looked up and smiled at Betsy. He then stretched out his hand and offered her a Goldfish, one of those tiny yellowish, cheesy crackers. He said loudly, "This is for you, Betsy!" Then, with a big self-congratulatory smile on his face, he skipped off to catch up with his parents.

The sacrament of the Eucharist is ultimately about relationships, connections with God and other human beings. It is an expression of thanksgiving for those alliances that also carries with it some responsibilities. Like the other sacraments, and liturgy in general, sharing in a holy communion is not a solitary experience but a communal one. Indeed, the word "companion" comes from two Latin words—"with" and "bread." It was in the "breaking of the bread" that the disciples at Emmaus recognized Christ, "raised

from the dead by the Spirit" (see Rom 8:11). In Pope Francis's 2018 catechetical series on the Mass, he described the Communion Rite as a time when "Christ comes towards us to assimilate us in him. There is an encounter with Jesus."[1] The pope continued by paraphrasing St. Augustine, saying, "to nourish oneself of the Eucharist means to allow oneself to be changed by what we receive."[2] Breaking bread with others is a way of saying "I am with you all the way." The congregation's embrace of the paschal event is a means of identifying who they are as the Body of Christ—celebrants of their own mystery in the church and in the world.

Roger Haight offered this insight about Paul's understanding of the Body of Christ: "Many make up one; differences are acknowledged and coordinated, divisions in class, rank, order, charism, ministry, gender, nation, and race are overcome."[3] A centralized layout of a church with a circular, semicircular, or antiphonal seating plan is simply the best expression of a relational community. In such arrangements the focus of the congregation during the eucharistic liturgy is the altar table, the symbol of Christ.[4] The language in current ritual books of the Catholic Church clearly states that the altar is not in a remote location but in the true center of the congregation. In the General Instruction of the Roman Missal, we read, "The altar should, moreover, be

1. Pope Francis, General Audience on the Liturgy of the Eucharist (March 21, 2018), http://w2.vatican.va/content/francesco/en/audiences /2018/documents/papa-francesco_20180321_udienza-generale.html.

2. Francis, General Audience on the Liturgy of the Eucharist.

3. Haight, *Ecclesial Experience*, 86.

4. Others might argue that the ambo is also important as a place for the Liturgy of the Word. I maintain, as did Aidan Kavanagh, that the font and altar are the two major furnishings around which the faith community gathers. The proclamation of the word of God does not require a particular furnishing. Further, in the Catholic ritual for the dedication of a church and altar, there is no dedication of the ambo or reading desk. It does not bear a symbolic value as does the altar, which is a symbol of Christ. There is, however, a blessing for the ambo in the *Book of Blessings.*

so placed as to be truly the center toward which the attention of the whole congregation of the faithful naturally turns" (GIRM 299). In the Order of the Dedication of a Church and an Altar the bishop prays, "Here may your faithful, gathered around the table of the altar, celebrate the memorial of the Paschal Mystery and be refreshed by the banquet of Christ's Word and his Body" (ODCA 62). These words are not intended for the ordained ministers only. They are invitations to the whole congregation to assemble around the altar table during worship.

From the earliest Christian periods the altar was a symbol or figure of Christ who replaced the altar of the temple. The practice of "vesting" the altar with decorative fabrics is a way of signaling Christ as the high priest of every liturgy. Placing the altar in the center of the congregation supports the belief that the church, the Body of Christ, is itself Christocentric. There is no logical reason for not placing the altar in the midst of the entire assembly, especially if full, bodily, sensory engagement with the paschal mystery is expected. The studies on the psychology of space and how humans behave in certain physical settings are too convincing to ignore. To place the altar on a distant and raised dais, where only ordained ministers are standing and presiding, perpetuates the notion that the laity are spectators. In terms of the impact of the architectural setting on adult behavior at worship, Sarah Williams Goldhagen pointed out in an interview that people do not notice how the built environment affects them. "People can gravitate to spaces, for example, that may not be psychologically good for them. Research shows that when we habituate to something, whether it's an environment or a pattern of buying, we tend to prefer that pattern, even if we'd be better off with something else."[5] Goldhagen's commentary is helpful in understanding the

5. Martin Pedersen, interview with Sarah Williams Goldhagen: "How Architecture Affects Your Brain: The Link Between Neuroscience and the Built Environment," *ArchDaily* (July 25, 2017), https://www.archdaily.com/876465/how-architecture-affects-your-brain-the-link-between-neuroscience-and-the-built-environment.

ways people behave in church buildings. It calls our attention to how the experience of the places they construct or arrange is central to their well-being, their physical health, and their communal and social lives. This reasoning, based on advancements in the field of cognitive science, suggests to us that if church buildings are to continue to serve their congregations effectively, they need to be reflections of who those people are and what their social-psychological needs are in the contemporary world. The question is this: Should attention be given to revivifying traditional models of church design that were better suited to the pre–Vatican II liturgy? Or should more energy be spent exploring new prototypes that just might be more beneficial to the future welfare of the church?

The Church Remembers.

"And he took bread, and when he had given thanks, he broke it and gave it to them, saying, 'This is my body, which is given for you. Do this in remembrance of me' " (Luke 22:19).

Back in the 1970s I attended a lecture on liturgy presented by Lawrence Madden (1933–2011), a well-known and respected liturgical practitioner and scholar. He spoke about the meaning of anamnesis or remembrance as a way of engaging with the paschal event in real time. He was not specifically referring to the mystery of faith but a way of understanding memory as it related to Christian identity. He said the word "remember" can be thought of in three dimensions: remember where you were yesterday; remember who you are today; and remember where you are going tomorrow. It is natural to think we move from the past, to the present, into the future. Astrophysicists will argue, of course, there are maybe three or six or more dimensions of space and time that we need to understand. But what Madden suggested is that Christians connect three dimensions of time—past, present, and future—and try to understand them as a holistic organism. Do church buildings reflect different dimensions of Christian time and space or do they lock into place one facet only?

1. Remembering Who We Were

While looking at photos of my deceased father before he was married, my siblings, cousins, and I could not identify some of the other people in the pictures. That's when our imaginations kicked in and the storytelling began. We probably made up a few tales, too. We also shared memorized proverbs or "words of wisdom." This is not mere amusement or diversion, but an exercise springing from a deeply human impulse. If we do not tell the stories about our ancestors, a piece of our own history will be lost. The new interest in finding our genetic roots is an indication that many of us *do* care about people and events of the past, even though we no longer live in that time. Catholic teaching says that the church is a communion or an assembly of saints.[6] To remind us of how we fit into our very large multigenerational family tree and how our ancestors contributed to our identity it has been customary to keep images of them in our midst.

Knowing the stories behind the saints or blessed ones is equally important. In this case it is also helpful to distinguish fact from fiction. We know for sure that Oscar Romero, a newly canonized Catholic saint, preached passionately about justice for the people of El Salvador and was assassinated in the Divine Providence Hospital chapel in Colonia Miramonte while celebrating Mass. We are certain that Teresa of Kolkata ministered to people who were dying from diseases and living on the edges of society. These are two exemplars of faith worth emulating.

John Nava is the Renaissance-style artist who drew the images of saints woven into the tapestries mounted in the Cathedral of Our Lady of the Angels in Los Angeles, California. One hundred thirty-five saints and blessed ones as well as a number of anonymous figures are woven into this collection of twenty-five tapestries. Nava depicted most, if not all of them, in unique garb, holding a symbol associated with them. No one can be sure of

6. *Catechism of the Catholic Church*, 946.

every historical fact behind this hagiographical artwork, but it does not seem to matter. That these figures are now in procession with living church members as they approach the altar for Communion makes a significant statement about a church for all ages and all regions of the world. The Communion of Saints tapestry collection is one artistic and architectural reminder of who we are as members of the long lineage of holy ancestors in faith worth remembering.

2. Remembering Who We Are

An impressive lesson from liturgical history is that the early Christians were quite adaptive and persistent even as they struggled to establish their identity. Up to the beginning of the fourth century they had little or no political influence or power in the wider community. In fact, because they were a persecuted lot they worried about their safety. Still they managed to gather frequently to break bread and tell stories about Jesus of Nazareth, even though they may have never met him. Scholars Smith and Taussig reminded us that partaking in early Greco-Roman style table customs, that is, the breaking of the bread, helped the members of the group to bond with one another and to pledge loyalty to a common cause. Sharing the meal to keep the memory of Christ alive defined the group more than any doctrine or attention to ceremonial detail.

The breaking of the bread symbolized their unity with the mission of Jesus and their bond with one another. When someone could not be present at table because of distance, illness, or some other reason, members would carry a fragment of the broken bread of Eucharist to them. It was a way of saying we have not forgotten you. By the second century Christian writers linked the meal to the sacrifice of Jesus on the cross and referred to the bread and wine as his "flesh and blood."[7] The Eucharist was thought to be

7. See the writings of second-century church leaders Polycarp of Smyrna, Justin Martyr, Clement of Alexandria, and Irenaeus of Lyons.

similar to the sacrifices reported in the Hebrew Bible. Jesus of Nazareth would be called the new Lamb of God whose blood was shed as an atonement for human sin.

As the ritual ceremonies for celebrating the Eucharist evolved, so did the respect for the reserved sacramental breads. In the beginning the Eucharist would be kept in the homes of Christians. From the fourth century on it most likely was kept in a church building. The receptacle came in all shapes and sizes—a suspended dove, a free-standing tower, a cupboard in a wall, and a receptacle known as a sacrament house. The locations were not made standard until much later. When the practice of adoring the reserved sacrament became a popular tradition in the Middle Ages, the tabernacle took on further prominence. There have been many decrees regarding the shape, size, and location of the tabernacle in a church, too many to investigate here.

When I was growing up it was taken for granted that the most important part of the church was the main high altar (reredos or retablo), where the tabernacle was located. Early post–Vatican II documents indicated that the sacrament was to be reserved properly in a chapel distinct from the altar table. Today, there are two equally legitimate locations for the tabernacle (GIRM 315). The first is in the main part of a church behind the altar table used for the enactment of the eucharistic liturgy. The other place is in a distinct chapel in a conspicuous part of the church. The Ceremonial of Bishops[8] recommends this second location in cathedrals, especially ones that draw large tour groups or serve as venues for different events.

One location is not preferred over the other, although the popular trend in the United States seems to be to return the tabernacle to the main church. Nevertheless, there is only one tabernacle in each church. The primary purpose for saving the Eucharist after Mass is, as it was in the very early church, to take it to sick

8. *Ceremonial of Bishops*, 49, (Collegeville, MN: Liturgical Press, 1989).

and dying members of the community and those, who for some reason, are not able to be present when the church gathers. The secondary reasons are for private adoration and, in case of need, distribution of the sacrament during the Communion Rite. Belief in the substantial presence of Christ in the eucharistic bread is the reason why some individuals, as a form of personal piety, keep watch over the reserved sacrament. This practice has in turn led to making the place where the sacrament is reserved an area "suitable for private prayer." The public adoration of the sacrament may occur periodically, in which case the sacrament is displayed in a decorative vessel for all to see.

Although my focus in this section has been on breaking and sharing bread for the journey, one does not come to the eucharistic table without being initiated in the Christian water bath. This is the main reason why, through most of Christian history, our fonts have been located in or near the main entrance to the place of worship. As we enter the church we remember how we entered the church. That there may be more than one entry to a church should not stop us from visiting the font to enact this customary ritual. Splashing our hands into the living water of our baptismal fonts and perhaps blessing ourselves and little children with the water, we remember the dates of our baptisms. It might be a good idea to help our children remember their baptismal date just like they remember their birthdates.

3. Remembering Where We Are Going

This is the dimension of time that may be fraught with anxieties. Will I find the right partner in life? Will a college degree guarantee a better job? How will I support my children? Will I ever get into heaven? Envisioning the future requires a vivid imagination. Making the world a better place for all to live in today and tomorrow is an even greater challenge. The anticipation of heavenly paradise as our eternal reward is the conventional way to inspire good behavior and a certain amount of social outreach. Although a dualistic understanding of an eschatological end time,

that is, earth-here–heaven-there, is a tenet of faith, it is not realistic to assume that this will foster the Christian vocation in this place and time. What Christians are summoned to do today is to work with other faith groups and with nonsectarian organizations to fill in the gaps caused by income insecurity, prejudice, and crime. Protesting government policies that reduce or cut programs intended to serve low-income adults and children can remind politicians of their duty to serve all people.

Christian churches can respond to cries for help by remembering the examples set by holy ancestors and the gospel summons to care for one another today. But there is a danger warning on the Christian label. Christians must know that the journey into the future will involve taking risks, opposing autocratic leaders, and the hard work of developing plans to establish peace and justice. Engagement in civic discussions about how to serve the common good will require diverse voices to reach compromise on issues. Church properties, as long as they are still perceived as safe havens, can serve those who participate in such conversations. Prayer and strategy sessions are always helpful, but without good work they are ineffective. What will matter most of all is participation in a cause greater than our own self-interest. Taking action on human rights issues, doing something—however large or small—will make a difference in the lives of people. Full, active, and conscious participation in the eucharistic meal is not an undertaking separate from volunteering in a work of mercy. Most Scripture scholars doubt that when Jesus said, "Do this in memory of me" he was instructing the disciples on how to say Mass. Rather, he was urging his followers to feed the hungry, house the homeless, clothe the naked, visit the sick, heal divisions, and protest injustice. His upper room commandment, the mandatum of service, is worth remembering in church buildings and out in the public square. It links the past, the present, and the future of Christianity.

part five

Urgent Issues

25. Generational Expectations

"I want to go to a church where I know I will not be criticized."
—a young Catholic woman

Human beings have always yearned to connect in some way with a higher good and power. Some call it the search for an ineffable being. Societies have erected temples, churches, and shrines to house rituals and artifacts to glorify or ingratiate themselves with one or more mysterious deities whose favor they desire or whose power they fear. Some people have turned away from communal practices altogether and rely on meditation, exercise, and simple lifestyles to move away from the business of "big religion." Pop-up worshiping communities and online churches are part of the mainstream. Charismatic leaders not tethered to ancient doctrines surface as new moral authorities. Older church buildings need structural maintenance while younger generations seek spiritual sustenance elsewhere. Rendering new and old houses of worship energy-efficient, barrier-free, and ecologically sound is a slow and expensive process. Income inequity is a global problem, yet we manage to spend billions of dollars on houses for a God who never really asked for them. Robert Hovda once assured me that money spent on places of worship is justified *only* if the buildings and the liturgies inside them will inspire assemblies to work for justice and peace.

Arguments about architectural style and worship formularies have long overshadowed other more important factors pertaining

to the secular and ecclesial worlds. In our own time, the future outlook for organized religion is being challenged by unimaginable scandals, intramural clashes, deception, and incompetent leadership. In some instances the doctrines embedded in older religious practices are just plain worn out. While the majority of Christians, ordained or not, maintain faith and hope and continue to promote the gospel mission and message, no effort to revive historical convention will set an effective course for the future. There are so many diverse voices claiming to represent the true faith, it is hard to figure out which map to follow. Maybe the English author of children's fiction Lewis Carroll (1832–98) was on to something when he wrote the dialogue between Alice and the Cheshire Cat. Alice: "Would you tell me, please, which way I ought to go from here?" The Cat: "That depends a good deal on where you want to get to."

Today, many people of faith are at a crossroads in their lives and vocations. Some do prefer to follow a well-worn path, while others are willing to explore new avenues. Throughout this book I have maintained that egalitarian places of worship are powerful architectural and artistic statements of unity. They can bring people together in pursuit of a common good, a common ground.

The future of any religion depends on whether younger generations will want to participate fully as active members as they mature. That is a big gamble because, as many studies have shown, younger people are feeling disenfranchised by the religion they were raised in. Some of their parents share the same sentiments and have either switched religions or rejected religion altogether. What a place of worship looks like does not appear to be a deciding factor for Generations Y and Z when it comes to affiliation. They are concerned about how church leaders will respond to their needs. On the other hand, surprisingly, there are some indications that not even clerical scandals and leadership deficiencies will drive people away from practicing their faith and doing good work. Without a formal membership in a church, people will live decent lives and help others when they can. The literature refers

to these people as "nones." Maybe "nonreligious Christians" is a more suitable term. But what about the young people on the fringe, neither here or there, in or out, who want a say in how their religion develops? Perhaps they want to be listened to as they search for God and justice.

As I write this book, the Roman Catholic Church is conducting a Synod of Bishops. The topic for the Fifteenth Ordinary General Assembly is "Young People, Faith, and Vocational Discernment." The working document (*Instrumentum Laboris*) for the synod was divided into three lengthy parts: on recognizing the reality of young people today, on interpreting its meanings, and on choosing paths forward for the church. A pre-Synod meeting was held in Rome in March 2018. Young people from different countries participated in that meeting and drafted the Pre-Synodal Meeting Final Document.[1] In the opening lines it reads, "It is necessary for the Church to examine the way in which it thinks about and engages with young people in order to be an effective, relevant and life-giving guide throughout their lives." Some of the key points suggest that young generations are looking for a sense of self. They are also seeking communities that will empower them, ones that are supportive, uplifting, authentic, and accessible. These participants see their church as having the potential to make significant changes that will help the Catholic religion take a place among other faith traditions in addressing personal, regional, and global issues.

For many youths religion remains a private matter. The sense of the holy in their lives matters a great deal to them. However, they see the church as "too severe and associated with excessive moralism." Young people are questioning the church's doctrines on contraception, abortion, homosexuality, cohabitation, marriage, the

1. Synod of Bishops XV Ordinary General Assembly, "Young People, the Faith, and Vocational Discernment": Pre-Synodal Meeting Final Document, http://www.synod2018.va/content/synod2018/en/news/final-document-from -the-pre-synodal-meeting.html.

lack of women in top ecclesial governing positions, and how the priesthood is perceived through different realities in the church. They say they want to address social justice issues even as they want better lives for themselves. Passionate about different expressions of the church, the participants also stated, "The church should try to find creative new ways to encounter people where they are comfortable and where they naturally socialize: bars, coffee shops, parks, gyms, stadiums and any other popular cultural centers." They see technology as a valuable tool for evangelization. "Above all, the place in which we wish to be met by the church is the streets, where all people are found." Toward the end of the report the participants suggested, "The church must adopt a language which engages the customs and cultures of the young so that all people have the opportunity to hear the message of the Gospel." By the time this book is released the results of this 15th Synod will be published. One hopes the bishops present there will have listened carefully to the dozens of nonvoting "collaborators" and "observers" of all ages who were invited to the Synod by Pope Francis.

Reaching millennials, who are now in their forties, and the Pluralists or Generation Z, who are now entering the work force, is not the only concern for pastoral leaders. Just before the pre-Synod meetings took place, St. Mary's Press of Minnesota and the Center for Applied Research in the Apostolate, affiliated with Georgetown University, released a study on why younger people of the Catholic faith are leaving the church.[2] According to the report titled *Going, Going, Gone*, 46 percent of those youths leaving the church "seek a different faith expression or religious practice that better aligns with what they believe or how they desire to express their sense of a spiritual life." The study indicated that the problem is not just a Catholic one but symptomatic of "changes in religious affiliation across all religions in the United States."

2. *Going, Going, Gone: The Dynamics of Disaffiliation in Young Catholics* (Winona, MN: St. Mary's Press, 2017).

This in-depth qualitative study supported and expanded on the well-known quantitative research conducted by the Pew Research Center, Barna Group, and the Public Religion Research Institute. The document focuses on the life stories and reasons why young people between fifteen and twenty-five no longer wish to belong to the Catholic Church. From many interviews the researchers estimate that approximately 13 percent of US young adults in this age group are former Catholics and about 7 percent of the teens aged fifteen to seventeen are disaffiliated.

The study breaks up the "narratives" of the young people into three categories: The Injured, The Drifter, and The Dissenter. The entire study is available, but here are some of the summaries on each grouping. The Injured spoke of negative experiences, disruptions in family life, and the lack of support from a faith community. Also, feelings of ostracism were reported, especially by LGBTQ youths.[3] References were made to the inauthenticity of church leaders and the hypocrisy of parents who went to church but led immoral lives. Teens in this grouping also resisted being forced to go to church where they often felt that they were being judged by older members. Finally, although the Injured did pray often, they were hurt when God did not seem to answer them. The lack of a divine response was puzzling, especially since they were taught in church that God was all loving.

The Drifters in the study could not find any value in religion. They thought there was an overemphasis on meaningless rules and rituals in "confusing structures" that had no connection to their real world. Some felt abandoned because their friends had left the church. With no support from family or church groups, they grew weary and lonely. The sacrament of confirmation was a turning point for them, like a graduation from the church. Again, a broken or unhappy family life had a dire impact on teens who, although

3. Most dictionaries define LGBTQ as lesbians, gays, bisexuals, transgenders, and queers (and/or those questioning their gender identity or sexual orientation).

they kept going to church, actually left it emotionally. The Drifters, according to the study, were anchorless and aimless.

The final category was made up of The Dissenters. This group was more intentional about rejecting the church. They expressed disagreements with doctrines on almost every social issue, but particularly on same-sex marriage and birth control. Although many opposed abortion, they were in favor of the right to choose that option. Some took issue with "teachings about the bible, salvation, heaven and after life." Even those who participated in parish programs were disillusioned when their concerns were not addressed or when they were not even allowed to raise questions. Some of these Dissenters turned to other religions, science, or different spiritual movements. Still others became agnostics or atheists. Many older millennials become "nones," nonreligious Christians. Their distrust of institutional religions does not mean they are not interested in spirituality, community, ecumenism, or social action. If they cannot find these facets in their church, they will create them elsewhere.

What does this study and the reports from pre-Synod meetings have to do with church art and architecture? Nowhere in either account is there an indication of what younger people think about the place of worship as a factor in deciding whether to leave or stay in a church. For that data we turn to a 2014 publication by Barna Group called *Making Space for Millennials*.[4] This study, done in partnership with the Cornerstone Knowledge Network (CKN), was primarily concerned with how congregations are "struggling with how to make space for Millennials—not just appealing space in their buildings and gathering places, but also space in their institutional culture, ministry models and leadership approach."[5] The big question in the survey centered on the creation of transformational opportunities for and with millennials.

4. *Making Space for Millennials: A Blueprint for Your Culture, Ministry, Leadership and Facilities* (Ventura, CA: Barna Group, 2014).

5. *Making Space for Millennials*, 5.

Earlier I discussed how transformation was a key characteristic of membership in a congregation as well as a defining attribute of what might be called a "sacred" place or experience.

The Barna Group conducted over 30,000 interviews of millennials from "across the faith spectrum." The study listed five reasons why millennials choose to stick to a Christian community. They included 1) a biblically-based engagement with the wider society to assess the impact of a prevailing culture on human "flourishing"; 2) a life-shaping relationship with an older Christian who takes interest in their lives; 3) a personal experience of Jesus of Nazareth that would sustain an individual in times of trouble; 4) confidence that their "knowledge, skills and energy" are valued by the older members of the congregation; 5) experiencing "whole-life spiritual formation" that responds to a calling from God.

Noticeably, none of these top five reasons mentioned anything specific about church art, architecture, worship, or even attending church! Still, the study did survey a range of attitudes about worship and church facilities. First, the study pointed out that, although millennials see potential in organized religion, they are "skeptical about the role churches play in society." This study, like the sources cited above, disclosed that millennials feel the church is "judgmental, out of touch and riddled with political striving." When it comes to church facilities the input in the study varies. It stated, "It is unlikely that any generation—let alone Millennials, who are so at home in the digital space—will seek to recreate the physical spaces of the past" (meaning great buildings such as the great cathedrals of Europe). On the other hand, the 18–29-year-old age group felt that modern churches, which are great for corporate worship and community building, are not conducive to "personal reflection and prayer." This reasoning could stem from a lack of appreciation for a communal worship experience.

The Barna Group and CKN recruited millennials from different religious backgrounds and led them on tours of cathedrals, megachurches, parks, and coffee shops in the United States. The majority described their ideal church as community (78%), followed

closely by sanctuary (77%). Classic (67%), flexible (64%), and modern (60%) came next. When asked about worship itself, these words were used: upbeat (78%), variety (77%), quiet (67%), and relaxed (60%). Fewer than 50 percent of survey respondents preferred the word "traditional" over "modern.'" In terms of the altar setting, the more traditional Christian settings were preferred overall (37% with a crucifix and 33% with a cross). When broken down by affiliation, nonmainline Protestants (48%) and Evangelicals (55%) chose the cross setting. Catholic millennials (63%) selected the setting with a crucifix. According to the Barna Group, "these patterns illustrate most Millennials' overall preference for a straightforward, overtly Christian style of imagery—as long as it doesn't look too institutional or corporate."[6]

Stephanie Samuel, a reporter for the *Christian Post*, presented a different interpretation of this study. She wrote, "Online surveys administered to 843 young adults ages 18 to 29 by Christian research firm Barna Group and Cornerstone Knowledge Network . . . found 67 percent chose the word 'classic' to describe their ideal church. By contrast, 33 percent prefer a trendy church as their ideal."[7] Samuel may be correct in her analysis, but a closer examination of the whole study reveals some inconsistencies in the responses from the participants. While the respondents did find that more traditional buildings had a "rich religious atmosphere," they said they would probably end up worshiping in a megachurch building on Sundays. This finding suggests that many millennials "aspire to a more traditional church experience, in a beautiful building steeped in history and religious symbolism, but they are more at ease in a modern space that feels more familiar

6. *Making Space for Millennials*, 87.

7. Stephanie Samuel, "Study Shows Millennials Turned Off by Trendy Church Buildings, Prefer a Classic Sanctuary," *The Christian Post* (September 14, 2014), http://www.christianpost.com/news/study-shows-millennials-turned-off-by-trendy-church-buildings-prefer-a-classic-sanctuary-129675/.

than mysterious."[8] Some participants, who were originally impressed with the functionality and simplicity of the megachurch, modified their opinions after visiting a traditional cathedral. Here's the comment from the study. "Once they viewed the rich religious décor of the cathedrals, they wished there were more of it in the modern facilities."[9] This particular insight supports my earlier proposal that modern church design should not ignore some of the time-honored artistic and architectural elements found in more historic church buildings.

In a curious sidebar story, a new 2018 study in the United Kingdom reported that "thousands" of British young people converted to Christianity after visiting a church. According to multimedia journalist Tola Mbakwe, "The ComRes survey, commissioned by Christian youth organization, Hope Revolution Partnership, claimed one in six young people in the United Kingdom are practicing Christians and around 13% of them decided to become a Christian after visiting a church."[10] In a commentary on this phenomenon, the traditional uCatholic website suggested that teenagers were becoming Christian after seeing the design of traditional churches and cathedrals, and that beautiful architecture was more effective than most other evangelization efforts. Religious affairs correspondent Olivia Rudgard wrote, "One in five said reading the Bible had been important, 17 per cent said going to a religious school had had an impact and 14 per cent said a spiritual experience was behind their Christianity."[11] A

8. *Making Space for Millennials*, 78.

9. *Making Space for Millennials*, 82.

10. Tola Mbakwe, "Study Shows One in Six Youngsters Consider Themselves Christian," *Premier* (June 18, 2017), https://www.premier.org.uk/News/UK/Study-shows-one-in-six-youngsters-consider-themselves-Christian.

11. Olivia Rudgard, "One in Six Young People Are Christian as Visits to Church Buildings Inspire Them to Convert," *The Telegraph News* (June 17, 2017), https://www.telegraph.co.uk/news/2017/06/17/one-six-young-people-christian-visits-church-buildings-inspire/.

similar report quoted Joseph Kramer, a member of the Priestly Fraternity of St. Peter, who only celebrates the Latin liturgy. "There is a movement among young Catholics to know, discover and preserve their Catholic heritage, and the traditional Latin Mass fits in with that. I think they are drawn to the liturgical richness of the past."[12] These reports are decidedly different in scope compared to the United States data referred to above. They show how, for some younger adults, older forms of worship and traditional architecture are interconnected.

The Barna Group study here in the United States offers no definitive conclusions about what style of worship or church architecture is favored by millennials. Nevertheless, *Making Space for Millennials* is worth reading by anyone interested in how millennials think about religion, culture, and church facilities. A return to older styles of worship or church art and architecture may or may not be the ideal strategy for attracting new members, or keeping old ones, on a long-term basis. Much more is required of a religion. Many of the magnificent churches and cathedrals in some other countries are never completely filled on Sunday. Whether Classical, Victorian, Mission, or Modern in style, once the beauty and awe of the art and architecture wear off, there will have to be other reasons for young people to keep coming back to church. Based on the three studies mentioned above, younger generations are looking for something more than attractive worship facilities. Evangelical pastor Ralph Hicks offered some advice about reaching millennials, and church buildings have nothing to do with his suggestions. He said that millennials want to be listened to, they do not want to be preached at, they can handle truth, they want to be accepted, and they want to be included in making decisions

12. "What Causes Young People to Convert? Beautiful Churches and Cathedrals, Says Study," *UCatholic* (March 15, 2018), www.ucatholic.com/news/what-causes-young-people-to-convert-beautiful-churches-and-cathedrals/.

for the church.[13] These are the same expectations listed above by Catholic youths when asked for their input.

Although some of the fundamental creeds or dogmas of a religion may stand the test of time, a historic substantial reform of any major religion will necessarily include changes in governance, doctrines (teachings), ministry, pastoral practice, and worship. Church leaders who are adamant about preserving the existing state of affairs will want to pay closer attention to what the above research studies and others report about the attitudes of younger generations toward their religion. A self-described millennial "none" and interfaith activist Katie Gordon asks a profound question: "How can our religious institutions consider the issues that young people raise within and outside of religious communities? What would it look like to center and empower the emerging generation's voices?"[14] Some sources say that, if given such a voice, young people would push for significant reforms within their churches. They would like to experience an authentic, supportive, loyal and trustworthy church that practices radical hospitality. Until this happens we cannot be sure that what a church building looks like inside or out is the sole reason for disenchantment and disaffiliation. However, we can say that the way a place is arranged for worship will foster a clearer definition of what the church is—the Body of Christ acting together to bring about peace and harmony in the world.

13. Ralph Hicks, "Seeking Millennials: Aim for Inclusion, Being a Mentor," *Worship Facilities* (June 29, 2018), https://www.worshipfacilities.com/millennialsgen-zers/seeking-millennials-aim-inclusion-being-mentor.

14. Katie Gordon, "The Rise of the 'Nones' Part 2: Rethinking Religious Communities," *St. Mary's Press Research* (April 25, 2017), https://catholicresearch.smp.org/nones-enriching-religious-communities/.

26. Emerging Church Alternatives

" . . . the gap between the spiritual revolution
and religious institutions both persists and widens."
—Diana Butler Bass

The previously mentioned studies reveal a lot about the shifts in religious behavior in the United States, especially among younger people. The findings show that some age groups have diverse opinions about church design. However, there is no reliable data showing that the architectural style of a church building is a significant reason for joining or leaving a particular Christian denomination or community. The study from the United Kingdom about teenagers joining a religion after visiting a traditional place of worship is not corroborated by surveys conducted in the United States. The variable findings in *Making Space for Millennials* also offer no clear conclusions to indicate that the place of worship is more important than the sense of belonging or the opportunity to grow spiritually. A close read of the study suggests that what matters most is what goes on inside. What conclusion can we make about the different generations of people who make no mention of church art and architecture when listing their expectations from a religion? It seems that the jury is out.

Some have touted emergent churches or the megachurch model as the shape of the future. Not all nondenominational and evangelical church structures are modern abstract buildings, of course, yet some would fall under the criticism that those structures "do not look like churches." Before offering any critique of my own I

wanted to worship in some of the emergent churches. While on sabbatical I visited four of the recently constructed nondenominational churches in the Capital District of New York State. According to studies conducted by the Barna Group (2014–15), this area ranks first in the United States as a "post-Christian" region and almost last (ninety-nine out of one hundred) as a Bible-minded territory. Many mainline churches in this Northeast section of the country have been closed, merged, or sold to other denominations.

My first stop was the Life.Church, a congregation that belongs to a nationwide cohort of about twenty-five churches. The "mother" church is in Oklahoma City, Oklahoma. As I approached the driveway one Sunday morning, I found myself in a traffic jam as people were coming and going. The church building is a brand new, glistening off-white structure. There were no religious symbols on the building, only the name "Life.Church" coupled with its logo.

By the time I arrived at the main door I was genuinely greeted three times along the way by smiling teenage parking lot attendants and ushers. Inside the soaring sunlit lobby I noticed immediately that I was much older than everyone else. Young parents clutching cups of coffee and their preschoolers mixed with teens and millennials. There was an energetic buzz in the atrium similar to what one hears at a concert or ball game. I had time to check out the church annex for "kids" and noticed the tight security at the reception desk. When a parent brings a child into the Kids Church, both receive a barcoded badge that must match when the child is picked up afterward. A sign near the entrance said, "Protection of our children is a priority." Clocks everywhere tell you exactly when the next worship event will begin, so I headed over to the "auditorium" to get a good seat. Inside the vast, windowless room there were no religious artifacts, no communion table, no pulpit. One jumbo screen above the stage was flanked by two others. Soon all one thousand seats were filled. A friendly young family of four sat next to me. They were engaged with the service the whole time.

The services in these churches are somewhat predictable in terms of format. Preliminary praise music, led by an enthusiastic

and rather professional band, was followed by a warm welcome from one of the ministers. Next we shared communion (a little cup of juice and a small cracker). The communion procession toward the ministers who were scattered throughout the room was preceded by a brief reference to the Last Supper and the words of Jesus. There were no readings from the Bible prior to the sermon, which was streamed in via satellite. The practical and inspiring talk, sprinkled with excerpts from Proverbs and a few New Testament texts, was part of a series called "Shut My Big Mouth." The sermon that Sunday dealt with gossip. I admit I was captivated. The service ended in exactly sixty minutes with some more music and a short "thanks for coming" followed by a prayer and blessing. The worship service was upbeat. The nonjudgmental sermon and song lyrics focused on feeling good about yourself.

The pastors in these places admit that not all who attend Sunday worship are loyal members. They come and go. The leaders realize that religion today is a commodity and they have to contend with a consumer mentality. Mainline church leaders are critical of these popular evangelical and nondenominational emergent churches. They are also skeptical about the rise in "pop-up" churches in taverns, restaurants, homes, and places of work. They worry that such worship is all about entertainment, the preaching is theologically light, and member affiliation is unpredictable.

Still, while many older or traditional congregations are struggling to attract young members, these assemblies are filled with crowds of baby boomers as well as Generations X, Y, and Z seeking alternatives to their childhood churches. What is the attraction? Lutheran Pastor Rev. Erik Parker says, "Evangelical churches are doing something with their people that many mainliners have mostly given up on decades ago—evangelicals are creating biblically literate Christians."[1] Parker noted that "liturgy is rooted in

1. Erik Parker, "Confessions of a High Church Millennial—Is Liturgy a Fad?," in *The Millennial Pastor* (March 4, 2015), https://millennialpastor .net/2015/03/04/confessions-of-a-high-church-millennial-is-liturgy-a-fad/.

the rich and beautiful biblical narratives that help us to make sense of the world—or perhaps show us how God is making sense of us."[2] The mere proclamation of Scripture will not make sense to most members of a congregation if the sermon or homily does not "unwrap" the biblical texts and apply them to everyday realities. I once asked my cousin, a young professional and Catholic from birth, why she attended a megachurch. She said she felt that the preacher was speaking directly to her, using language she could relate to in her life.

No doubt advanced technology has a great deal to do with attracting people to these well-choreographed worship experiences. Such congregations spend millions of dollars on the latest audio-video-lighting (AVL) systems. Wealthier churches outfit their buildings with first-rate studios from which they sequence images on their sanctuary jumbo screens. They can record services for homebound members or live stream them to anywhere in the world. Some denominations build satellite churches to bring the service into different neighborhoods. The first point of contact, however, happens even before people get to a church building. Pastors use social media all week long to communicate with loyal members and curious seekers. The actual service itself can be an entertaining performance, dependent on technology. If you cannot personally get to the church you can download Scripture, the sermon, or the entire service on one of your devices. The intention is to offer many ways to connect with and belong to a congregation and to make worship and membership a rewarding experience. However, Craig Janssen, a "facility strategist" who studies theater design and technology in terms of group engagement, warns, "Churches that want to connect with Millennials and GenZ aren't going to get the job done by simply upgrading AVL technology. It will require a deep dive into what they value, and a willingness to look at some of the hard reasons we are missing them in both

2. Parker, "Confessions of a High Church Millennial."

our mission and our activities."[3] This observation supports the testimonies of younger generations mentioned earlier. They report that some older mainline religions are no longer relevant in terms of addressing the cultural milieu they live in. Yet, it also seems that advanced technology alone is not enough to satisfy the yearnings of young and old seekers.

But what about art and architecture, the main concern of this book? A common denominator in almost every "megachurch" building is the layout of the worship space. Typically there is a stage setting at one end of the auditorium or sanctuary. The congregation is usually arranged in straight or semicircular rows of benches or chairs facing the front of the stage. The purpose of such a layout is so everyone can see the ministerial leaders, choirs, and musicians, as well as the large projection screens that are now standard in these buildings and in some mainline churches. Although it seems as if not much attention is given to the interior layout of these churches, some designers and worship team leaders are now beginning to pay closer attention to the impact of the space on the behavior of the congregation. The congregations at most of these services are nonparticipative. According to Janssen, "Worshippers walking into many of these spaces are cued into where the 'important' location is. They settle into their seats and wait for the main event to begin. Then they are told when to sit and when to stand. Everything is nicely under control. It cues passivity."[4] This scenario is eerily similar to many worship experiences in the Catholic Church and other mainline Christian denominations. Instead of "stage" the words "sanctuary" or "chancel" are used. Still, the effect is the same. The congregations are arranged in tightly knit seating plans that foster spectatorship during worship. This might not matter to most worshipers or even

3. Craig Janssen, "What the Coming Cultural Shift Means for Church Designers," *Church Design* (September 4, 2018), https://church.design /perspectives/what-the-coming-culture-shift-means-for-church-designers/.
4. Janssen, "What the Coming Cultural Shift Means."

be noticed by them. Yet, on some level it is shaping the kinds of Christians they are and will become.

One of the reasons these viewer-oriented layouts are so familiar is that they correspond to how we are accustomed to being entertained in other facets of life. If the preconceived notion is that the clergy are there to "perform" a service for you, why not sit back and enjoy it? However, when the ecclesiological, liturgical, and moral principles of a church call for both active, conscious engagement in worship and social action, the interior design of the church must change. Nondenominational churches are now thinking about new ways to arrange their church interiors so as to engage everyone in the worship service and in mission.

Janssen's critique is based on the premises that "current communication models are not passive" and that there is growing enthusiasm for more engagement in the worship service. This could signal a movement toward a common ground. Different religious groups are looking for ways to increase "social connections." Janssen uses the Royal Shakespeare Theatre in Stratford-upon-Avon as an example of a space in which everyone is engaged. In that venue no one is more than forty-five feet away from a performer and no one is more than sixty-five feet away from another member of the audience. With regard to church interiors, Janssen claims, "When active minds come up against passive experience, they check out."[5]

I began this book on church art and architecture by suggesting it is all about relationships with God, creation, and one another. The thinking among some megachurch leaders is coming to the same conclusion. Cathy Hutchinson heads a company specializing in technology design, acoustics, and theatre design. She wrote, "As upcoming generations value connection over consumption of content, the space will need to evolve not just to present information, but to create relationships." Her conclusions are based on

5. Janssen.

this assumption: "Millennials were raised consuming information in a way that is active rather than passive. They can comment, follow a hyperlink trail, or share—which fuels a desire for a two-way conversation. Gen Z takes it a step further. They want to shape and help lead the conversation."[6]

This line of thinking will require a transition from a "presentation" model of worship to one that is more "relational." It will also challenge mainline church leaders to rethink the reliance on a way of celebrating ancient rites that foster spectatorship instead of participation. Young people want a say in what goes on in church. That includes the practice of worship as well as how the congregation responds to global issues. Hutchinson refers to the work of Daniel Homrich, who helps organizations bridge generational gaps. He wrote that the millennial generation, more so than others, has responded to issues of social justice. "They can't ignore social context given their exposure to an expanded world view. After all, if your world view is expanded and you feel like that you want a sense of purpose, well, the church can do something about that."[7] More churches are ramping up their global mission programs. Congregations are sending young members to countries in need of help. Interestingly, this practice mirrors the longstanding and continual missionary efforts of older mainline churches. Again, there is a relationship between church membership, worship, and social action.

How churches draw members into an experience of God, and how they help to create relationships with others, are two interlocking questions of importance for any church. Architecture for congregational worship can help create a common ground

6. Cathy Hutchinson, "What Church Designers Need to Understand about Millennials and Gen Z," *Church Design* (August 21, 2018), https://church.design/cover_stories/what-church-designers-need-to-know-about-the-impact-of-mille/.

7. Daniel Homrich, quoted in Hutchinson, "What Church Designers Need to Understand."

within congregations by structurally creating an experience that engages all persons in the act of worship. The art in church buildings can remind the members of a religion about their social responsibilities.

Leaders will always be required for the good order of the worship experience. However, effective leaders will not draw attention to themselves but to those who are around them. I remember reading about the comedian Johnny Carson and why he was such a popular host on *The Tonight Show*. Off-camera he had a huge ego and a controlling disposition. On camera, however, he placed the interests of his guests above his own ambitions. He would interact with celebrities in ways that "set them up" for engagement with the audience in the theater and viewers at home. It was the same in the Greek theater, where the actors "put on" the audience. Carson's audiences identified with his monologues and saw themselves in his jokes and imperfections.

Whether or not emerging nondenominational churches and others will stand the test of time remains to be seen. Right now they are drawing people of all ages away from mainline churches. Without emulating any one megachurch model, there is plenty to learn from their approach. My brief experience with some of them is that hospitality trumps everything else.

27. A Vision for the Church Buildings of Tomorrow

"Having pride in our heritage and traditions does not excuse us from writing new chapters."
—Rabbi David Ellenson

Church buildings are gathering places for people who are committed to making a difference in the world. When congregations worship together in a collegial spirit, they can be more effective as advocates of justice and peace in the public square. When a sociocultural group, religious or secular, is torn apart, it must be repaired if it is to regain its credibility and authenticity. Various occurrences have stymied many mainline religions. They include shifts in religious behavior among different generations, divisive rhetoric among religious leaders, abuse of power and authority, and polarizations within the membership. Some of the suggestions for resolving the discord, anger, and disenchantment include listening to one another, welcoming all people, involving different people in major decision-making roles, restructuring hierarchies, and reworking worn-out teachings.

In this book I have offered a proposal using art and architecture as a way of coming to a common ground. Why? Church structures are symbolic manifestations of the presence of God made visible in a living church. In this church there can be no boundaries that separate worshipers from one another according to rank, ministry, or privilege. Paul reminded the members of his congregation in Corinth: "You are God's building" (1 Cor 3:9). Here is my vision for the design of churches in the future.

A. The liturgical plan does not perpetuate the notion that God resides outside our being. Nor does it suggest that there is a real geographical destiny for humanity that is located somewhere in the cosmos. The architectural focus of worship is not on a singular physical endpoint in the church building but is, rather, a Christocentric one that unites all worshipers, clergy and laity, around the eucharistic banquet table, the symbol of Christ. The congregation may gather in a circular or semicircular or antiphonal floor plan. What matters is that the arrangement of seats and ritual furnishings makes it possible for all members of the congregation to hear, see, and feel that they are members of the one Body of Christ gathered to ritualize the remembrance of the paschal mystery.

B. Church buildings are vivid resonators of a church that interacts with a larger society, in its joys and sorrows. Our places of worship are "servant churches"—full, active, and conscious participants in liturgy as in life. Engagement with the paschal mystery requires more than carrying out a liturgical ministry. It also demands public witness. However, as Rita Ferrone points out, "One looks in vain for a forceful and clear statement that the liturgy commits us to justice, or refashions society in such a way that toxic individualism is ruled out, or that any economic narcissism is likewise forbidden. The link between liturgy and building a just society does not 'jump off the page' of the Liturgy Constitution."[1] To strengthen the synergy between worship and social action, prayers, homilies, song lyrics, and works of art in the church must remind the congregation that their mission also includes honoring human beings and planet earth. Artists use their talents to create aural, visual, and tactile commentaries on societal needs.

C. One architectural or artistic style is not more appropriate for the worship of God than another. Different forms have been used throughout the history of the Christian liturgy. Designers today

1. Rita Ferrone, "Liturgy and Social Justice: Fresh Challenges for Today in Virgil Michel's Legacy," unpublished paper presented at St. John's Abbey, Collegeville, Minnesota (April 7, 2013).

should take the lead in creating innovative forms without having to defer to the past. It is time to move bravely forward. The development of new building technologies and digital design tools will continue. They will make it possible to explore new structural shapes without disavowing the time-honored use of light, color, materials, proper proportions, scale, and ornamentation. What will matter most is that the interior plan of a church building be an egalitarian one that does not discriminate people or divide them into different classes.

Architects Michael Crosbie and Julio Bermudez asked some students at The Catholic University of America to reflect on what they thought churches might look like in the future. Here's what they found. Their designs reflected "some of the elements of contemporary ideas about spirituality, with a combination of places for the spirit, places to share community, places for outreach, places for creation and performance, places for gathering in worship and ritual, places to share meals and fellowship (like pubs or coffeehouses) . . . They came away [from the design project] to challenge and confront the idea that a religious building should be static and unchanging."[2]

D. In light of the ideas generated by these architectural students, one can imagine that the church building of the future is a multiplex center. New churches will no longer be designed solely for worship. Older ones can be retrofitted to be more functional. The purpose of worship is to respond to God's graces with gratitude and by making sure those graces are shared with others who are poor, hungry, abused, homeless, and tired. In addition to housing liturgical events, a multifunctional church complex will be tailored to provide basic necessities in urban neighborhoods, the suburbs, or in rural areas. Those community services might include a food pantry, day care for children and the elderly,

2. See Julio Bermudez and Michael J. Crosbie, "What Will Future Houses of Worship Look Like?," *Religion News Service* (June 14, 2017), https://religionnews.com/2017/06/14/what-will-future-houses-of-worship-look-like/.

a playground, a counseling center, a visiting nurse's station, and sanctuary for refugees seeking asylum.

E. Houses of worship will be shared properties. Religious construction in the United States is a multi-billion dollar industry. Some faith groups such as the emergent churches are building new houses of prayer while others are closing theirs down. Many congregations are concerned about aging infrastructures. The religious multiplex of the future can no longer be owned by one religious group but by a cooperative that would share responsibility for programs and maintenance. The time is ripe for all communities to see that the carbon footprint emitted by the duplication of houses of worship and other properties is hurting the planet. Why should there be several religious buildings in one community that house the same services?

In a practical way, before selling a stable but empty building, different faiths in the same municipality could work together to explore ways to convert their building into a community center. Cooperation among different faith traditions could also serve to gradually heal unnecessary breaches among people of different faith traditions who share the same interest in making a difference in the world. It is another step in reaching a common ground. These holy coalitions can transform their communities and become truly sacred spaces. The worship of God and responsible citizenship are becoming more mutually sustaining partners.[3]

Standing together on common ground in order to serve the common good is not easy. A true dialogue is not a strategy to prod the other side into giving up their values and beliefs. Rather, open and honest conversations can help us discover how art and architecture for congregational worship can help in the search for a common ground. Regardless of what houses of worship will look like tomorrow, the main feature should not be overlooked. These

3. Richard S. Vosko, "Between No More and Not Yet," *Faith & Form* 50, no. 3 (2017): 25.

venerable liturgical structures are metaphors. They derive their meaning and function from the people who are served by them. Robert Hovda noted that the "historical problem of the church as a *place* attaining a dominance over the faith community need not be repeated as long as Christians respect the primacy of the living assembly . . . the building "does not have to 'look like' anything else, past or present."[4] Hovda's wisdom is an invitation to continue to find ways to build churches that honor and celebrate the equality of all human beings and the beauty of all of God's creation.

4. *Environment and Art in Catholic Worship* (Washington, DC: United States Catholic Conference Office of Publishing Services, 1978), 24.

Selected Resources

Alexander, Christopher. *The Timeless Way of Building.* New York: Oxford University Press, 1979.

Atkins, Peter. *Memory and Liturgy: The Place of Memory in the Composition and Practice of Liturgy.* Brookfield, VT: Ashgate Publishing, 2004.

Baldovin, John F. *Reforming the Liturgy: A Response to the Critics.* Collegeville, MN: Liturgical Press, 2008.

Barrie, Thomas. *The Sacred In-Between: The Mediating Roles of Architecture.* New York: Routledge, 2010.

Barron, Robert. *Heaven in Stone and Glass: Experiencing the Spirituality of the Great Cathedrals.* New York: Crossroad, 2000.

Bachelard, Gaston. *The Poetics of Space: The Classic Look at How We Experience Intimate Places.* Boston: Beacon Press, 1994.

Bell, Catherine. *Ritual: Perspectives and Dimensions.* Oxford: Oxford University Press, 1997.

Benedikt, Michael. *God Is the Good We Do: Theology of Theopraxy.* New York: Bottino Books, 2007.

Bergmann, Sigurd, ed. *Theology in Built Environments.* London: Transaction Publishers, 2009.

———. *Religion, Space, and the Environment.* London: Transaction Publishers, 2014.

Bermudez, Julio, ed. *Transcending Architecture: Contemporary Views on Sacred Space.* Washington, DC: Catholic University of America Press, 2015.

Blesser, Barry, and Linda-Ruth Salter. *Spaces Speak, Are You Listening? Experiencing Aural Architecture.* Cambridge, MA: MIT Press, 2007.

Boersma, Hans. *Heavenly Participation: The Weaving of a Sacramental Tapestry.* Grand Rapids, MI: Eerdmans, 2011.

Boeve, L., M. Lamberigts, and T. Merrigan, eds. *The Contested Legacy of Vatican II: Lessons and Perspectives.* Leuven: Peeters, 2015.

Bouyer, Louis. *Liturgy and Architecture.* Notre Dame, IN: Notre Dame University Press, 1967.

Boyer, Mark G. *The Liturgical Environment: What the Documents Say.* Collegeville, MN: Liturgical Press, 2015.

Britten, Karla Cavarra, ed. *Constructing the Ineffable: Contemporary Architecture.* New Haven, CT: Yale University Press, 2010.

Burns, Stephen, ed. *The Art of Tentmaking: Making Space for Worship.* Norwich: Canterbury Press, 2012.

Congar, Yves. *The Meaning of Tradition.* Translated by A. N. Woodrow. San Francisco: Ignatius Press, 2004.

Crosbie, Michael. *Architecture for the Gods I.* Victoria, Australia: Images Publishing Group, 1999.

———. *Architecture for the Gods II.* Victoria, Australia: Images Publishing Group, 2002.

———. *Houses of God.* Victoria, Australia: Images Publishing Group, 2006.

Crowley, Eileen D. *Liturgical Art for a Media Culture.* American Essays in Liturgy, ed. Edward Foley. Collegeville, MN: Liturgical Press, 2007.

Daelemans, Bert. *Spiritus Loci: A Theological Method for Contemporary Church Architecture.* Leiden: Brill, 2015.

Delio, Ilia. *Making All Things New: Catholicity, Cosmology, Consciousness.* Maryknoll, NY: Orbis Books, 2015.

DeSanctis, Michael E. *Building from Belief.* Collegeville, MN: Liturgical Press, 2002.

Doig, Allan. *Liturgy and Architecture: From the Early Church to the Middle Ages.* Burlington, VT: Ashgate, 2008.

Elkins, James. *What Happened to Art Criticism?* Chicago: Prickly Paradigm Press, 2003.

Ferrone, Rita. *Liturgy: Sacrosanctum Concilium.* New York and Mahwah, NJ: Paulist Press, 2007.

Foley, Edward. *Theological Reflection across Religious Traditions: The Turn to Reflective Thinking.* New York: Rowan & Littlefield, 2015.

Foley, Edward, Nathan D. Mitchell, and Joanne M. Pierce, eds. *A Commentary on the General Instruction of the Roman Missal.* Collegeville, MN: Liturgical Press, 2007.

Gaillardetz, Richard R., and Catherine Clifford. *Keys to the Council: Unlocking the Teaching of Vatican II.* Collegeville, MN: Liturgical Press, 2012.

Gebara, Ivone. *Longing for Running Water: Ecofeminism and Liberation.* Minneapolis: Fortress Press, 1999.

Geva, Anat, ed. *Modernism and American Mid-20th Century Sacred Architecture.* New York: Routledge, 2018.

Goldhagen, Sarah Williams. *Welcome to Your World: How the Built Environment Shapes Our Lives.* New York: HarperCollins, 2017.

Gorringe, TJA. *Theology of the Built Environment: Justice, Empowerment, Redemption.* New York: Cambridge University Press, 2002.

Grimes, Ronald L. *The Craft of Ritual Studies.* New York: Oxford University Press, 2014.

Greene, Maxine. *Releasing the Imagination: Essays on Education, the Arts and Social Change.* San Francisco: Jossey-Bass, 1995.

Hale, Jonathan. *The Old Way of Seeing: How Architecture Lost Its Magic (And How to Get It Back).* New York: Houghton Mifflin, 1998.

Halgren Kilde, Jeanne. *Sacred Power, Sacred Space: An Introduction to Christian Architecture and Worship.* New York: Oxford University Press, 2008.

Haught, John F. *Resting on the Future: Catholic Theology for an Unfinished Universe.* New York: Bloomsbury Academic, 2016.

Hejduk, Renata, and Jim Williamson, eds. *The Religious Imagination in Modern and Contemporary Architecture: A Reader.* New York: Routledge, 2011.

Hoffman, Douglas. *Seeking the Sacred in Contemporary Architecture.* Kent, OH: Kent State University Press, 2010.

Inge, John. *A Christian Theology of Place.* Burlington, VT: Ashgate Press, 2003.

Janowiak, Paul. *Standing Together in the Community of God: Liturgical Spirituality and the Presence of Christ.* Collegeville, MN: Liturgical Press, 2011.

Jensen, Robin M. *The Cross: History, Art and Controversy.* Cambridge, MA: Harvard University Press, 2017.

Johnson, Timothy. *The Revelatory Body: Theology as Inductive Art.* Grand Rapids, MI: Eerdmans, 2015.

Kieckhefer, Richard. *Theology in Stone: Church Architecture from Byzantium to Berkeley.* Oxford: Oxford University Press, 2004.

Lathrop, Gordon W. *Holy Things: A Liturgical Theology.* Minneapolis: Fortress Press, 1998.

———. *Central Things: Worship in Word and Sacrament.* Minneapolis: Fortress Press, 2005.

———. *Holy People: A Liturgical Ecclesiology.* Minneapolis: Fortress Press, 2006.

———. *Holy Ground: A Liturgical Cosmology.* Minneapolis: Fortress Press, 2009.

Lawson, Bryan. *The Language of Space.* Burlington, VT: Architectural Press, 2001.

Madathummuriyil, Sebastian. *Sacrament as Gift: A Pneumatological and Phenomenological Approach.* Leuven: Peeters, 2012.

Martos, Joseph. *Deconstructing Sacramental Theology and Reconstructing Catholic Ritual.* Eugene, OR: Wipf and Stock, 2015.

McCall, Richard D. *Do This: Liturgy as Performance.* Notre Dame, IN: University of Notre Dame Press, 2007.

McCarthy, Daniel, and James Leachman. *Come into the Light: Church Interiors for the Celebration of Liturgy.* Norwich, CT: Canterbury Press, 2016.

Merton, Thomas. *Disputed Questions.* New York: Harcourt Brace, 1960.

Michael, Vincent. *The Architecture of Barry Byrne: Taking the Prairie School to Europe.* Chicago: University of Illinois Press, 2013.

Mitchell, Nathan D. *Meeting Mystery: Liturgy, Worship, Sacraments.* Maryknoll, NY: Orbis Books, 2006.

Mitrović, Branko. *Philosophy for Architects.* New York: Princeton Architectural Press, 2011.

———. *Visuality for Architects: Architectural Creativity and Modern Theories of Perception and Imagination.* Charlottesville, VA: University of Virginia Press, 2013.

Morgan, David, and Sally Promey, eds. *The Visual Culture of American Religions.* Los Angeles: University of California Press, 2001.

Morrill, Bruce. *Anamnesis as Dangerous Memory: Political and Liturgical Theology in Dialogue.* Collegeville, MN: Liturgical Press, 2000.

O'Malley, John W. *What Happened at Vatican II.* Cambridge, MA: The Belknap Press of Harvard University Press, 2008.

Osborne, Catherine R. *American Catholics and the Church of Tomorrow: Building Churches for the Future, 1925–1975.* Chicago: University of Chicago Press, 2018.

Osborne, Kenan B. *Christian Sacraments in a Postmodern World: A Theology for the Third Millennium.* New York: Paulist Press, 1999.

———. *Orders and Ministry.* Maryknoll, NY: Orbis Books, 2006.

Otto, Rudolf. *The Idea of the Holy.* Translated by John Harvey. Mansfield Center, CT: Martino Press, 2010.

Pallasmaa, Juhani. *The Eyes of the Skin: Architecture and the Senses.* New York: John Wiley & Sons, 2012.

Pallister, James. *Sacred Spaces: Contemporary Religious Architecture.* New York: Phaidon Press, 2015.

Pecklers, Keith F. *The Unread Vision—The Liturgical Movement in the United States of America: 1926–1955.* Collegeville, MN: Liturgical Press, 1998.

Pivarnik, R. Gabriel. *Toward a Trinitarian Theology of Liturgical Participation.* Collegeville, MN: Liturgical Press, 2012.

Price, Jay M. *Temples for a Modern God: Religious Architecture in Postwar America.* New York: Oxford University Press, 2013.

Proctor, Robert. *Building the Modern Church.* Burlington, VT: Ashgate, 2014.

Rae, Murray. *Architecture and Theology: The Art of Place.* Waco, TX: Baylor University Press, 2017.

Rausch, Thomas P. *Eschatology, Liturgy, and Christology: Toward Recovering an Eschatological Imagination.* Collegeville, MN: Liturgical Press, 2012.

Richardson, Phyllis. *New Spiritual Architecture.* New York: Abbeville Press, 2004.

Roberts, Nicholas. *Building Type Basics for Places of Worship.* New York: John Wiley, 2004.

Rouet, Albert. *Liturgy and the Arts.* Translated by Paul Philibert. Collegeville, MN: Liturgical Press, 1997.

Runkle, John Ander, ed. *Searching for Sacred Space: Essays on Architecture and Liturgical Design in the Episcopal Church.* New York: Church Publishing, 2002.

Saliers, Don E. *Worship Come to Its Senses.* Nashville, TN: Abingdon, 1996.

Salingaros, Nikos A. *Unified Architectural Theory: Form, Language, Complexity: A Companion to Christopher Alexander's "The Phenomenon of Life—the Nature of Order, Book 1."* Kathmandu, Nepal: Vajra Books, 2012.

Schloeder, Steven. *Architecture in Communion.* San Francisco: Ignatius Press, 1998.

Scott, Robert. *The Gothic Enterprise: A Guide to Understanding the Medieval Cathedral.* Los Angeles: University of California Press, 2003.

Searle, Mark. *Called to Participate: Theological, Ritual, and Social Perspectives.* Edited by Barbara Searle and Anne J. Koester. Collegeville, MN: Liturgical Press, 2006.

Seasoltz, Kevin. *A Sense of the Sacred: Theological Foundations of Christian Architecture and Art.* New York: Continuum, 2005.

Seligman, Adam J., Robert P. Weller, Michael J. Puett, and Bennett Simon. *Ritual and Its Consequences: An Essay on the Limits of Sincerity.* New York: Oxford University Press, 2008.

Sheldrake, Philip. *Spaces for the Sacred: Place, Memory, and Identity.* Baltimore: Johns Hopkins Press, 2001.

Shewring, Walter. *Making and Thinking.* Buffalo, NY: Catholic Art Association, 1958.

Sövik, Edward A. *Architecture for Worship.* Minneapolis: Augsburg, 1973.

Smith, Dennis E., and Hal E. Taussig. *Many Tables: The Eucharist in the New Testament and Liturgy Today.* Eugene, OR: Wipf and Stock, 2001.

Smith, Jonathan Z. *To Take Place: Toward Theory in Ritual.* Chicago: University of Chicago Press, 1987.

Storms, Mary Patricia, and Paul Turner. *Guide for Ministers of Liturgical Environment.* The Liturgical Ministry Series. Chicago: Liturgy Training Publications, 2009.

Tanizaki, Jun'ichirō. *In Praise of Shadows.* Translated by T. J. Harper and E. G. Seidensticker, foreword by Charles Moore. Chicago: Leete's Island Books, 1977.

Torgerson, Mark A. *Architecture of Immanence: Architecture for Worship and Ministry Today.* Grand Rapids, MI: Eerdmans, 2007.

————. *Greening Spaces for Worship and Ministry: Congregations, Their Buildings, and Creation Care.* Herndon, VA: The Alban Institute, 2011.

Tyson, Neil deGrasse. *Astrophysics for People in a Hurry.* New York: Norton, 2017.

Upton, Julia. *Worship in Spirit and Truth: The Life and Legacy of H. A. Reinhold.* Collegeville, MN: Liturgical Press, 2009.

Viladesau, Richard. *Theology and the Arts.* New York and Mahwah, NJ: Paulist Press, 2000.

Vincie, Catherine. *Worship and the New Cosmology: Liturgical and Theological Challenges.* Collegeville, MN: Liturgical Press, 2014.

Vosko, Richard S. *God's House Is Our House: Re-imagining the Environment for Worship.* Collegeville, MN: Liturgical Press, 2006.

Walton, Janet. *Worship and the Arts: A Vital Connection.* Collegeville, MN: Liturgical Press, 1988.

Yates, Nigel. *Liturgical Space: Christian Worship and Church Buildings in Western Europe 1500–2000.* Burlington, VT: Ashgate, 2008.

Zimmerman, Joyce Ann. *The Ministry of Liturgical Environment.* Collegeville, MN: Liturgical Press, 2004.

Index

Architecture,
 as devotional places, 62–63,
 128, 171
 elements of, 69, 74, 120, 126,
 139–40, 144–45, 152, 207,
 223
 as metaphor, 50, 72, 85, 118,
 150, 200, 225
 as servant, 4, 72, 111, 171–79,
 180–87, 188–96, 222
 styles of, 7, 21, 57, 66, 69,
 72–74, 76–78, 111–13,
 126–31, 128–32, 199, 208,
 210, 222
 and transformation, 69, 111,
 120, 126, 139, 142, 145,
 150, 159, 173, 204
Art,
 as conscience, 153–60
 as devotional, 128, 154, 159,
 161–67
 elements of, 153, 162–63,
 207
 as liturgical, 161–67, 172
 styles of, 7, 111, 158, 222,
 208
 and taste, 7, 135, 156, 158,
 164
 and transformation, 155, 157–
 59, 167

Beauty,
 in architecture, 4, 6, 9, 30, 42,
 126–27, 130–31, 139–40,
 142, 144–47, 159, 163–66,
 206–8
 in art, 146–48, 158, 166
 in nature, 146–48, 149–50,
 152, 157–58
 in human beings, 42, 97, 225
Boundaries, divisions, tensions,
 3–7, 10–11, 14, 157
 within congregations, 5–6,
 18–19, 24, 39, 50–54, 61,
 101, 104, 119, 151, 176,
 189–90, 221
 in houses of worship, 5–6, 12,
 20, 39, 46, 51, 53–57, 115,
 119, 176–77, 221
 and liturgical reform, 13, 16–
 18, 22–23, 26–29, 51, 61,
 95, 151, 181

Church,
 as Body of Christ, 4, 7, 9, 30,
 34, 41, 51–54, 78, 88–89,
 92, 101, 104, 107, 119,
 150, 177
 as Paschal Mystery, 4–5, 34,
 90, 100–107, 112, 160,
 189–90, 222

Suppression, fear, obstruction
of, 20, 77, 99

Dualism, dualities, dualistic, 7,
42, 45–50, 67, 88, 144, 150

God, creator, 4, 9, 36–42, 53,
117–20, 144, 149–50, 173,
178, 221–24

Holy, holies,
as place, 39–40, 45, 70
as alliance, ancestors, coalition,
69, 101, 119, 154, 162, 177,
193, 196, 224
as things, 135, 162, 184–85

Immanence and transcendence,
37, 42, 67, 88, 90, 111, 118–
21, 139, 150, 178
Influences,
doctrine and dogma, 31–33,
47, 84–87, 99, 106–7, 162,
200–201, 204, 209
hidden dimensions, 103,
132–37
memory, remember, 75–79,
81, 101, 104, 107, 154,
191–96
nostalgia, 27, 62, 67, 74, 78,
81, 113
perceptions, habits, 24, 43–
45, 49, 61–62, 72, 81, 89,
86, 134–36, 141, 148, 164,
190, 215
philosophical, 71, 83–91, 136,
155
quadralectic architecture, 149

technology, 81, 114, 134,
145–47, 202, 213–15, 223
theological, 8, 23, 34, 45, 47–
48, 70–71, 83–91, 119–20,
143, 155, 178
ritual studies, performance
(*see* Liturgy, worship)
scale, proportion, 73–74, 115,
126–31, 136, 144–47, 152,
163, 223
scientific, 43–44, 46–47, 70,
94, 132, 134, 145, 191, 204

Justice, social action, 4, 8, 17,
22–24, 30, 32–34, 90, 105–6,
131, 154, 173–78, 222

Liturgy, worship,
as devotional, 47, 62–63, 107,
128, 133, 154, 161, 163–64
elements of, 23, 26, 99, 153,
162–63, 173, 177
as embodied, bodies, 30, 47,
54, 85, 92, 95–97, 99, 102,
132, 135, 181, 188
as ritual performance, 4, 23,
29, 38, 51, 62, 90–99,
115–19, 125, 131–35, 160
as memorial, 5, 84–86, 100–
101, 177–78, 190
and sacrament, 5, 29, 38, 51–
53, 69, 78, 83–93, 98, 105,
111, 143, 161, 175–78
and unity, 5, 17, 54, 166, 63,
96, 101–3, 160, 175, 193
as sensory experiences, 38,
85, 92–95, 97–99, 121,
135–36, 166, 190